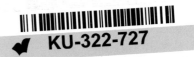
PIERRE CABANNE

CUBISM

·TERRAIL·

Cover:
Pablo Picasso,
Woman with a Fan,
1908, oil on canvas, 152x101 cm,
Hermitage Museum, Saint Petersburg.

Page 1
Pablo Picasso,
The Absinthe Glass,
1914, bronze and sand,
MNAM-Centre G. Pompidou, Paris.

Page 2
Pablo Picasso,
Les Demoiselles d'Avignon,
Detail
1907, oil on canvas,
243.9x233.7 cm,
Museum of Modern Art, New York.

Editorial Director
Anne Zweibaum
Graphic Design
Caroline Keppy, Sandrine Roux
Editorial Assistant
Soline Massot
Iconography
Hélène Orizet
Copy Editor
Marie-Paule Rochelois
Photoengraving
L'exprimeur, Paris

© **FINEST S.A./ÉDITIONS PIERRE TERRAIL, PARIS 2001**
25, rue Ginoux 75015 Paris - France

Editor N° 285
ISBN : 2-87939-236-5
Printed in Italy

The publisher wish to thank the Succession Picasso
for his contribution to this work.

Georges Braque,
Violin and Jug,
Detail
1909-1910, oil on canvas,
117x73.5 cm,
Kunstmuseum, Basle.

Contents

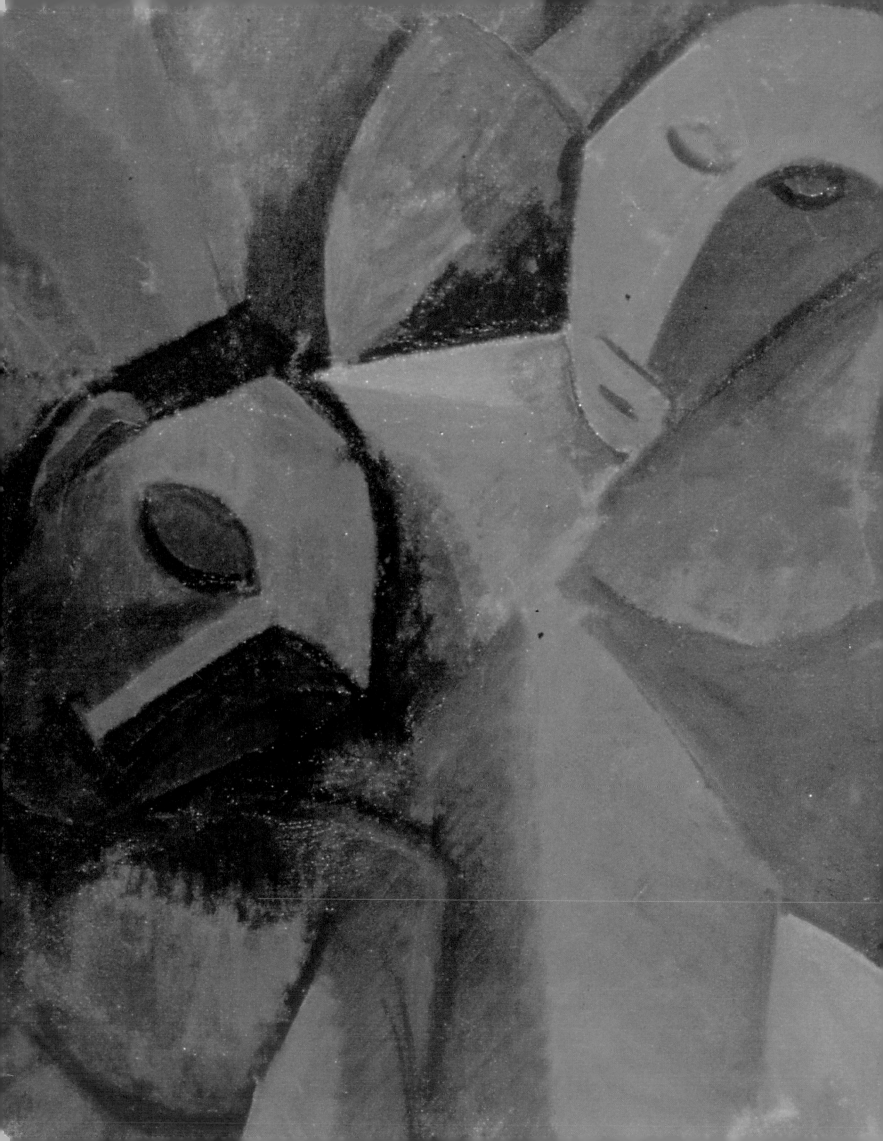

1 The heroic years of cubism

Preceding page
Pablo Picasso,
Three Women,
1907-1908, oil on canvas,
200x178 cm,
Hermitage Museum, Saint Petersburg.

Pablo Picasso,
Les Demoiselles d'Avignon,
1907, oil on canvas,
243.9x233.7 cm,
Museum of Modern Art, New York.

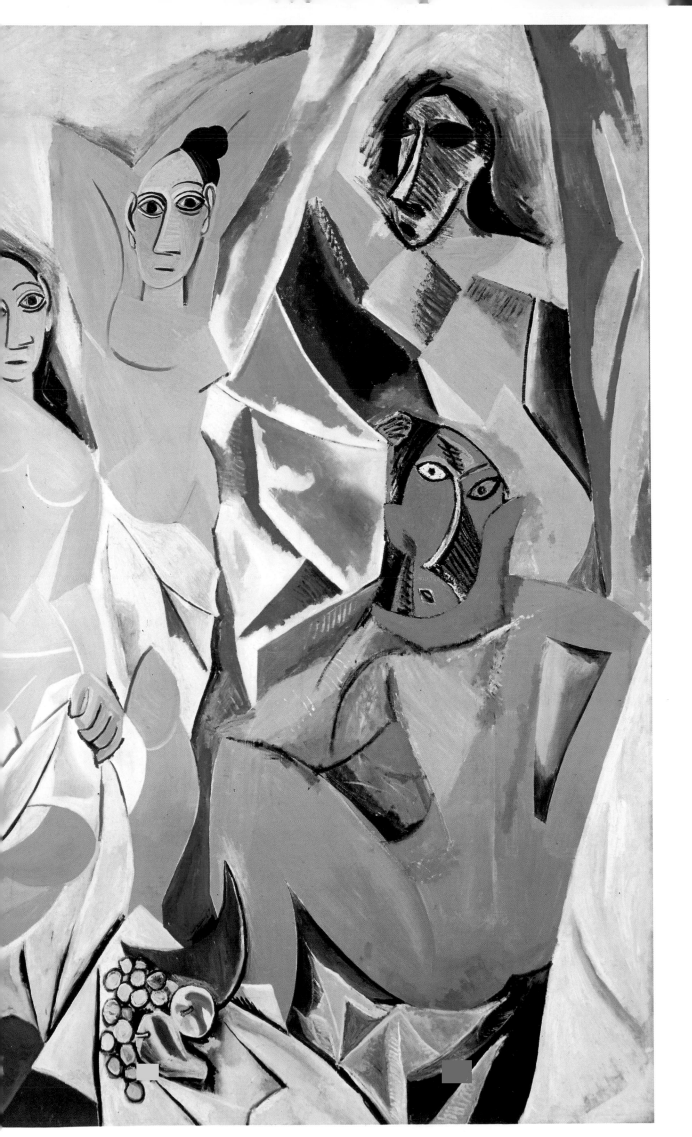

First artistic shock of the century:
Les Demoiselles d'Avignon

The hostility which arose against cubism would be enough to prove that it was indeed a revolution: the vocabulary, the syntax, the meaning and even the space of painting were questioned. "Everything is recognisable, and yet misguiding…", says Beckett. Continuous research led to an entirely new conception and vision of the act of painting and of its purpose. Cézanne's famous laconic piece of advice to Émile Bernard in 1904, can be considered as the starting point: "Treat nature in terms of the cylinder, the sphere and the cone, everything in proper perspective…". Even if the Aix master appears as the initial reference, "Cézannism" will soon be questioned, overtaken and renewed, both in content and spirit, by two young painters: Braque and Picasso.

The word "cubism" will at first be used in derision to describe a series of pictures painted by Braque at L'Estaque in 1908; then, by extension, it will refer to a number of artists who, by diverting the new course, will adopt only the geometrization of the surface, grouped together under the sign of the "Section d'Or". Braque and Picasso's cubism – and only theirs – determined the first great plastic revolution of the 20th century, it was to be exploited by the cubists.

In 1906, the Louvre exhibits Iberian sculptures from the Osuna and Cerro de los Santos excavations which reveal to Picasso the primitive art of his own country, and at the same time the Gauguin retrospective in the Salon d'Automne underlines the "barbarian" primitivist influences in the work of the Atuana exile. In Gosol, a small Catalan village, during the summer, Picasso creates violently schematic figures in which he replaces the face by a mask – that is how he concludes the portrait of Gertrude Stein. In the spring of the same year, he had met Matisse, also fascinated by African art, known then as "Negro art".

Cézanne dies on 23rd of October, 1906, Braque studies his teachings on constructive and simplificatory harmony at L'Estaque where he worked a great deal; he remains there until February. He says later on[1] that "he applied himself to submitting" his own paintings "to the influences of light, atmosphere, the effect of rain which revived colour…" of the Aix master. His watercolours, exhibited at the Bernheim-Jeune Gallery, in June 1907, and in the Salon d'Automne retrospective, will have a great impact on young artists.

During these extraordinarily eventful and productive first years of the century, two main trends emerge in the research and preoccupations of the young painters: on the one hand Cézanne's construction and apprehension of space, colour and light, and on the other, the expressive violence of the Negro, Oceanian or Egyptian primitives. Iberian for Picasso, who begins in March 1907 his first studies for the composition that will become, after several variations, *Les Demoiselles d'Avignon*. In the Salon

1 Statements made by Braque to Jacques Lessaigne in 1961, in catalogue *Les Cubistes*, Bordeaux 1973.

André Derain,
● **Bathers,** _____
1907, oil on canvas, 132.1x195 cm,
Museum of Modern Art, New York.

Following page
Henri Matisse,
Blue Nude, (remember of Biskra) ●
1907, oil on canvas, 92x140 cm,
Baltimore Museum of Art.

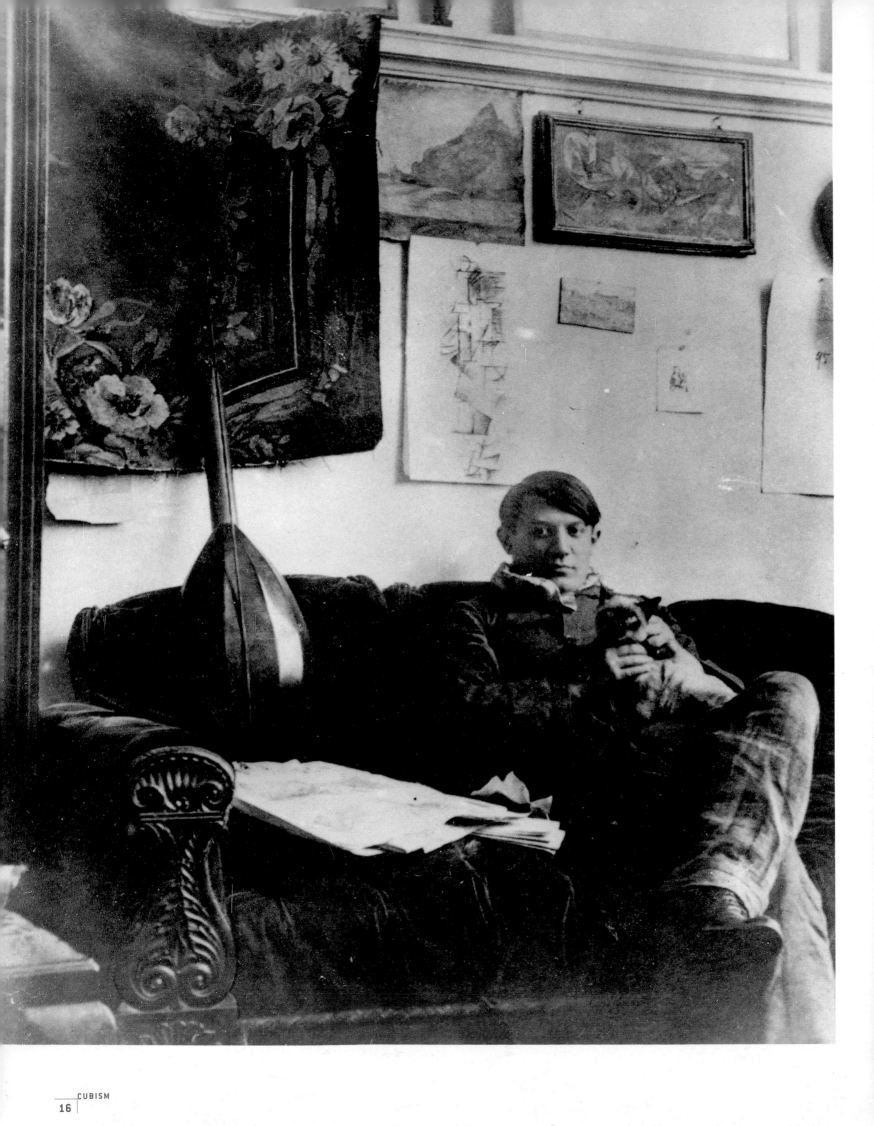

des Indépendants where Braque shows some of his Cézannian paintings from L'Estaque, Picasso sees Matisse's *Blue Nude*[2], a primitivist, hedonistic vision which causes a scandal because of its distortions and crude colours – pink and blue – and Derain's *Bathers*[3] in which the volumes are sharply and strikingly cut out with hard schematic lines.

Thus, without any form of premeditation, the various elements that lead up to *Les Demoiselles d'Avignon* are laid out. Using a Cézannian construction of figures in space, and stimulated by the revelation of Derain's *Bathers*, Picasso attempts to surpass them, to go further, by an even more brutal geometrization of volumes which, making use of Gauguin's primitivism, will lead to a radicalisation of set influences; his figures, thanks to the painter's exceptional visual memory, tend to merge with Iberian heads, African masks, with the Oceanian and Polynesian tribal art shown in the Ethnographic Museum of the Trocadero; the impact of this exhibition will cause Picasso to reshape the second half of *Les Demoiselles d'Avignon,* without altering the first half. "I wondered whether I should start all over again. But then I said to myself: 'No, they'll understand what I intended to do…'", declares Picasso, more sure of himself than of his future public.

2 Baltimore Museum of Art.
3 Museum of Modern Art, New York.

Pablo Picasso
in his studio in 1910.

The Bateau-Lavoir in Montmartre.

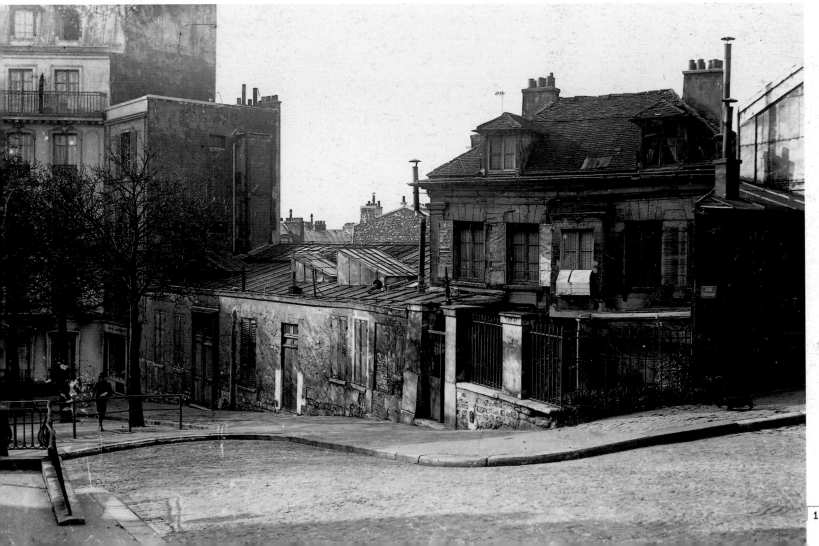

17

Pablo Picasso and Fernande
in Montmartre,
Musée Picasso, Paris.

The successive sketches of the whole composition, reshaped several times, the study of details in the sixteen sketchbooks used by the painter during 1907, show the changes brought to the anatomy and distribution of the figures, and the variety of different styles. These figures, often identified with the prostitutes of the carrer d'Alvinyo in Barcelona, present a contrast between on the left, the transposed sediments of the pink period of 1906, and on the right, the new language stemming from the "Negro" masks, but technically fauvist because of the violent colours; they represent a kind of fantastic visual and mental laboratory in terms of conflict, thought and impact.

The *Demoiselles*, aggressive and incoherent, are intriguing and questioning. They were not painted in broad daylight but in the painful confinement of a miserable studio in the Bateau-Lavoir in Montmartre; the first visitors to see them, are disorientated or shocked; the author is a short and stocky Spaniard of twenty-six, with the dark eyes of a genius or a neurotic. His wild paintbrush like an axe has ferociously cut up the female body which, in the exhibitions of the "Belle Époque", is represented with sensuality, love and respect in so many nude paintings.

But the female is also a diabolical and perverse being, a symbolical man-eating ghoul, like the Montmartre grisette, expert in romance, who caused the suicide of his friend Casagemas, a germ carrier with heavily made-up eyes. Forty years later, speaking to Malraux, Picasso refers to the *Demoiselles* as: "my first form of exorcism"[4].

The laboratories of cubism

A young art dealer, Daniel-Henry Kahnweiler having heard, from the critic and collector Wilhelm Uhde, about a "strange picture on which the painter Picasso was working"[5], goes to the Bateau-Lavoir. He is struck by "the two different halves of the picture" and will write later on[6]: "It is the right side ... which constitutes the beginning of Cubism", the standing Demoiselle whose face is roughly lined with brightly

4 A. Malraux, *La Tête d'obsidienne*, Paris 1974.
5 and 6 D. H. Kahnweiler, *Weg zum Kubismus*, Munich 1920.

coloured strokes and outlined in black, and the violently geometrical anatomy of the figure below, distorted, back to front, crouching on her thighs spread wide apart. After several studies, she is shown wearing a mask with shifted almond shaped eyes and a quarter of a circle shaped nose similar to those of the masks which have been called "Negro", but which may come from other purely imaginative sources as one can see in the preparatory studies and sketches.

Everything combines to make these months of struggle, research and conflict, a painful period of tension. At the time, Picasso is going through complicated emotional problems with his companion, the beautiful Fernande Olivier; she is unable to give him the child he says he wants, consequently, maybe in hope of distracting her lover from his carceral solitude, she decides to take into the Bateau-Lavoir a teenager from a nearby orphanage. The unexpected cohabitation, under difficult circumstances, is a disaster, to the extent that Fernande has to return the child in July. It is during this period of crisis that Picasso paints the present version of *Les Demoiselles d'Avignon*; in August, he and Fernande temporarily break up.

When he returned to Paris from L'Estaque, in February 1907, Braque showed his work in the Salon des Indépendants and Uhde bought five (out of six) of his pictures. He had evolved from fauvist lyricism to Cézannian constructivism. Picasso meets him and carefully studies his work of which the geometrical simplification and monochromatic harmonies correspond to his own preoccupations.

Does Braque's Cézannism, in Picasso's view, temper the primitivist impact of Derain's *Bathers* and the hedonism of Matisse's *Blue Nude*? Or is it their counterpoint? The Spaniard from Malaga is disturbed. "Write to Braque", he puts down in one of his notebooks.

The Norman's contribution "verifies" Picasso's own Cézannism; hence the share he no doubt had, in the creative process of the left side of *Les Demoiselles d'Avignon*; while, in return, Picasso's primitivism has an influence on the *Nude* of Alex Maguy's old collection, often thought to be a direct consequence of the impact of *Les Demoiselles d'Avignon* – "This painting of yours, it's like making us drink petrol to spit fire!" says Braque to Picasso. Their relationship is at the time all the more friendly that they live very near one another, the rue d'Orsel where Braque has his studio, is just next door to the Bateau-Lavoir and they meet almost every day.

Will Braque, with the *Nude*, go a step further than Picasso? The boldness of the simplification, the violence of the geometrization of form, contrast, rhythm and colour, had put Derain's *Bathers* in the forefront of modernity; with *Les Demoiselles d'Avignon,* the Spaniard had the advantage. Braque with his *Nude*, created during the winter of 1907-1908, achieves a synthesis between primitivism and Cézannism and takes the lead. Displaying a face with schematic features, ochre volumes bound in thick outlines and modelled without chiaroscuro in hatching, anatomical distortions, the buttocks and the back seen from three-quarters and joined on to the profile, set on a blue-green drapery with angular forms against a red brick background: the *Nude* stands as an icon for the future.

From *les Demoiselles d'Avignon* to Braque's *Nude*

During the summer period of 1907, Picasso worked on a strange pictu-re, the *Nude with Drapery* of the Hermitage Museum, bought by Leo and Gertrude Stein as soon as it was finished, together with its prepara-tory studies. The angular dynamism of this strange half-swooning oda-lisque – in reference to Matisse – contemporary with the final stage of the *Demoiselles*, in which the hatching in a violently aggressive arrange-ment merges the figure into the background, constitutes a return to pri-mitivism. The most "Negro" painting of this period is accompanied by several oil or gouache studies of African masks with empty almond-sha-ped eyes, a nose at an oblique angle and a tilted head with hatched cheeks. After the *Demoiselles* and the *Nude with Drapery*, the classical image of the female is definitively pulled to pieces. Everything is now ready for the revolution to come.

Through continuous experimentation on the insertion of figures into the space that they create, Picasso develops the plastic and mental pro-blematics of *Les Demoiselles d'Avignon*. This research keeps him busy throughout the spring and autumn of 1907, and culminates in the monumental *Three Women*, also at the Hermitage in Saint Petersburg, in the spring-autumn of 1908. Derain is exploring the same theme and continues his series of *Bathers* with which he tries to regain the advanta-ge over his terrible rival, but the latter has already moved on.

The primitivist gouache produced in the spring of 1908, just after *Les Demoiselles d'Avignon*, called *Three Women* from André Lefèvre's old col-lection, now belonging to the Musée National d'Art Moderne in Paris, first stage of the definitive version, is contemporary with a more abstract composition, *Three Women – (version with rhythm)*, and various studies on the same theme and on that of the *Standing Nude*. During that pe-riod, the *Five Women (Bathers in a Forest)* from the Museum of Modern Art in New York, watercolour and pencil on paper mounted on canvas, can be related to the two versions of *Five Women* from Hanover and Philadelphia, gouache and watercolour on paper. By increasing the figures, from three to five, and their layout, Picasso also multiplies the contrasts of rhythm, sometimes on the verge of abstraction, and the opposition of volumes supported by the parallel lines of the trees. The harmonies are dark, brown-ochre and blue-green.

Gertrude Stein, in *The Autobiography of Alice B. Toklas*, describes a first visit to Picasso's studio: "Against the wall was an enormous picture, a strange picture of light and dark colours… and next to it another in a sort of red brown, of three women, square and posturing, all of it rather frightening…" What the young women probably saw, in October 1907,

Pablo Picasso,
Nude with Drapery,
1907, oil on canvas, 152x101 cm,
Hermitage Museum, Saint Petersburg.

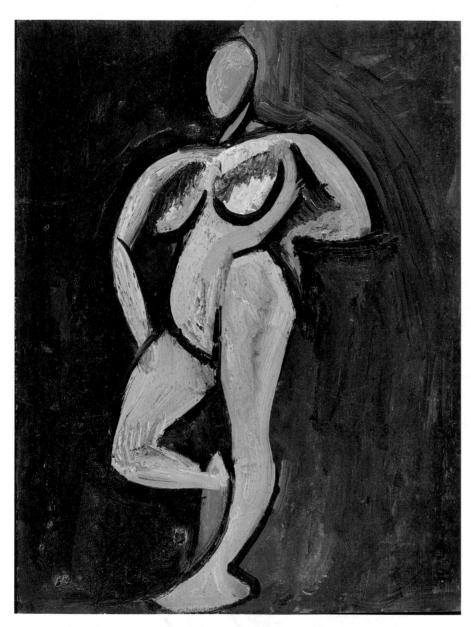

Pablo Picasso,
Standing Nude,
1908, gouache on wood,
27x21 cm,
Musée Picasso, Paris.

Pablo Picasso,
Three Women,
1907-1908, oil on canvas,
200x178 cm,
Hermitage Museum, Saint Petersburg.

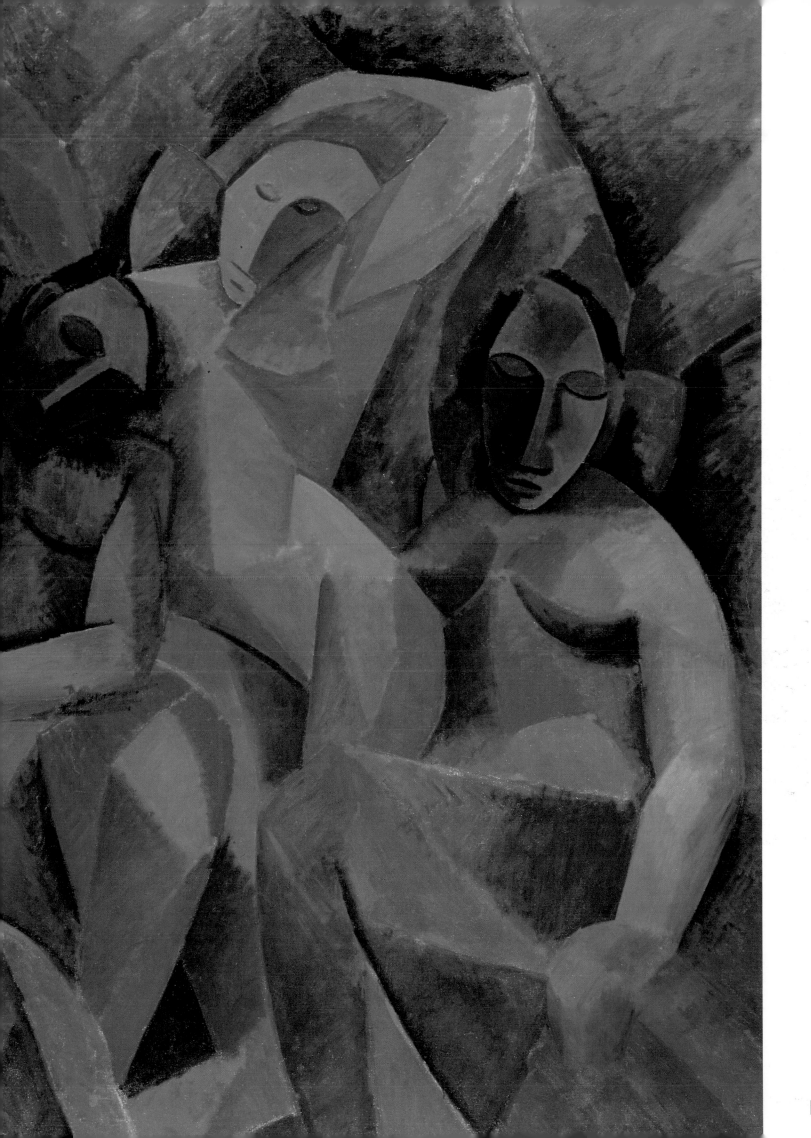

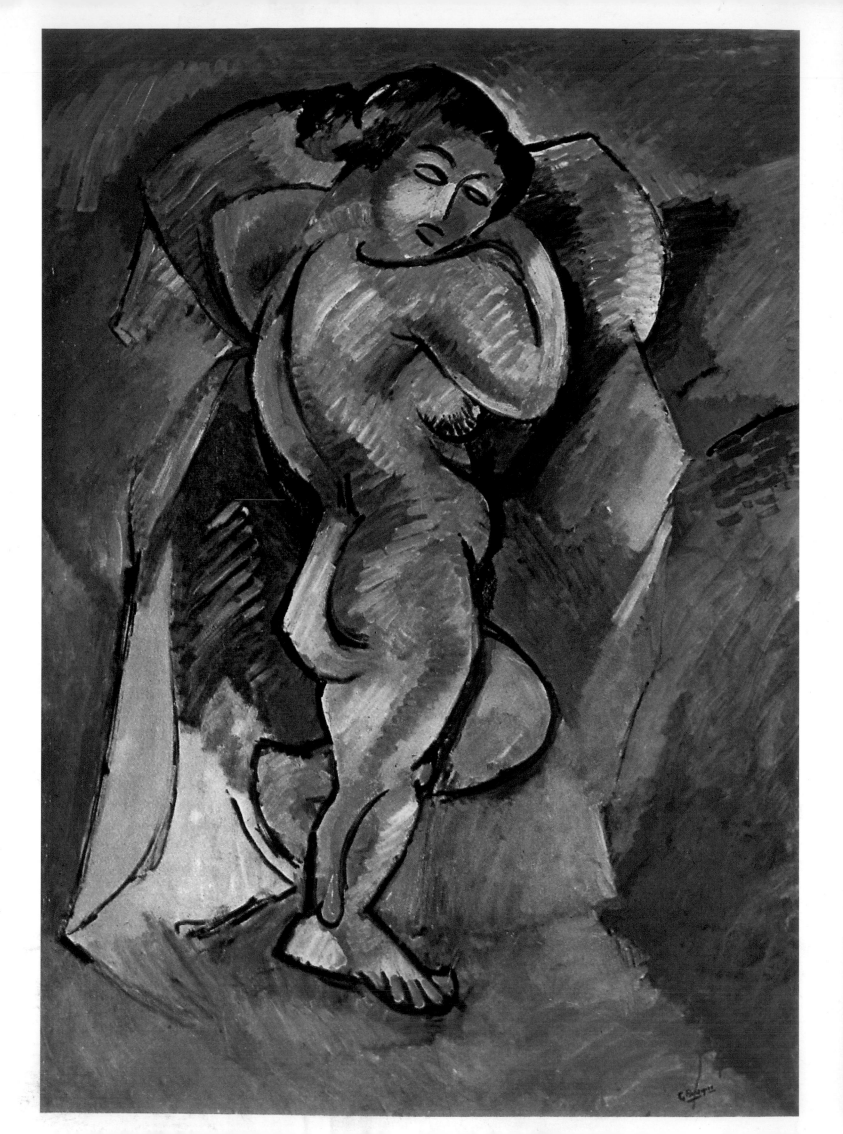

next to the "strange picture of light and dark colours" of the *Demoiselles*, must have been the *Three Women* of Saint-Petersburg, that Picasso finishes in the spring-autumn. They "felt that there was something painful and beautiful there, and oppressive but imprisoned…"

Braque sees the picture at the Bateau-Lavoir at the end of 1907, it inspires him a drawing in which he retains the contrasts of rhythm and movement, underlined by hatching, but not the masks. The American journalist Frank Gelett Burgess reproduced it under the title "*Woman*", in an article in the *Architectural Record* in 1910. The drawing has since disappeared.

The relation between the *Demoiselles*, via the *Nude with Drapery* and the *Three Women*, and Braque's *Nude* becomes clear. At the same time a number of fundamental differences between the two friends emerge: Picasso remains attached to primitivism, to its power of contrast, violence and challenge, whereas Braque, who is fascinated by the Spaniard's boldness but does not adopt his wild energy, for him out of character, continues constructive experimentation in the steps of Cézanne.

In March Braque alone shows several pictures in the Salon des Indépendants, including maybe *The Woman*, of which only the drawing is known. It is probably concerning this aggressive picture that the critic Louis Vauxelles writes on 20th March, in *Gil Blas*: "With Braque I am definitively out of my depth… It is Kanak art, resolutely and aggressively unintelligible…" Most critics are similarly sarcastic or fierce.

Towards the end of May or the beginning of June, Braque returns to L'Estaque, his experimental laboratory. There he paints austere and dense landscapes, in ochre and brown-green, without a skyline, reduced to their essential structure, in which he opposes the cubic architecture of the houses to the foliage painted following Cézanne's "passage" technique.

In August, Picasso goes to the village of La Rue-des-Bois near Creil, where he paints figures and landscapes with powerfully schematic geometrical simplification, which bear similarities, in the analysis of volume and the frontal monumentality and unbroken perspective, with Braque's L'Estaque landscapes. Although their ideas on Cézannism are different, both friends, separated by several hundred miles, are drawn closer together. It is the beginning of the period when, according to Braque, they were "like two mountaineers roped together". The rope will suffer a few snags.

Georges Braque,
The Nude,
1907-1908, oil on canvas,
142x102 cm,
private collection.

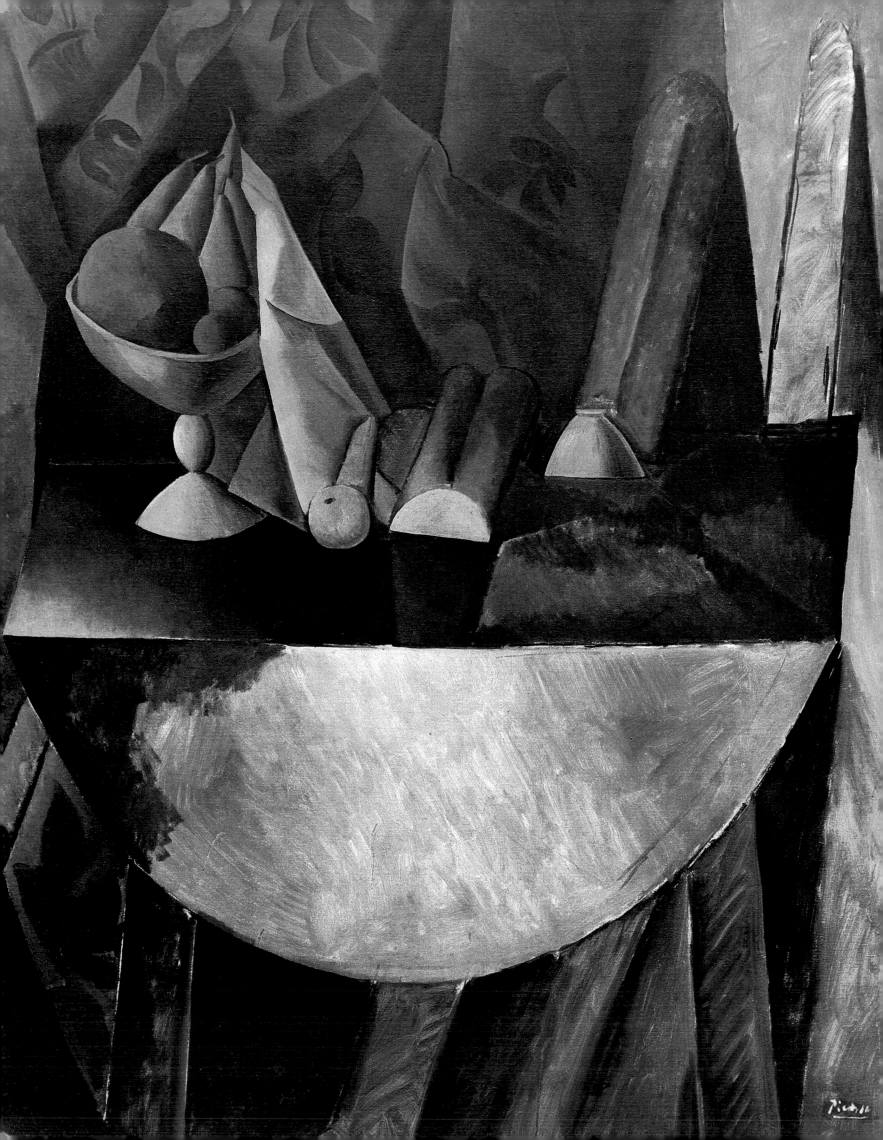

Picasso dissociates, Braque assembles

During the summer of 1908, Dufy, ex-fauvist, joins Braque in L'Estaque, Derain is at Les Martigues. They also geometrize form and build according to Cézannian patterns.

Back in Paris, Braque shows Picasso his work from the South of France. Matisse also sees it and according to Apollinaire, he will be the first, in Vauxcelles' presence, afterwards to speak about "little cubes"; but is the imaginative Guillaume to be trusted? Braque's canvases are rejected at the Salon d'Automne by a jury that includes Matisse, they will be shown in November at Kahnweiler's Gallery. In a paragraph of *Gil Blas* dated 14th November on Braque, Mr. Vauxcelles writes: "The disturbing example of Picasso and Derain has emboldened him … He despises form and reduces everything, landscapes and figures and houses, to geometric patterns, to cubes…" The word is out, it circulates by word of mouth, in derision, among the small artistic circles. Its paternity is not clearly established: Matisse, "who always denied it", affirms the critic Maurice Raynal, or Vauxcelles or Max Jacob.

The dialogue between Braque and Picasso intensifies during the winter 1908-1909, based on Cézannism. "With Picasso we saw each other every day, we talked a lot, we would each test the ideas that came to us, we compared our paintings….", said Braque to Jacques Lassaigne[7]. And according to his friend Françoise Gilot, Picasso told her some forty years later: "In those days, almost every evening I went to see Braque in his studio, or else he came to me. We just had to talk about the work we had achieved during the day[8]…."

They are both working on still lifes, maybe to avoid further denigration. In homage to Cézanne, Picasso paints *The Hat* (private collection) in which the tall black egg-shape of the master's famous "Cronstadt" dominates the discreetly geometrized grey and dark green fruit and drapery. Moving away from primitivism, he paints two versions of a strange *Carnaval au Bistro*, in watercolour, ink and lead pencil (private collection, London and Musée Picasso, Paris), maybe a draft for a more ambitious composition, inspired by the famous banquet given for the Douanier Rousseau in December 1908 at the Bateau-Lavoir. Harlequin dressed in pale blue, surmounted by a Renommée, is surrounded by a number of ghostly figures behind a table, among which are two women in white. The same table reappears in the large still life *Bread and Fruit Dish on a Table*[9] in which the characters are replaced by everyday objects in harmonies of ochre, light and dark brown, on blue-green draperies with angular planes. While Picasso is geometrizing with precision, Braque tests the dynamic whirling movement of ochre and grey curves in the *Fruit Dish* of the Moderna Museet in Stockholm, whereas in the *Guitar and Fruit Dish* of the Rupf Foundation in Bern, he disrupts the perspectives and planes of the yellow-ochre monochromatic harmonies. We are a long way from Mr. Vauxcelles' "cubes".

Georges Braque,
The Fruit Dish,
1908, oil on canvas, 53x64 cm,
Moderna Museet, Stockholm.

Pablo Picasso,
Bread and Fruit Dish on a Table,
1908-1909,
oil on canvas 164x132.5 cm,
Kuntsmuseum, Basle.

7 *Op. cit.* note 1.
8 Françoise Gilot and Carlton Lake, *Life with Picasso*, New York 1964.
9 Kunstmuseum, Basle.

The Spaniard's fruit bowls, glasses, cups and fruit in which Pierre Daix sees "a cure of Cézannian experimentation", displayed the steady and powerful forms of La Rue-aux-Bois, then suddenly the planes are shaken up and the objects, set aside, are replaced by the massive monumental geometry of the *Seated Male Nude* (private collection) and the sculptural *Seated Woman* (private collection, U.S.). That is Picasso.

His Cézannism is weakening, disintegrating; Braque, who does not have his creative powers, is still moving around the object and, with his analytical patience, is conquering it by successive stages; his methodical reflection, his approach to plastic harmonies, are stimulated by the same simple things, fruit bowl, guitar, pitcher, fruit, as in Chardin or Corot. Geometrical speculation attains its limits with him in the harmony between the eye and the mind, by degrees and deduction, with the intimist circumspection which goes with the most fascinating metamorphoses that he brings about as a craftsman and as a moralist.

Picasso often puts him to the test, he escapes or gets round him with his style. "Fortunately, he says, I had a slow mind." One dissociates, the other assembles.

"That's when it all started..."

Braque will say to Dora Vallier[10]: "Traditional perspective does not satisfy me… What particularly attracted me – and this was the main bearing of Cubism – was the materialisation of this new space that I could feel. So I began to concentrate on still lifes… This answered to the hankering I had always had, to touch things and not merely see them… for this was the first concern of Cubism, the investigation of space. Colour only played a small part… Light was the only aspect of colour that preoccupied us …"

New coup de force from Picasso: he carves into facets with cold precision the bust of a very strange picture, *La Reine Isabeau* (Pushkin Museum, Moscow) thus named because of her bonnet, the head with schematic features leans against a stylised arm in front of a rather chaotic pile of draperies which had already been used in previous still lifes.

At the beginning of 1909, the *Nude Woman by the Sea (Bather)*[11] shows in unpleasant brownish colours, her concave geometric forms. As in the *Woman with Mandolin* of the Hermitage, or the *Woman with a Book* (Anne Burnett Tandy, Fort-Worth, U.S.) Picasso breaks up the female anatomy, combining sculptural monumentality with the refinement of planes underlined by hatching punctuated with swellings. The brush strokes structure the surface, cutting it up into facets, playing with faces and harlequin hats. Then he returns to Cézannian figuration with the very realistic *Portrait of Clovis Sagot*[12], the antique dealer of the rue Laffitte where Leo Stern, in 1905, had discovered his first Picassos, the gouache of *The Family of Acrobats with Ape* and the slender *Girl with Flower Basket* taken by Gertrude Stein…

10 Dora Vallier, "Braque, la peinture et nous", *Cahiers d'art*, n°1.
11 Coll. Mrs Bertram Smith, New York.
12 Kunsthalle, Hambourg.

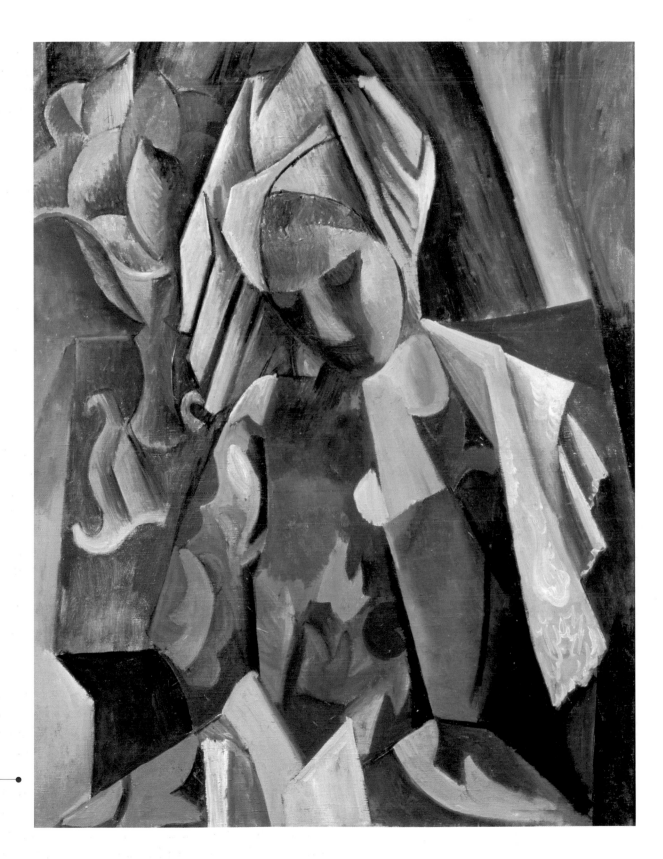

Pablo Picasso,
La Reine Isabeau,
1908-1909, oil on canvas,
92x73 cm,
Pushkin Museum, Moscow.

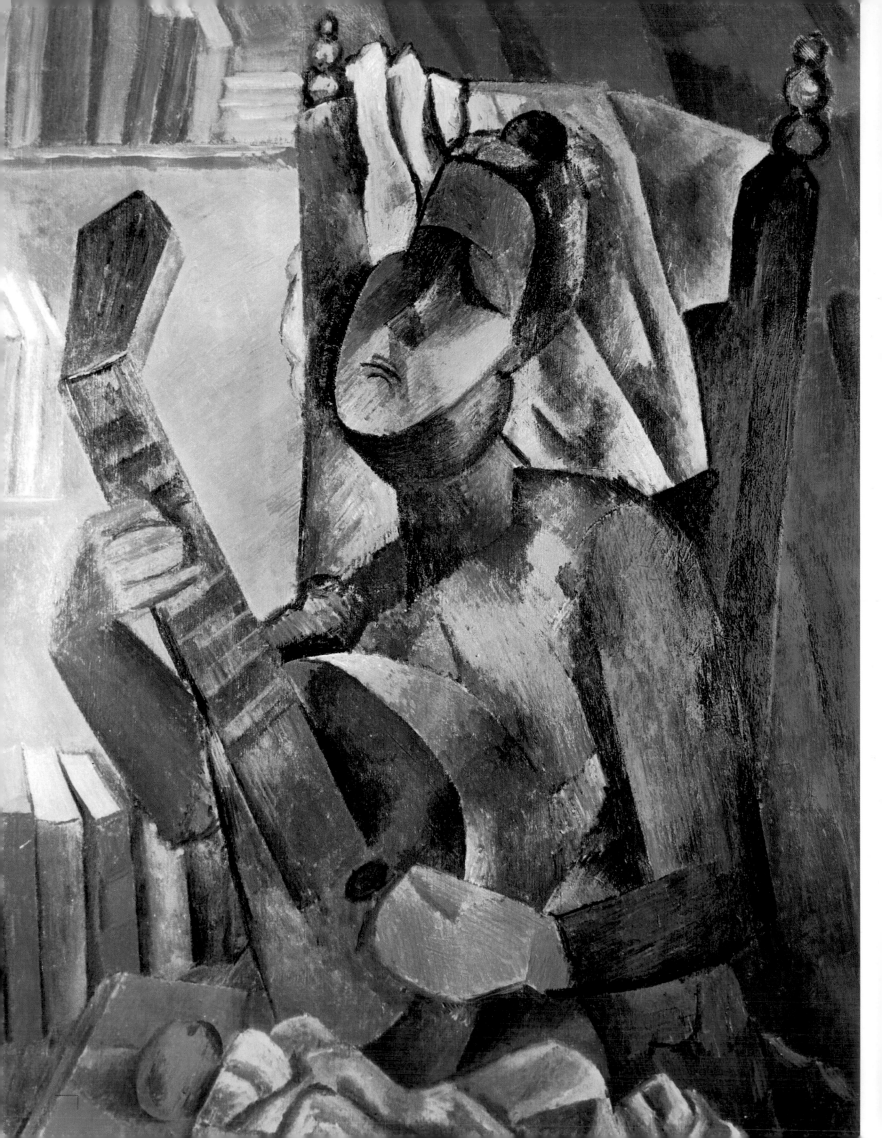

Pablo Picasso,
Woman with Mandolin,
1908-1909,
oil on canvas, 91x72.5 cm,
Hermitage Museum, Saint Petersburg.

Pablo Picasso,
Portrait of Clovis Sagot,
1909,
oil on canvas, 82x66 cm,
Kunsthalle, Hamburg.

Braque exhibits in the Salon des Indépendants in March 1909; it will be his last participation in a Salon until 1920. This gives Mr. Vauxelles another opportunity to mock the artist's "cubic oddities, and, I must admit, hardly intelligible" in *Gil Blas*. On the other hand, André Salmon, in *L'Intransigeant*, considers that "gravity suits Mr. George Braque whose mind is concerned mainly with eloquent lines, we owe him some noble discoveries…"

The critic and poet, Charles Morice, friend of Gauguin's, who very early had analysed Picasso's art with benevolence, is the first to write the word cubism (underlined by him) in the *Mercure de France* dated 16th April, 1909, in relation to Braque's work, whom he considers to be victim of his "over exclusive or insufficiently thought out admiration for Cézanne".

At the beginning of May, Picasso goes to visit his family and old friends in Barcelona with Fernande. He paints with a shivering brush, the portrait of his childhood friend Pallarès[13], and carries out in his hotel bedroom a series of drawings in pen of which he will say enigmatically later on to Pierre Daix: "That's when it all started… That's when I understood how far I could go[14]…" The reconstitution of forms gives a free rein to his imagination like for instance in *Landscape with Bridge*, of the Narodni Galery in Prague, dated from the spring in Paris, in which the monochromatic cubic forms suddenly seem strange. Then, as if he wanted to confront them with nature, he goes with Fernande to Horta de Ebro, a Catalan village overlooking the Ebro.

During the same period, June 1909, Braque is at La Roche-Guyon, a picturesque setting on the Seine not far from Mantes where Cézanne, in whose footsteps he is still following, had stayed with Renoir in 1885.

13 The Detroit Institute of Arts.
14 P. Daix, *Picasso créateur*, Paris 1987.

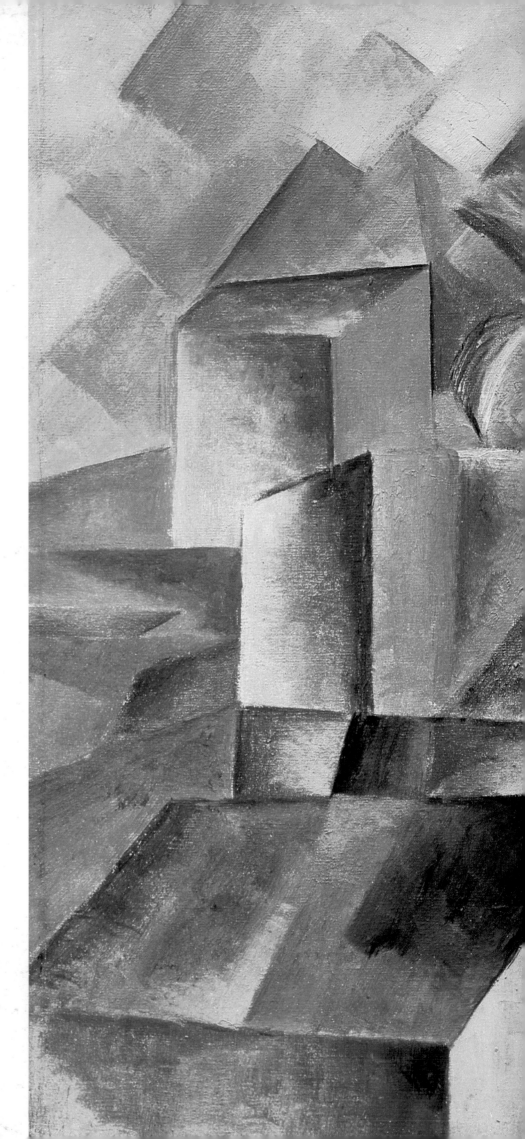

Pablo Picasso,
Factory at Horta de Ebro,
1909, oil on canvas,
50.7x60.2 cm,
Hermitage Museum, Saint Petersburg.

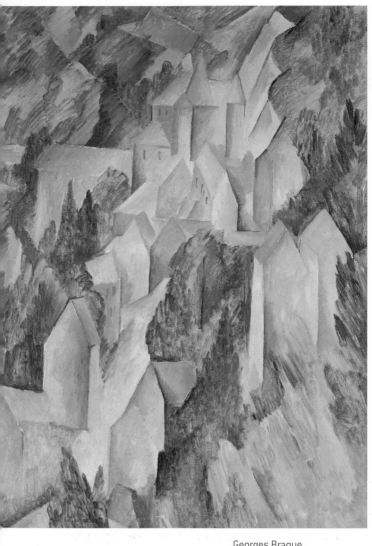

Georges Braque,
La Roche-Guyon, The Castle,
oil on canvas, 1909,
81x60 cm,
Moderna Museet, Stockholm.

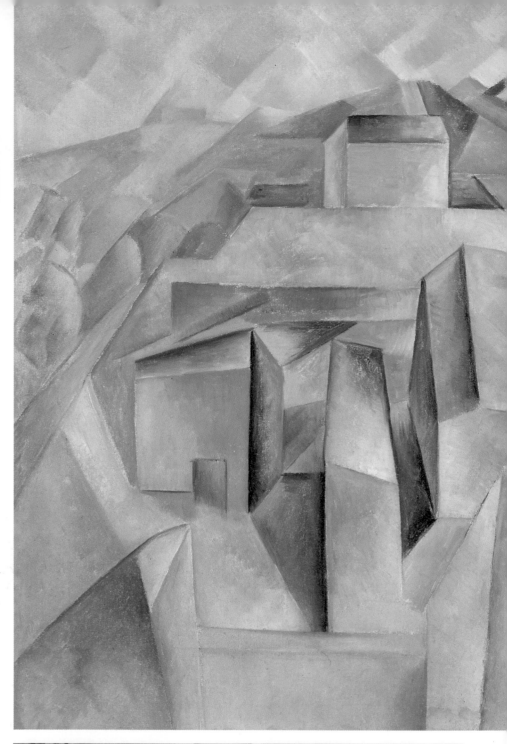

Pablo Picasso,
Landscape with Bridge,
1909, oil on canvas,
81x100 cm,
Narodni Gallery, Prague.

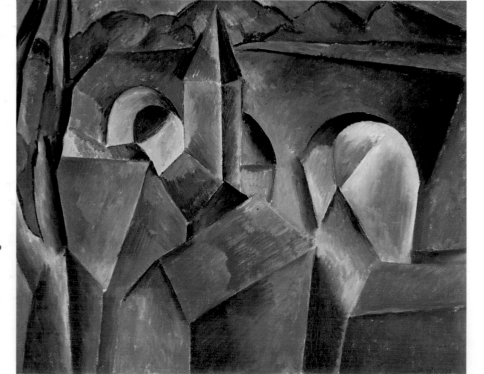

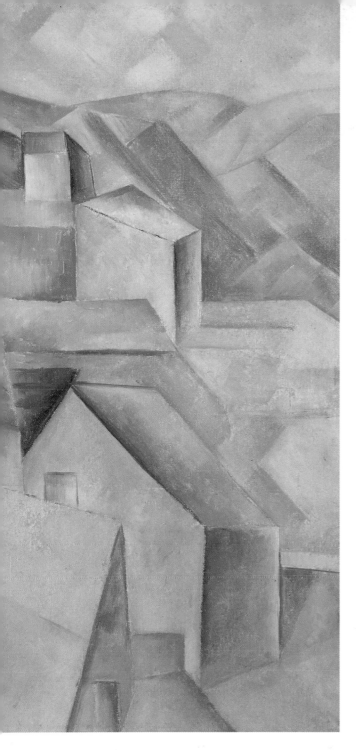

Pablo Picasso,
Houses at Horta de Ebro,
oil on canvas, 1909,
81x65 cm,
Museum of Modern Art, New York.

Portraits and still lifes: analytical cubism

Horta de Ebro (in fact Horta de San Juan) and La Roche-Guyon: two laboratories that engage the future. Sober constructed landscapes in which Braque paints in geometrical staggered forms the castle and the trees which surround the cubes of the houses in a light palette of ochres and grey-greens; the houses rise up to the dungeon and into the sky in a pyramid, in small fragments following Cézanne's "passage" technique (*La Roche-Guyon, The Castle,* Moderna Museet, Stockholm; *La Roche-Guyon Castle,* Musée d'Art Moderne, Villeneuve-d'Ascq…).

At Horta, Picasso is back in the village where he had stayed during his childhood in the spring of 1898; he rediscovers the harsh Catalan countryside, he emphasises its constructive geometry, its cubic houses in which to counterbalance their forms he invents the baroque parallels of palm trees. But most of all, he paints portraits of Fernande, cut up with a kind of wild determination, without anger or rebellion, but out of free plastic necessity; he breaks or curves the planes into angular facets in a series of pictures in tones of ochre and metallic greys. The young woman's sensuality disappears under her lover's repeated strokes, she becomes in close up the *Nude in an Armchair* (private collection), rising up vertically in fragmented geometrization while at the same he is painting the landscapes of Horta, both real and invented, *The Mill*[5], *Houses at Horta de Ebro*[6], *Factory at Horta de Ebro*[17], *The Reservoir, Horta de Ebro*[18]. Picasso sends Gertrude Stein some photographs of the village he used in his paintings to prove how true he

15 Private collection, France.
16 Nelson A.R. Rockefeller Collection, New York.
17 The Hermitage, Saint-Petersburg.
18 David Rockefeller Collection, New York.

was to nature; she will say that in these geometric landscapes she saw "the beginning of cubism".

The simplificatory intention and the plastic evocative power of Fernande's portraits, reduce Braque's La Roche-Guyon landscapes to mere Cézannian exercises; once more Picasso has taken the lead. For a number of reasons, and in particular geographical ones, the two friends no longer see each other as frequently as in the past; the mountaineers' rope is untied, each man works for himself. After their exchanges of the previous years, it is now for both of them a time for solitary exploration, which will last a few years. Only their painting matters, it contains tension, audacity, reflection, depth, challenge.

In the summer of 1909, serious events are happening in Barcelona following a series of defeats in the Rif War, strikes and riots break out, repression is severe. These tragic circumstances disrupt Picasso's Spanish stay. He returns to Paris at the beginning of September and shows his paintings to the Steins at the Bateau-Lavoir before moving out with Fernande to a bourgeois block of flats 11 Boulevard de Clichy. His Bohemian days are over.

Braque, who had spent part of the autumn carrying out the "twenty-eight day" period of his military service, returns to work and paints still lifes. In *Violin and Palette*[19], *Still Life with Mandola and Metronome*[20], *Fan, Saltbox and Melon*[21], the powerfully geometrized objects are staggered in facets following angular articulations that distort their identity, in harmonies of ochre and grey. The *Mandola*[22], of the winter 1909-1910, painted in greys and blacks with shades of green, appears like a sort of nocturnal parade of the object, whereas in *Violin and Jug*, of the

19 Solomon R. Guggenheim Museum, New York.
20 Private collection.
21 Cleveland Museum.
22 The Tate Gallery.

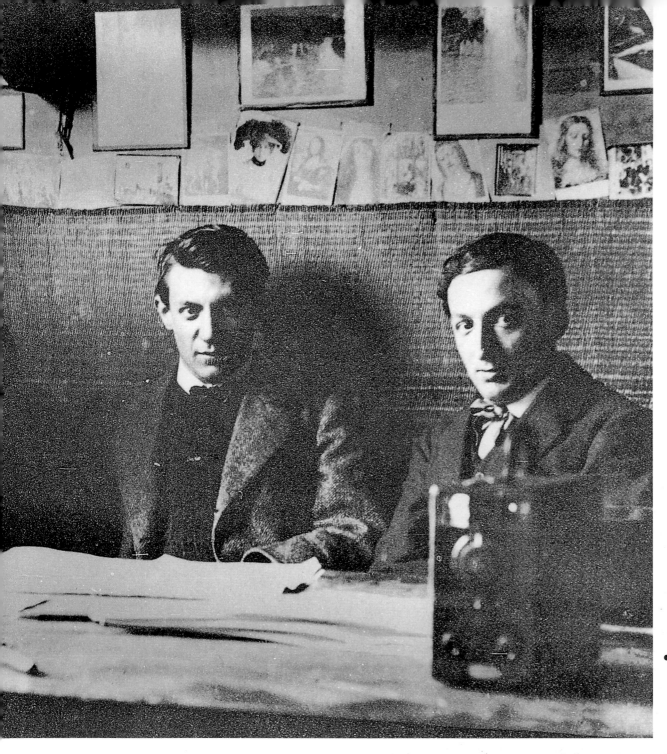

Pablo Picasso between
Fernande Olivier
and the Catalan writer
Ramon Raventos,
in Barcelona, 1905,
private collection.

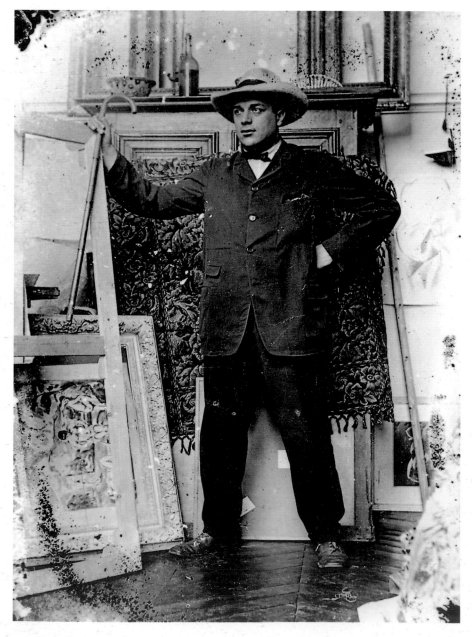

Georges Braque in his studio,
11 Boulevard de Clichy,
photographed
by Pablo Picasso,

Musée Picasso, Paris.

Pablo Picasso,
Portrait of Fernande,
1909, oil on canvas,
61x42 cm,

Kunstsammlung Nordrhein Westfalen,
Dusseldorf.

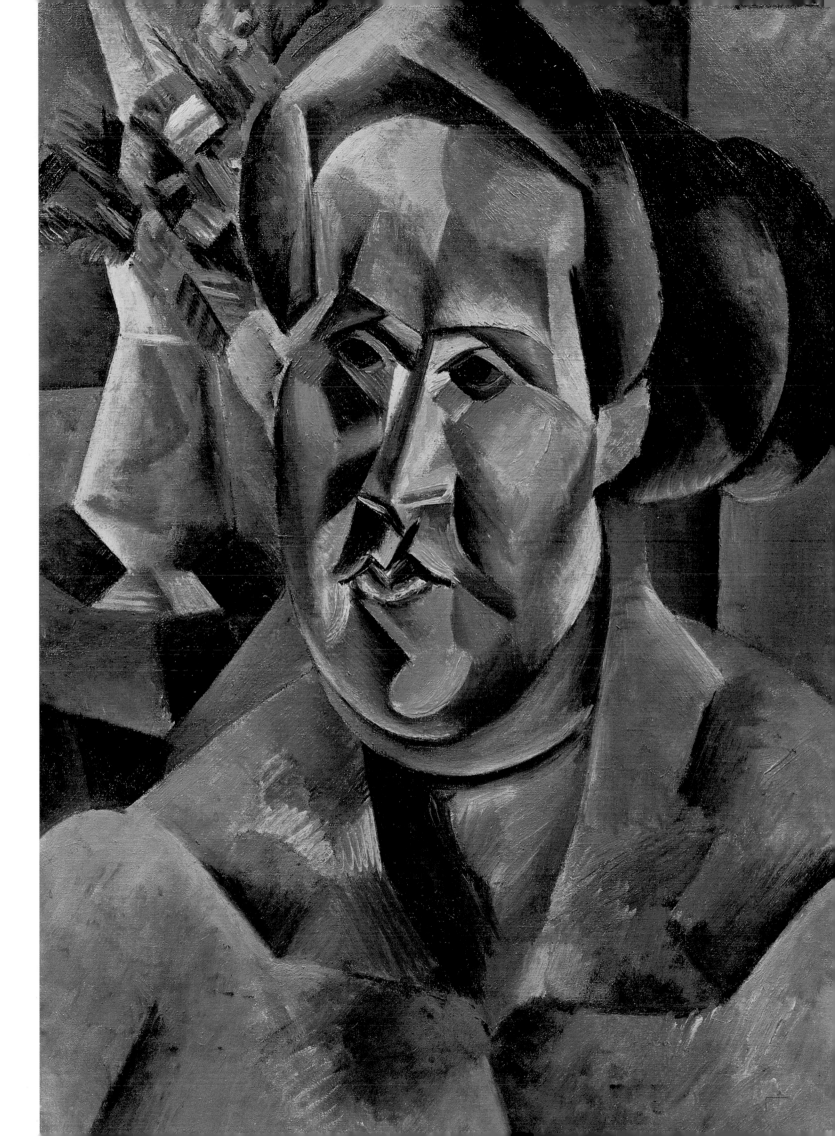

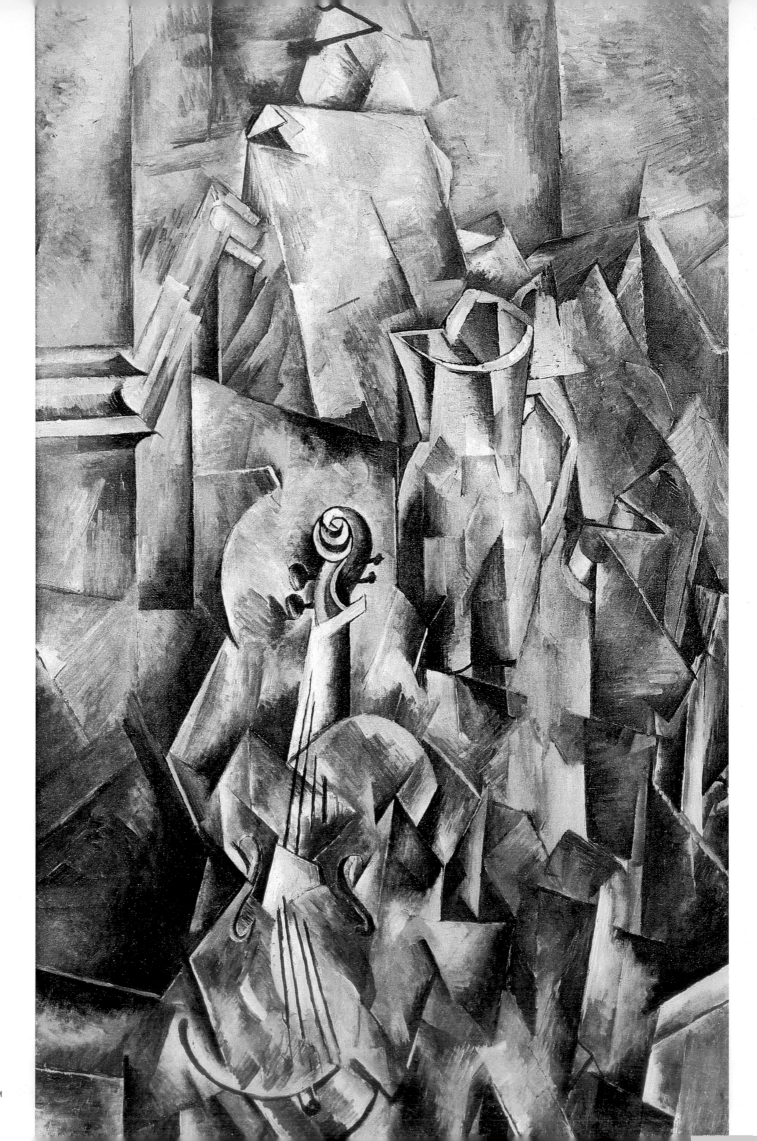

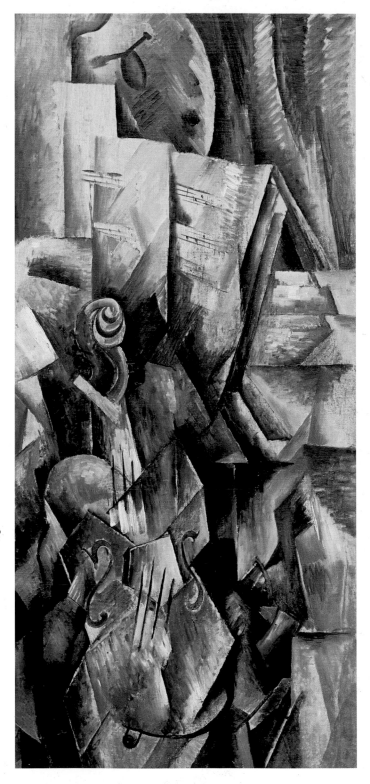

Georges Braque,
Violin and Jug,
1909-1910, oil on canvas,
117x73.5 cm,
Kunstmuseum, Basle.

Georges Braque,
Violin and Palette,
1909-1910, oil on canvas,
91.7x42.8 cm,
Guggenheim Museum, New York.

Kuntsmuseum in Basle, it seems that the frame of the objects is going to collapse in an apocalyptic descent into hell via fragmented and diamond-shaped planes which interpenetrate or overlap one another. The light ochre and cold grey scumble contrasts with the heaviness and the rigour of the objects. The motif of the nail in trompe-l'œil from which the palette hangs in the *Violin and Jug*, is a realistic counterpoint to the abstract structure of the painting.

Picasso's portraits and Braque's still lifes constitute the beginning of the "analytical period" of cubism.

First cubist sculpture

Picasso modelled in raw clay in Barcelona in 1902, his first sculpture, a very naturalistic *Seated Woman*, with basic and massive curved planes, in which only the features of the face and the curls of the hair are detailed. Several other works followed, among which *Le Fou*, a *Head of a Woman*, the future Alice Derain, in 1905, and a *Head of Fernande* with more pronounced volumes, prelude to several plastic experiments inspired by the primitivist masks of the Gosol period or African totems, a series of isolated studies including also some ceramic and embossed copper coins. With the 1909 *Head of Fernande*, made after his return from Horta, and an *Apple* (in tribute to Cézanne?), fractionalisation into broken multiple plane facets relays pictorial space and plastic function, and breaks up the classical face. Concave and convex volumes, light and shade emphasise the contours and create a discontinuous form. Picasso reaches another turning point, he is indeed, as his friend the sculptor Gonzales will say, "the man of form"; cubist sculpture is born.

The Salon d'Automne opens on 1ˢᵗ October, 1910. Braque and Picasso visit it and are fascinated by the revelation of twenty-four "Figures of Corot ". Is there, as suggested by the American art historian William Rubin, expert on Picasso, a connection between *The Woman with the Fur Hat* and the *Girl with Mandolin* of the Museum of Modern Art, in which the fragmented geometric monochrome planes underline specific realistic details, the mandolin, the girl's round breast, her hair and the boldly turned profile of her face. The model, Fanny Tellier, is said to have been so shocked at being thus mistreated, that she gave up posing, claiming that she was unwell.

It is the first of a series of "cubist" portraits in which Picasso breaks away

Pablo Picasso,
Head of Fernande,
1909, bronze,
40.5x24x26 cm,
Musée Picasso, Paris.

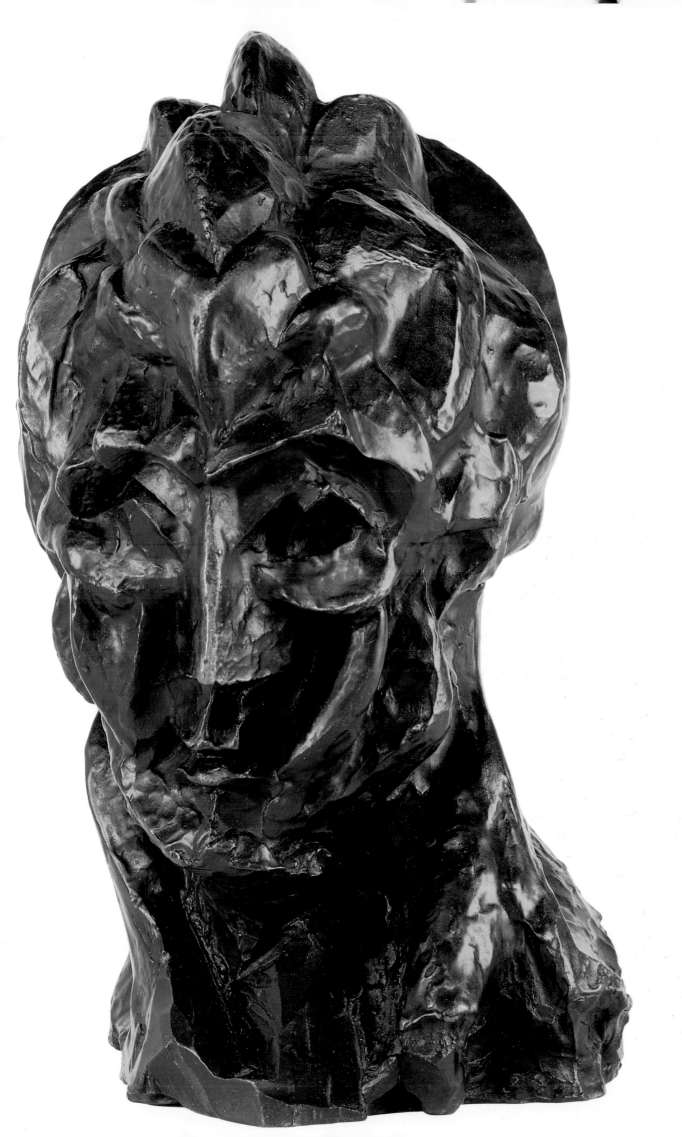

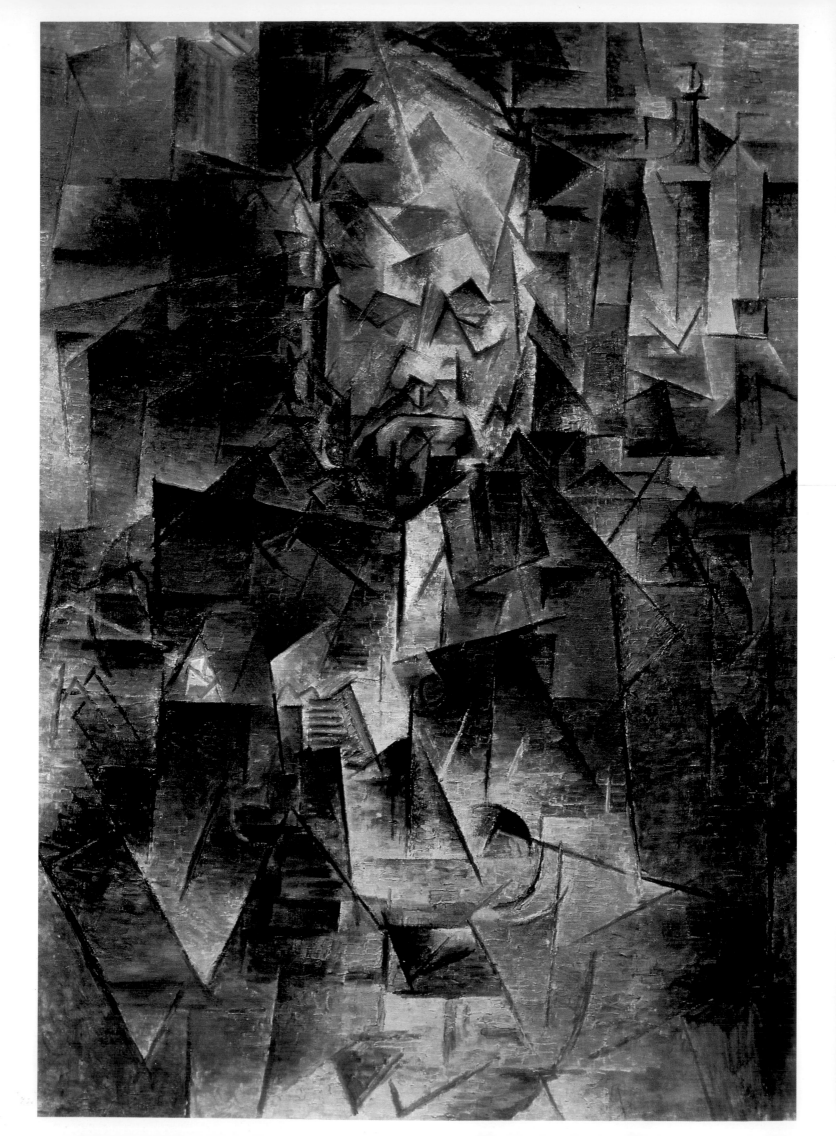

Pablo Picasso,
Portrait of Ambroise Vollard,
1910, oil on canvas,
93x66 cm,
Pushkin Museum, Moscow.

from form through impressive dissections of the face. Wilhelm Uhde's[23] portrait shortly precedes Vollard's[24], both of which were carried out in the spring 1910, the latter was completed after Picasso's stay in Cadaques in August. Cut out in monochromatic facets, the faces seem to emerge, like "lifelike" apparitions, from the fragmentation of the surrounding space, to which they are integrated by subtle "passages". A third portrait is achieved in the autumn, the *Portrait of Daniel-Henry Kahnweiler* (Art Institute, Chicago), much more conceptualised than the previous ones, it is constituted of abbreviation networks geometrically cut out and overlapping in harsh monochromatic effects. As in the case of Vollard, it had demanded many sittings.

The Rio Tinto factories

Picasso and Fernande spend the whole summer in Cadaques where they are joined by the Derains; the Spaniard is going through a painful period of tension probably caused by the difficulties he has had with the portraits, in particular Vollard's that he has temporarily gave up. He returns to Paris, according to Kanhweiler, "after weeks of painful conflict, bringing back unfinished works…." They represent, apart from a *Port of Cadaques* owned by the Narodni Gallery in Prague, abstract figures or still lifes, among which *The Dressing Table*, cut out in facets with the same constructive rigour as the *Glass and Lemon*, the mysterious *Woman with Mandolin*, which is as indecipherable as *The Guitarist* of the Musée national d'Art Moderne.

It is in Cadaques that Picasso engraved the etchings intended to illustrate Max Jacob's *Saint-Matorel*, published by Kahnweiler; without ever thinking of drawing his inspiration from the text, he used the cut up fragmented figures that he had created during the previous months, Max was quite stunned to say the least.

Upon his return from Spain, he meets up again with Braque who had spent part of the summer and the autumn until November at L'Estaque for the fourth time. The latter brought back several landscapes including *The Rio Tinto Factories at L'Estaque* (Musée d'Art Moderne du Nord, Villeneuve-d'Asq) constructed in juxtaposed faceted planes with an unfinished aspect, and showing small touches reactive to the vibrations of light. "I wanted to turn brush-work into a form of matter…", he says later on. Compared to Picasso's assertive outbursts, these landscapes are treated with subtlety, which gives them a kind of ethereal pyramidal discontinuity in space. Braque, as a patient analyst, faces with methodical application his friend's capacity of metamorphosis; there is nothing speculative or systematic in his work, his form of cubism also retains, in his eyes, an element of surprise, of discovery. His *Rio Tinto Factories* and other landscapes from his last stay in L'Estaque, are not, as with Picasso, constituted of effects of volume but of effects of light; geometrical forms in facets are only used for their capacity to create luminous, meditative, contemplative inflexions and passages. Braque fervently and skilfully handles scintillating and clashing colours.

23 J. Pulitzer Jr. Collection, Saint Louis.
24 Pushkin Museum, Moscow.

Georges Braque,
The Rio Tinto Factories
at L'Estaque,
1910, oil on canvas,
65x54 cm,
MNAM-Centre G. Pompidou, Paris.

The scandal of "The cubist room"

In March-April 1911, eighty-three drawings and watercolours by Picasso are shown in the "291" Gallery of Alfred Stieglitz in New York. It is his first personal exhibition abroad, he only accepted it reluctantly under pressure from Gertrude Stein. But its repercussion is considerable, the Spaniard from Malaga is considered, at least abroad, as the creator and leader of cubism. The preface of the catalogue is written by Marius de Zayas who had published the year before in the *America Revista Mensual Ilustrada*, in Spanish, an interview with the artist, also translated and printed in *Camera Work*, Stieglitz's periodical. It is also the first time that the ideas of Picasso who is usually not very prolific in words, are expressed in the United States. Reactions are mitigated, one New York magazine, *The Globe and Commercial Adviser* considers that Picasso's exhibition remains an "unfathomable mystery to all but art's super-intellectuals".

In the Salon des Indépendants, which opens on 21st of April, the "cubist" room causes a scandal. Yet neither Picasso, nor Braque are represented! The artists on exhibition are Delaunay, Le Fauconnier, Metzinger, Gleizes, Marie Laurencin, Léger, La Fresnaye, Lhote, etc. Ambiguity prevails. "What is a cubist? It is a painter of the school of Picasso and Braque …" writes *Le Petit Parisien*; thus a convenient label is circulated, which for a number of critics and part of the public amounts to a huge fraud.

The same confusion occurs in the Salon d'Automne, a few months later. Apollinaire sets things right in the review *Poésie*: "it is a pale imitation, without vigour, of works not shown, painted by an artist endowed with a strong personality and who furthermore has not revealed his secrets to anyone. This great artist is named Pablo Picasso. But the cubism of the Salon d'Automne is a jay dressed up as a peacock…"

Cubism had been an intuitive, spontaneous expression. "When we made cubism, we had no intention of making cubism, we were only expressing what we was within us", says Picasso to Christian Zervos. The followers or imitators of the Salons only retained Picasso and Braque's geometric fragmentation; they stylise, sometimes with talent, but they exploit, they do not create; all the same for the majority of critics who had not grasped the two friends experimentation work, these are "the cubists". From a limited initiative, a difficult and complex art, impossible to share, they made a programme, they created a school. Creative emotion cannot be reduced to a repetitive process. The history of cubism is Braque's and Picasso's, all the others are deviationists, epigones, "cubists".

Picasso's abstract experimentation continues during the spring of 1911, and causes a small upheaval with *Guitarist (The Mandolinist)* of the Narodni Gallery in Prague, or *Guitarist (The Torero)* belonging to a private collection in Chicago. Sometimes the paintings are connected to reality by a number of allusive elements, for instance in *Soldier and Girl, Buffalo Bill* or *Seated Woman with a Mandolin. La Pointe de la Cité* (Norton Simon Foundation, Los Angeles) reaches total abstraction whereas in *Le Pont-Neuf* (private collection, Switzerland) the arches of

Pablo Picasso,
Le Pont-Neuf,
1911, oil on canvas,
33x24 cm,
private collection.

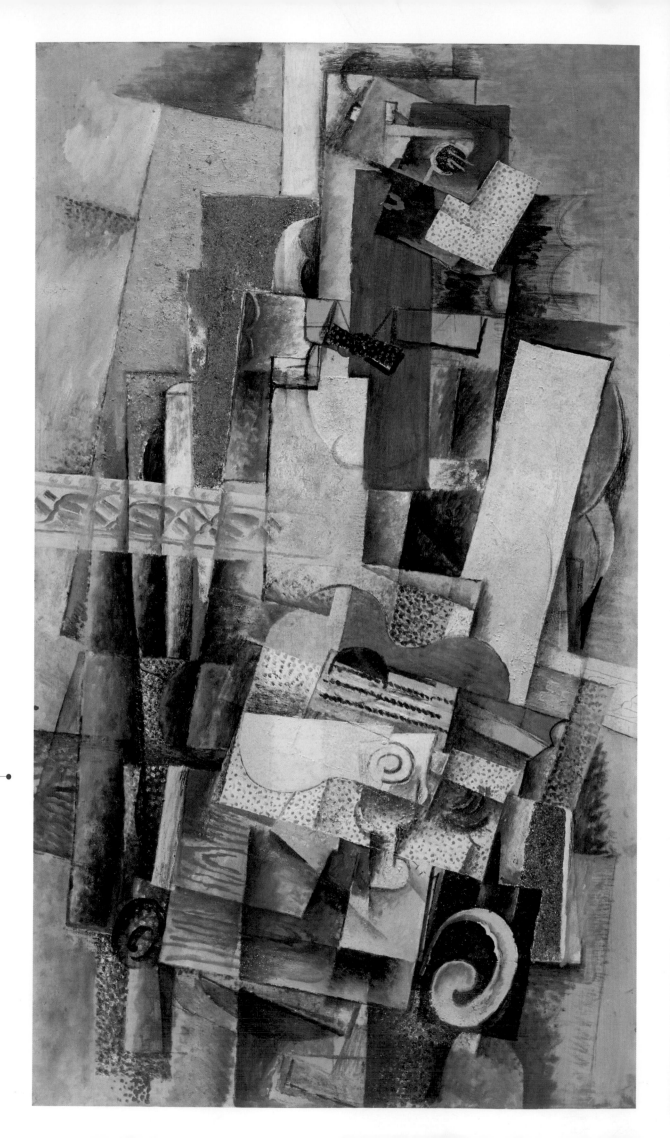

Georges Braque,
Man with a Guitar,
1914, oil and sawdust,
130x73 cm,
MNAM-Centre G. Pompidou, Paris.

the bridge, some houses and a little boat remain visible within the general break up.

In the middle of July, Picasso goes alone to Céret, a small town in the East of the French Pyrenees where his friend Manolo Hugué and his wife live. The canvases he paints there confirm the geometric breaking up of volume of his still lifes in which everyday objects are submitted to an extraordinary spatial dynamism. The *Accordionist*[25] and *The Poet*[26] are among the rare figures he paints during of this Catalan stay. In the middle of August, Braque is invited to join him. The two friends are sharing a house which will soon be known as the "cubists' house". The mountaineers' rope is tied up again.

If Braque's *Man with a Guitar*[27] corresponds to the pyramidal structure of Picasso's *Accordionist*, in *The Portuguese* of the Kunstmuseum in Basle, one of the major figures of this period, the planes are staggered within the space made coherent by the harsh rigour of the composition with mottled touches in a golden light that is also in Picasso's canvasses. Responding to the same desire of reality, they both print stencilled letters in order to balance the staggering of the picture space.

In spite of differences of character, their friendship is consolidated and fulfilled through common experimentation. "Things were said between us in those years, tells Braque to Dora Vallier[28], that no one will say again, that no one would know how to say, that no one would understand now… things that would be incomprehensible but that made us so happy… and it will be over with us… Above all, we were wholly concentrated…"

They are working with the same creative tension; it is during this period that Braque and Picasso's cubism reaches its highest intensity in the materialisation of the new space they have created, in which the relationship between objects, their juxtaposition, their interconnection reach full density. All his life Braque will keep the *Still life with Violin* painted in the summer 1911, as the most convincing testimony of his Céret work produced in fertile conviviality with Picasso; he only lent it once for the large exhibition in the Palais des Papes in Avignon organised by Yvonne Zervos in 1947. When he died, it went to the Musée National d'Art Moderne.

25 The Solomon R. Guggenheim Museum, New York.
26 Peggy Guggenheim Foundation, Venice.
27 Museum of Modern Art, New York.
28 Dora Vallier, *op. cit.*

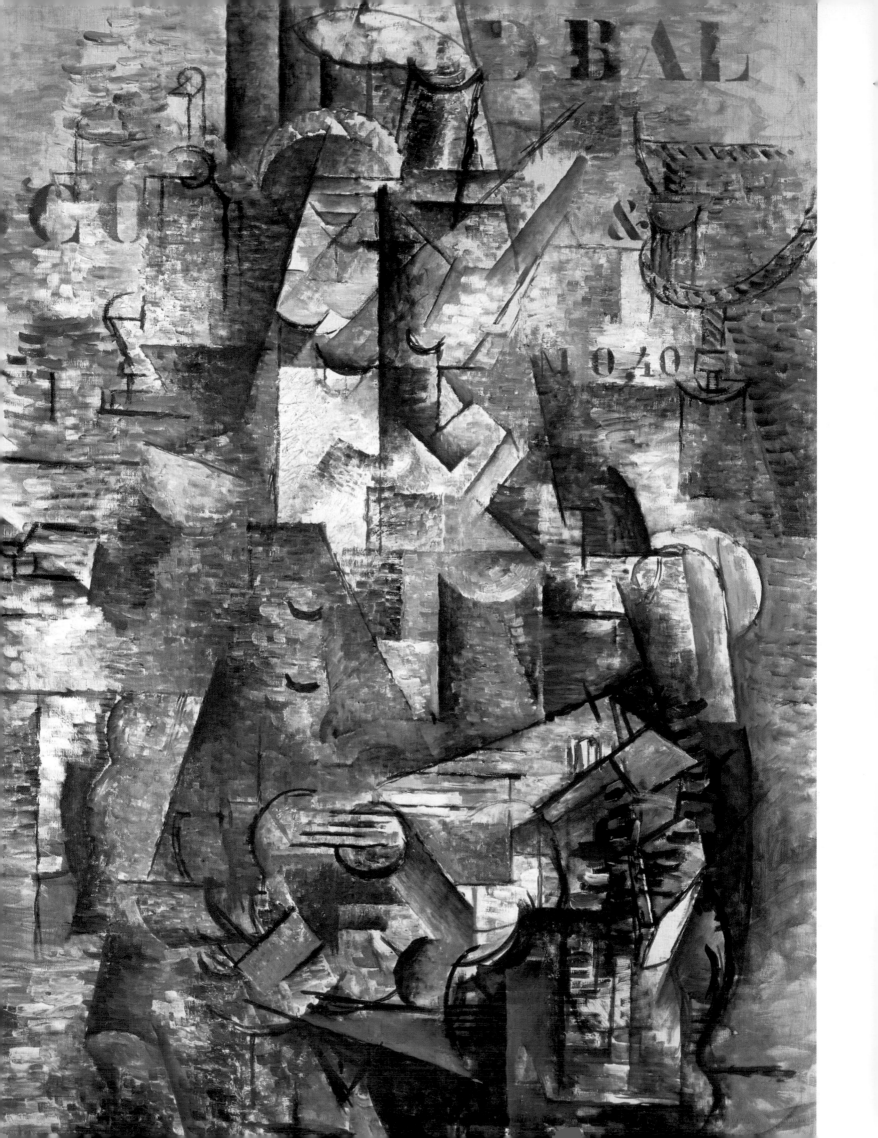

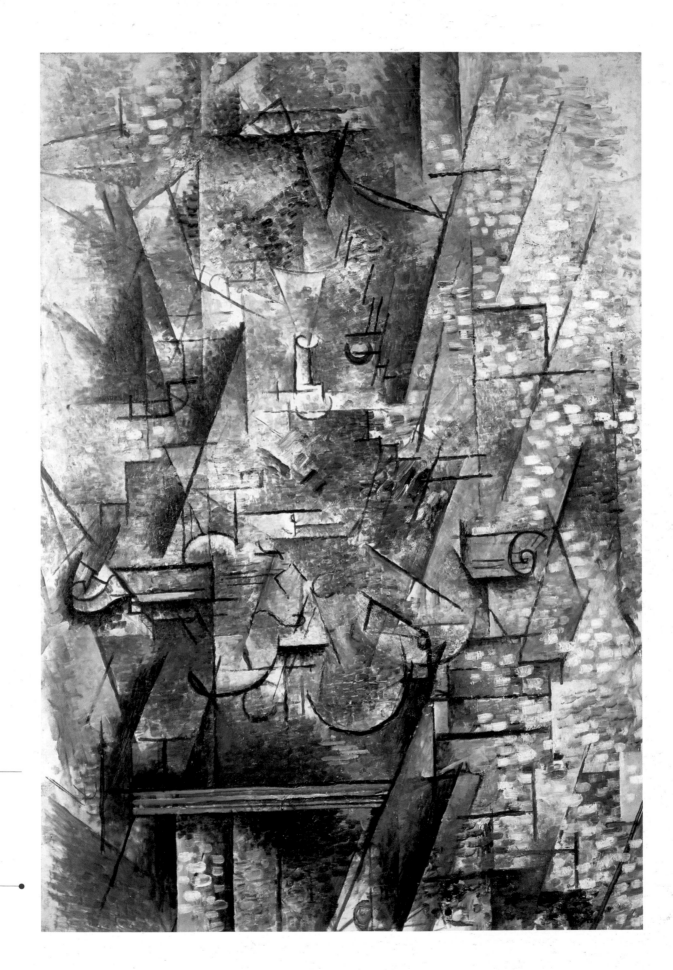

Georges Braque,
The Portuguese,
1911, oil on canvas,
117x81.5 cm,
Kunstmuseum, Basle.

Georges Braque,
Still life with Violin,
1911, oil on canvas,
130x89 cm,
MNAM-Centre G. Pompidou, Paris.

Cubism seen from abroad

A bomb explodes and upsets their peaceful working period: the theft of the *Mona Lisa* from the Louvre on 21ˢᵗ of August. It creates a huge stir. On the 29ᵗʰ, *Paris-Journal* reveals that a certain Gery-Pieret had taken two Iberian sculptures from the museum in March 1907 to prove how easy it was to steal from the badly guarded Louvre. In fact, the charlatan had sold the two heads to Picasso; Pablo hurries back to Paris and together with Apollinaire, of whom Géry-Peret claims to be the secretary, he takes the statues to *Paris-Journal* hoping that they will be discreetly returned to the Louvre. Guillaume is accused of being an accessory to theft and incarcerated, Picasso, summoned to appear before the examining judge, is not troubled, nevertheless this affair which is in no way directly connected to the theft of the *Mona Lisa*, has really shaken him; most of all, he had feared he would be expelled.

On 30ᵗʰ September, under the title "Les cubistes", the *Journal de Bruxelles* writes: "the current master is Mr. Pablo Picasso whose work betrays the contradictory influences of Cézanne, Van Gogh and Gauguin. With ingenious method the disciple details into fragments the subjects that his great predecessors had invented and painted in new harmonies. However cut up and crumbling that his "cubes" may seem, they remain joined by the old balance. It holds together, as the connoisseurs say…" It is one of the first kind articles, especially coming from abroad, to be published on Picasso since the painful interlude of the stolen statuettes and the tepid reactions to the New York exhibition. An important article by John Middleton Murray in the English periodical *Rhythm*, the visit Boulevard de Clichy of the German art historian, Max Raphaël after Picasso's participation in the Berlin Secession in Mai 1911, and a long article by the Italian critic and poet Ardengo Soffici, "Picasso e Braque", in *La Voce* in Florence in August, had already marked the growing resonance of cubism. For the first time in *La Voce*, the two friends were associated; they exhibit together in the autumn of 1911 at the Modern Kunst King in Amsterdam.

Braque remained at Céret, Picasso took his brushes back to Paris. In the autumn of 1911, a charming young woman Eva Gouel, the friend of the painter Marcoussis, who calls herself Marcelle Humbert, comes into his life. Pablo, very much in love, celebrates this new happiness with a superb painting, *Ma Jolie (Woman with Guitar)*, of the Museum of Modern Art in New York, the title was inspired by one of Fragson's songs, in fashion at the time; its pyramidal framework in grey and brown harmonies, punctuated with little square flecked touches is in the line of the dissymetrical geometrization of Céret. The words MA JOLIE are stencilled at the bottom of the composition like a signature. Kahnweiler will say: "Writing his love on his paintings, Picasso never did anything else…"

Fragile, slender, and what is more extremely pretty, Eva is the antithesis of Fernande, the beautiful placid model of the heroic years and of so many works which have modelled and tortured her face; the latter disappears out of Picasso's life. In her heart and her mind, and in her *Souvenirs,* printed in 1933 in spite of ex-lover's attempts to prevent their publication, she will

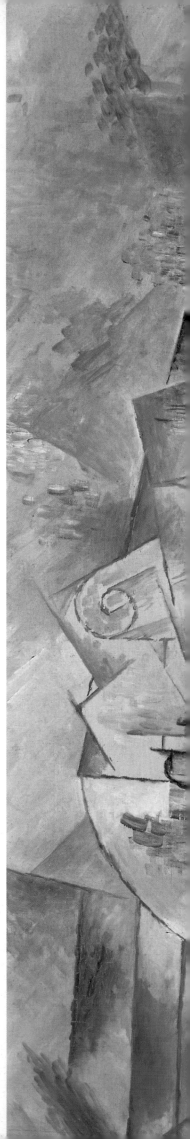

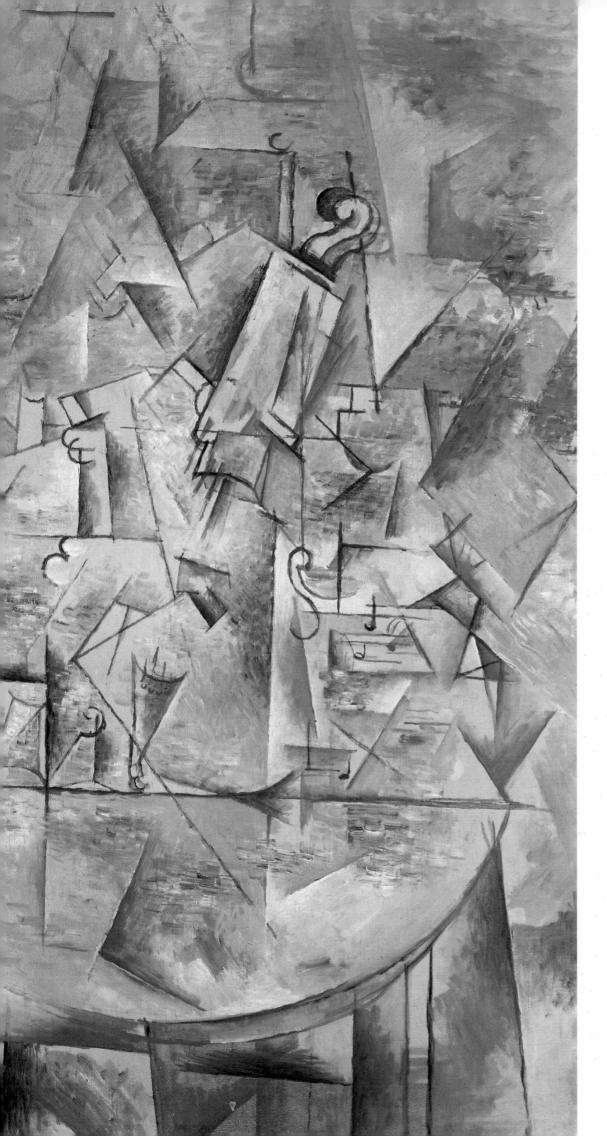

Georges Braque,
The Guéridon,
1911, oil on canvas,
116x81 cm,
MNAM-Centre G. Pompidou, Paris.

remain faithful till the end of her long life in 1966, to the genius who had been the insufferable and brilliant companion of her youth.

Braque surprises Picasso

"Every day I have to fight against the people of Céret who want to see cubism…", writes Braque from the small Catalan town to Kahnweiler in October. During the winter – he will not return to Paris until mid-January – he chooses preferably oval canvases. They lead him to circular formats which concentrate the objects and obliterate the angles; the rhythmic distribution becomes more vivid, more vibrant, the space is more tactile. For example *The Guéridon*[29], of which the fine framework fits into a very gentle crystalline harmony of pale ochres, beige and iridescent greys. Several times, throughout his life, Braque will return to the theme of the guéridon or the table laden with objects, which throughout the winter of 1911-1912 will protect him from the temptation of hermetism. During the same period Picasso is also concentrating on everyday objects, match-box, pipe, glass, jug, bottles, newspaper, etc., that he puts into his still lifes.

In the *Homage to J.S.Bach*[30], Braque organises vertically, in rectangular format, the layout of subdued ochre and grey rhythms, with discreet realistic reference to musical instruments; the word BACH and the initials J.S. are printed in stencil. For the first time the artist, no doubt applying his early apprenticeship as a craftsman, introduces in his composition the use of imitation wood in trompe-l'œil. Surprised, Picasso asks his friend to teach him the technique, the latter provides him with professional steel combs which Picasso will use for the *Poet*'s hair and moustache in the summer of 1912.

Braque also has fallen in love. In January he moves in with Marcelle Lapré, impasse de Guelma, in the XVIIIᵉ arrondissement. Picasso accompanies them when Braque goes to Le Havre to introduce Marcelle to his parents, probably in March or April. On his return, he paints *Souvenir from Le Havre* (Foundation Beyeler, Basle) and *Violin, Glass, Pipe and Inkstand* (Narodni Gallery, Prague) in which he uses the stencil; in the still life several fragmented words appear arbitrarily scattered: LE HAVRE, HONFLEUR, MA JOLIE and SOIREES DE PARIS, the periodical recently founded by Apollinaire, Salmon and Billy, among others, of which the first number had been published in February. In *Souvenir from Le Havre,* Picasso puts imitation wood made with a steel comb, applying Braque's technique, the words appear in a banderole at the bottom of the picture, the painter further innovates by using Ripolin paint to enhance the bright blue of the French flag at the top.

According to Severini[31], the futurist, who was in Picasso's studio when Braque saw the last two pictures, the latter was surprised by the "novelties" that were due to him, the imitation wood and the use of the comb, and by the application of industrial paint, he remarked wryly: "So, you've changed horses in midstream!" Pablo, filling his pipe, smiled sardonically. The dialogue with Braque had its failings.

29 Musée National d'Art Moderne, Paris.
30 Caroll and Conrad Janis Collection, New York.
31 G. Severini, *Tutta la vita di un pittore*, Milan, 1946.

Pablo Picasso,
Violin, Glass, Pipe and Inkstand,
1912, oil on canvas,
81x54 cm,
Narodni Gallery, Prague.

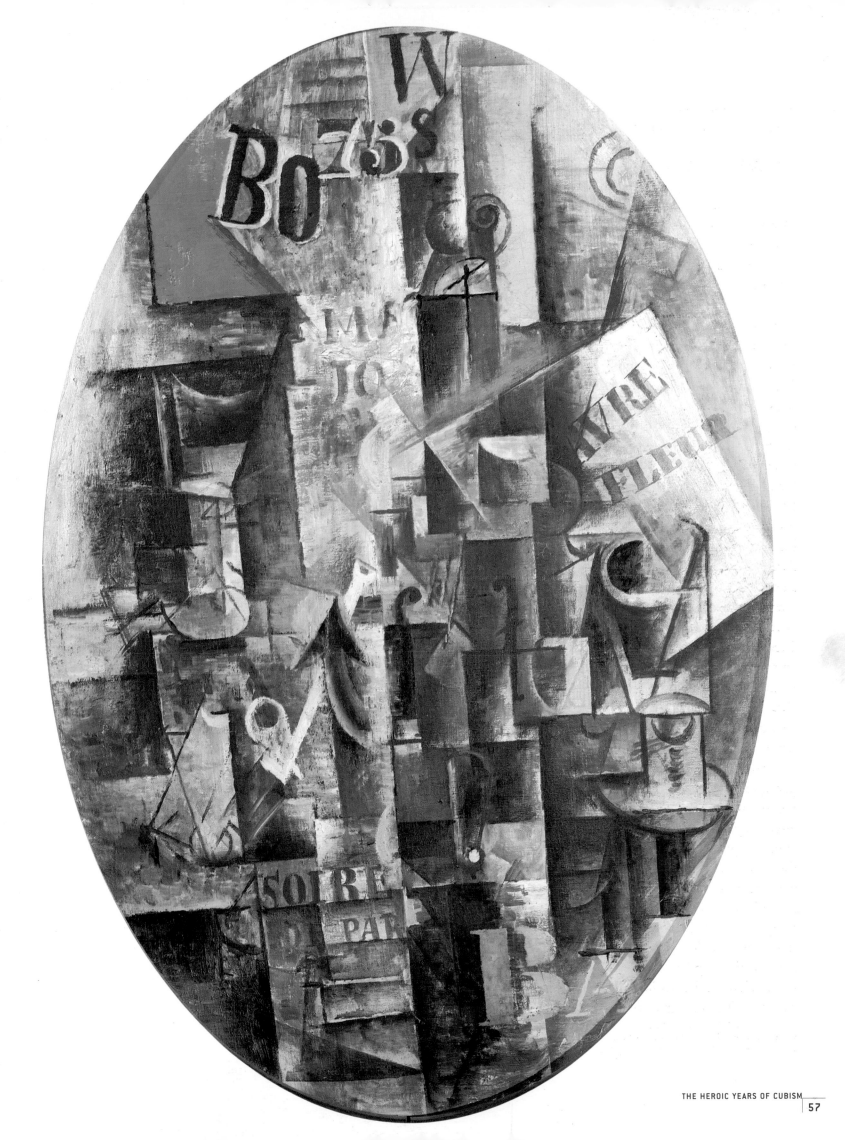

Assemblages and papiers collés

Picasso was commissioned in 1910 by the American critic and painter Hamilton Easter Field to make a decoration for his library. To this purpose he realises with some difficulty a number of large sized canvases that he needs to touch up several times; figures and still lifes are juxtaposed, they include the *Still Life on a Piano ("Cort")* of the Berggruen Collection, probably started in 1911 in Céret, then continued in the spring of 1912, which clearly shows the artist's change of style during that period. At the beginning of May, he produces one of the major works of cubism, *Still Life with Chair Caning*[32], oil on oilcloth onto canvas framed by rope. It is one of the first steps towards "synthetic cubism" and the papiers collés revolution.

32 Musée Picasso, Paris.

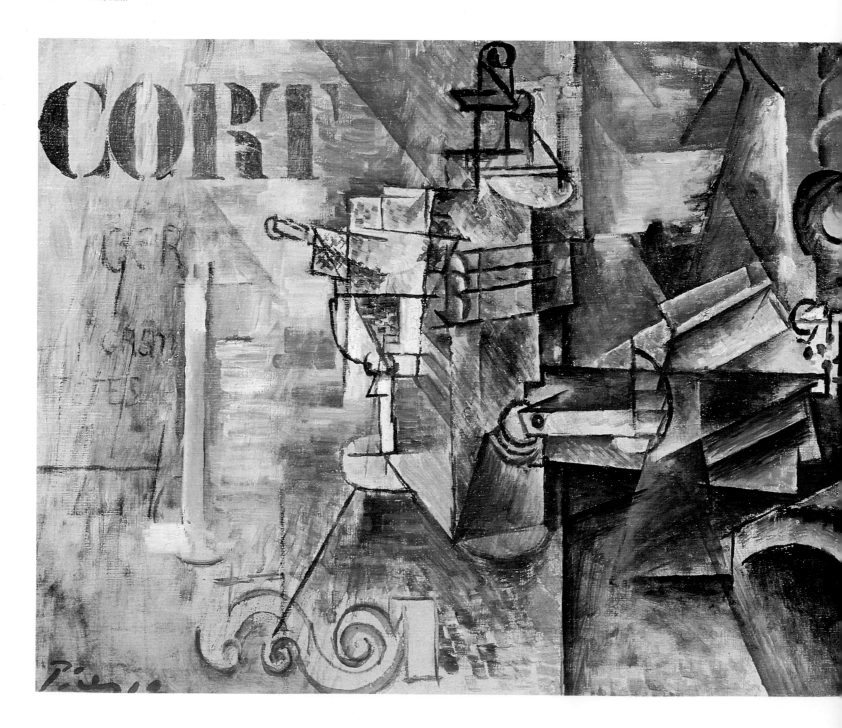

Pablo Picasso,
Still Life on a Piano ("Cort"),
1911, oil on canvas and stencil,
50x130 cm,
private collection.

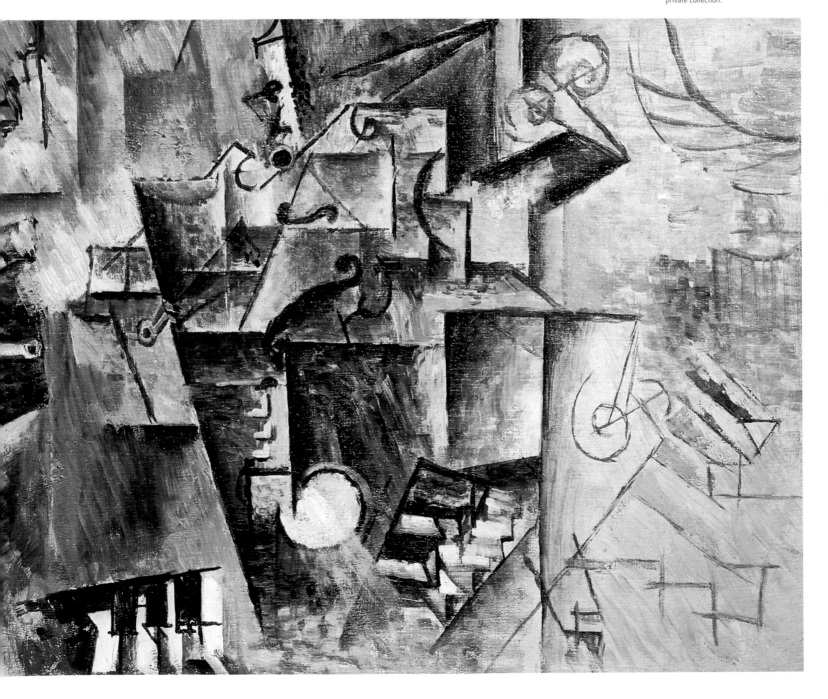

In May, in need of a rest and a change of air, he goes to Céret with Eva. But when they hear that Fernande is also going to the small Catalan town with her friends the Pichots, Picasso and Eva leave straight away and settle in Sorgues near Avignon. Braque and Marcelle join them there at the beginning of August. The mountaineers' rope is attached once more.

During their stay, the two friends take frequent walks together, renewing their conversations, their "art chats", as Picasso writes to Kahnweiler. "We've bought some Negroes... I've bought a very good mask and a woman with large boobs and a young Negro..." This mask came from the Wobé-Grebo ethnic group in Liberia from which Pablo already owned one specimen; they will be a source of fertile inspiration. The transformation they bring about is already perceptible in the *Guitar-assemblage* made by Picasso on his return from Sorgues, in the autumn. In cut and folded tin and wire, with inverted volumes, it is his first sculpture free of the block, with an open form. It leads up to several other *Guitar-assemblage*, also inspired from the Wobé mask with scrap material, card-board, bits of string, etc...

The *Guitar-assemblage* of the autumn of 1912, together with the *Construction with Guitar Player*, framed in papiers collés, appear in a series of photographs taken by Picasso, some of which he had retouched at the beginning of 1913; the Wobé mask also inspired several drawings in the sketchbooks in which Picasso experiments different types of construction. In his *Confessions Esthétiques*, Kahnweiler writes that the works of Picasso and Braque of around 1912, are only "the transposition, I'd even say the imitation in painting of a sculptural means which has found its legitimate use in Braque's paper reliefs (now lost) and in Picasso's reliefs in various materials..." For him there is no doubt about the fact that it is "the Wobé masks which have opened the painters' eyes..."

Another important event happened at the beginning of September, 1912; while Picasso was away on a short trip to Paris to deal with his removal, Braque, walking around Avignon, buys in a shop some imitation wood reproducing oak panelling, with two different kinds of printed motives on a beige background: wood grain similar to the one he had already made with the metal comb and a rectilinear relief of mouldings in trompe-l'œil obtained by lines of different thickness. He joins together these elements with a few structural charcoal strokes to indicate the table, the fruit dish, and the fruit, he writes the words BAR in the top right hand corner and ALE in the bottom left. *Fruit Dish and Glass* (private collection) that Picasso discovers probably with two others when he returns to Sorgues, is the first papier collé.

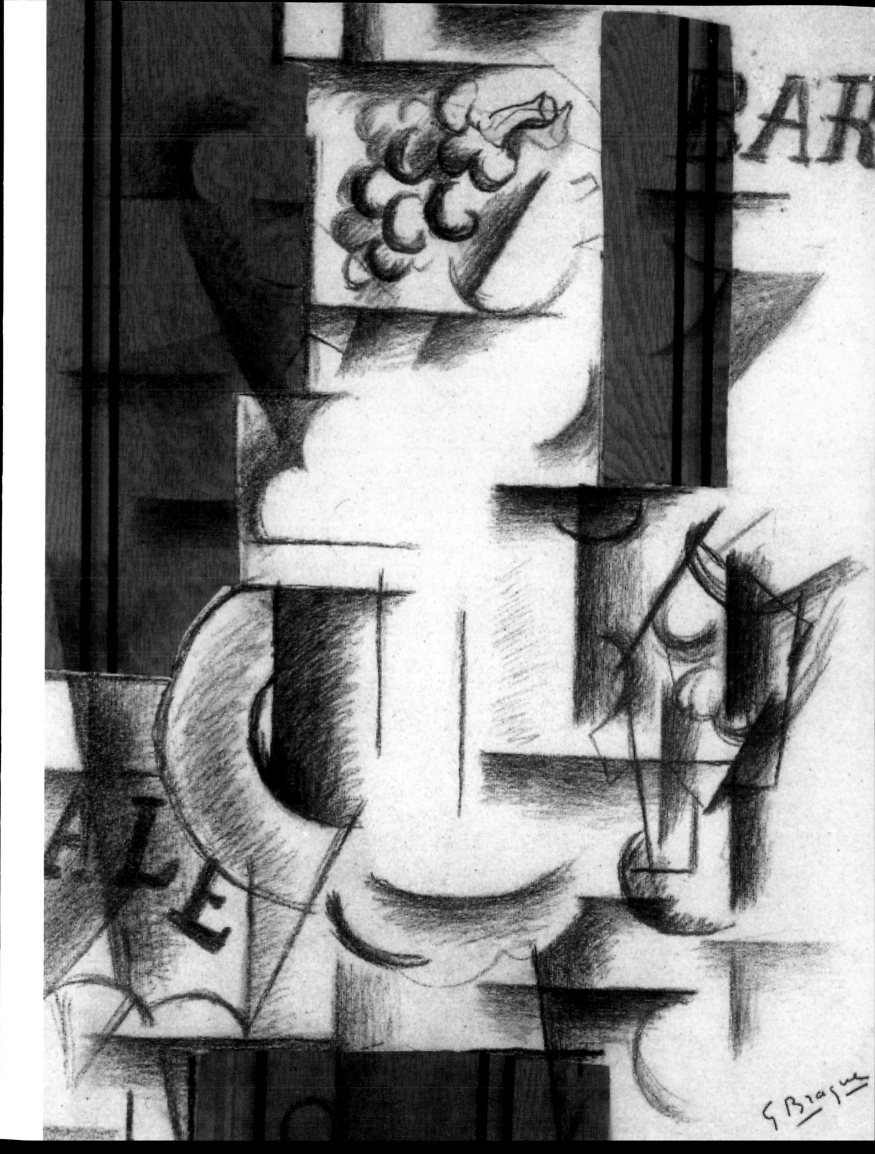

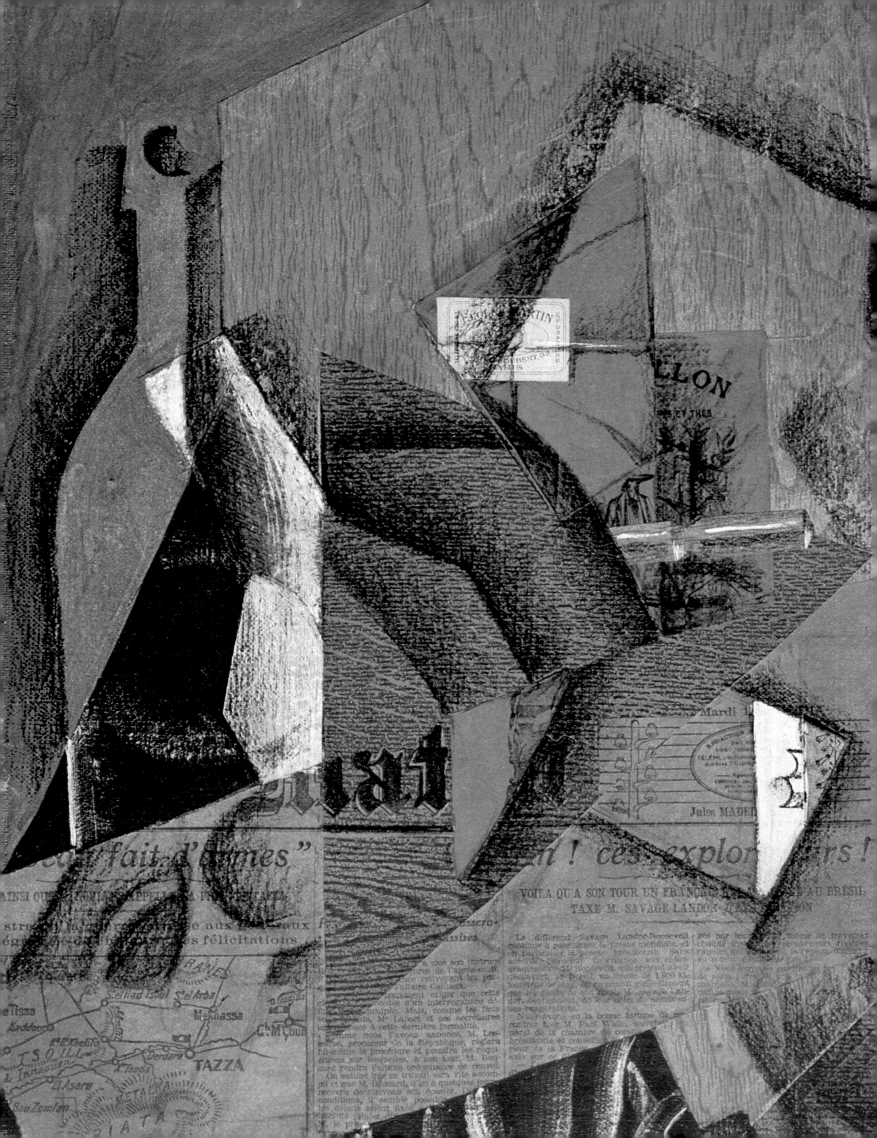

2 The time of the cubists

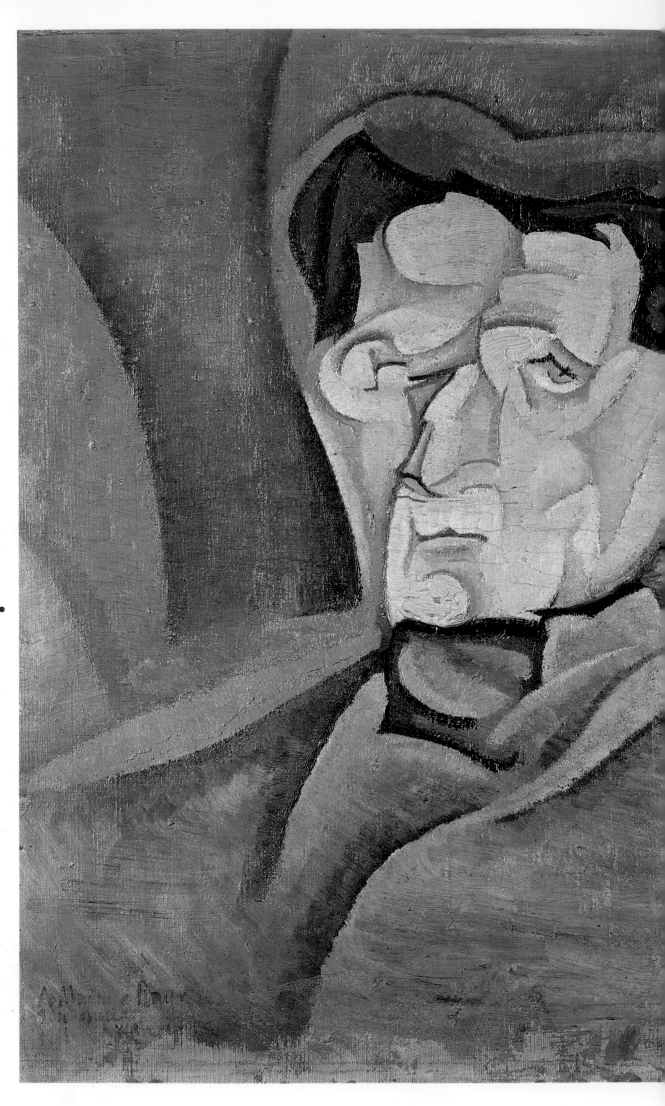

Preceding page
Juan Gris,
Packet of Coffee,
Detail,
1914, gouache, 64.5x47 cm,
Ulmer Museum, Ulm.

Juan Gris,
Portrait of Maurice Raynal,
1911, oil on canvas,
55x46 cm,
private collection.

Juan Gris, the ascetic of cubism

In 1906, a young illustrator of humorous periodicals from Madrid, Juan José Victoriano Gonzalez Perez, known as Juan Gris, arrives in Paris and thanks to Picasso immediately finds accommodation in the Bateau-Lavoir. Under the influence of his compatriot and Braque, he turns towards cubism of which he will become a protagonist of tense and noble austerity. There is no discussion or passion, no rumour or noise in his still lifes which constitute the main part of his work. One can easily imagine their slow maturation, and how with his concern for formal perfection he attempts to solve the problems posed by painting.

He uses geometrization and fragmentation of volume to which he juxtaposes effects of light that he distributes with great care, as in his *Portrait of Maurice Raynal*[33] of 1911; the rays of light that go through the objects in *Jar, Bottle and Glass* (Museum of Modern Art, New York), or in *Bottles and Knife* (Rijkmus. Kröller Muller, Otterlo), the following year, divide up the canvas according to a crystalline geometry of form which gives spatial relationships a kind of unreal weightlessness. The objects thus broken up, divided, but still easily decipherable, fit into a very coherent system of correspondences.

In January 1912, Gris shows about fifteen of his paintings in the shop next door to the dealer Sagot, and sends to the Salon des Indépendants in March three canvases including a *Portrait of Pablo Picasso* (collection of Mr. And Mrs. Leigh B. Block, Chicago), a half-length portrait of his famous compatriot whose face is cut out both in full face and in profile, in marked planes, with monochromatic metallic gleams running through it.

He starts seeing the artists of the Section d'Or group, thus named by Villon, who gather regularly at the latter's studio in Puteaux, this widens the painter's horizon, so far limited to the demanding Braque-Picasso pair; he meets the two brothers Duchamp-Villon and Marcel Duchamp, Gleizes, Metzinger, La Fresnaye, Kupka, Delaunay, whose research starting from cubist structuration also moves away from it under Villon's influence through analytical preoccupations inspired by the Renaissance laws on harmony, colour and movement. The inventor of the Section d'Or is a gentle and simple man who having worked several years for humorous and satirical newspapers – his brother the sculptor Raymond Duchamp-Villon started off in the same way – approached cubism with circumspection. He is interested in its analytical apprehension of form, which he expresses in 1911 in the sober *Portrait of Raymond Duchamp-Villon* (Musée National d'Art Moderne, Paris) whose relief is conveyed in facets in a range of ochres and browns. He avoids intellectual speculation that he mistrusts by nature, through his concern for bringing out volume and the essential rhythms of the subject. At the time, he doesn't know either Braque or Picasso. It is further to his own research on the pyramidal distribution of space, hence on linear perspective stemming from Leonardo da Vinci's *Trattato della Pintura*, that Villon suggested to call the group of friends who meet at Puteaux "La Section d'Or".

33 Private collection, Paris.

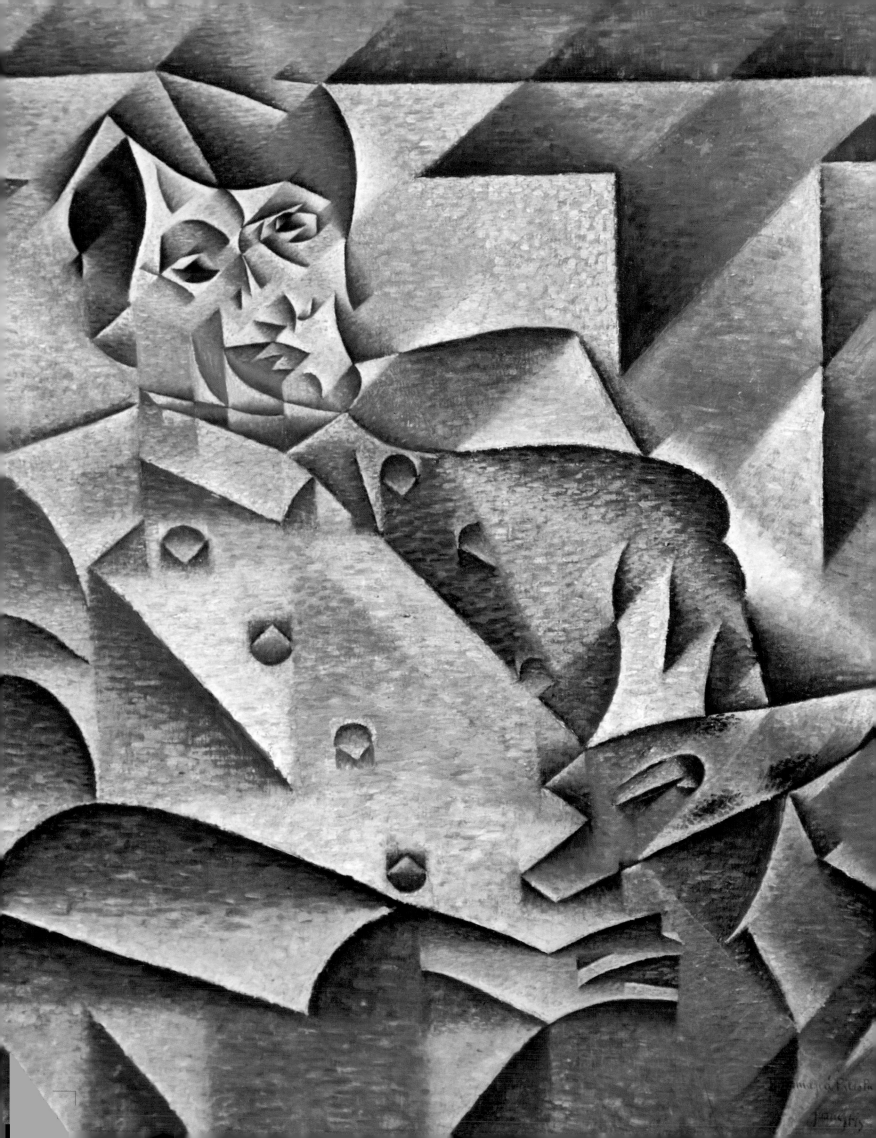

Juan Gris,
Portrait of Pablo Picasso,
1912, oil on canvas,
93x74 cm,
Chicago Art Institute.

Jacques Villon,
**Portrait of Raymond
Duchamp-Villon,**
1911, oil on wood,
35x26.5 cm,
MNAM-Centre G. Pompidou, Paris.

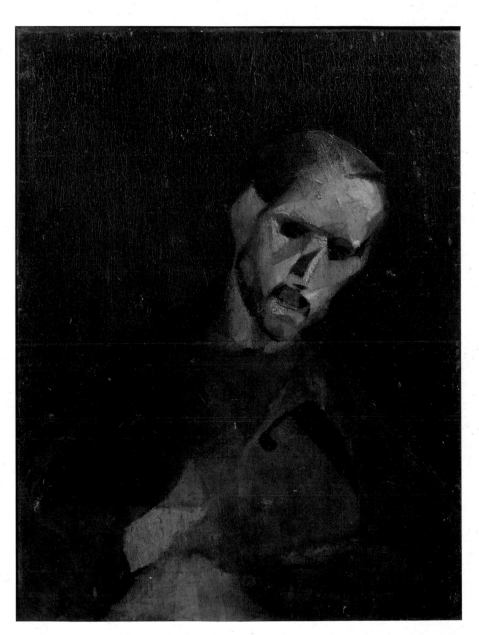

Gris will have a theoretical and practical influence on the members of the Section d'Or group, he will participate in their first exhibition in October 1912; some of the canvases he shows there, such as *The Watch* (private collection, Basle) and *The Wash Stand* (private collection, Paris) are built according to the golden section and follow a methodical modular system. The composition is cut up like a stained-glass window. In *The Wash Stand*, a mirror collage, in the line of Picasso and Braque, introduces an element of reality onto the painted surface.

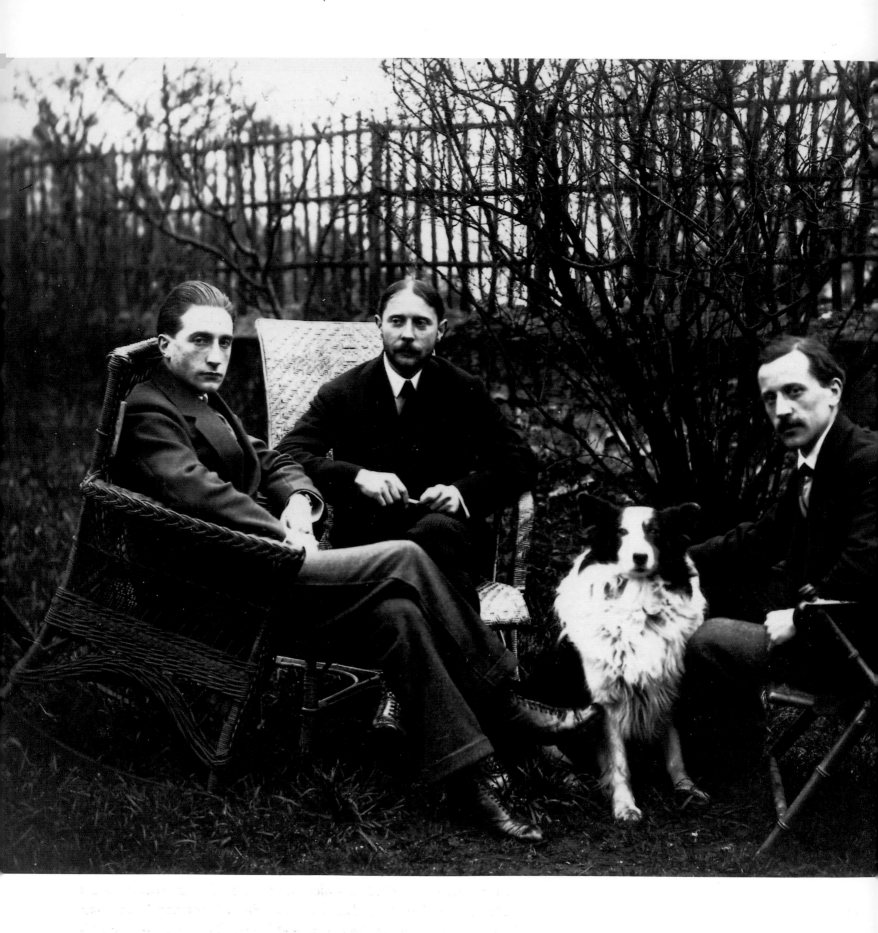

Polemic against the "cubisters"

Fernand Léger, a sturdy Norman from a simple background, sent five paintings to the Salon des Indépendants in 1911, including the *Nudes in the Forest* (Rijkmus. Kröller Muller, Otterlo) which in fact represents woodcutters at work; it is his first really personal work after his impressionist and Cézannian periods, it shows a harsh, strong almost monochromatic style. The figures are given a straightforward and determined geometry, without any "dressing up" effects or skilful gradations. The painter considers that these Nudes were just "a battle of volumes. I had felt that I couldn't get the colour to hold. Volume was enough for me." He accepts the term "tubist" that is used to qualify him.

Robert Delaunay, influenced by Cézanne, came into contact with cubism through Metzinger and Apollinaire. His reading leads him to study the problems of light and Chevreul's theories. His inclination for the colour and movement of modern life incite him to experiment, from 1908-1909 onwards, on contemporary subjects with colour and rhythm as form and matter. To full volumes, he substitutes the break up of tones, the dynamism of the composition and the brightness of his palette, as for example in his *City* and his *Tower* series. With his pictures of *The Eiffel Tower*, in 1911, he raises up an icon of modernity, shattered into space and asserts his own conception of cubist fragmentation.

On 23rd October, 1912, a violent polemic breaks out after an article published in *Paris-Journal* by the critic Olivier-Hourcade; he associates Le Fauconnier, Gleizes, Metzinger and Léger, whose "pure painting" he appreciates, and writes: "it is nevertheless these four painters who with Delaunay in 1910 and particularly in the Indépendants of 1911, created cubism and really are cubism (in the making in Cézanne, and Braque

and Picasso)..." Mr. Vauxelles is immediately inflamed and takes the opportunity to attack once more "those confounded little phoney cubists", while Delaunay protests in the *Gil Blas* of 25th October that he does not "rally to Mr. Hourcade's unjustly based opinion that proclaims me creator of cubism, with four of my colleagues and friends".

Hourcade's declaration reflects a singular blindness, it is probably due to the fact that the work of the real creators of cubism was not represented in the Salons: Picasso never participates; as for Braque, having been turned down at the 1908 Salon d'Automne, he just brought two canvases to the Indépendants the following year. Their works can only be seen in Paris at the Kahnweiler Gallery in the rue Vignon.

The adoption by those whom Braque will call "cubisters" of the geometrization and fragmentation of cubism which they will turn into a process, his and Picasso's silence on their own ideas and initiatives at the time of their close cohabitation during the years of respective or common research, in rivalry or complicity, in addition to the ambiguity or confusion of their defenders, permitted the users to appear as founders, to appropriate the label "cubism" and move into the foreground.

Picasso and Braque are those who renewed cubism, or what is known as such in painting, by dint of force and challenge. Their convergent or divergent relations are what gave it its originality and its substance. The revelation of papiers collés that we owe to Braque and that Picasso exploited with his extraordinary sense of metamorphosis, is one of its most creative moments.

The epigones of the Salons took over a style of geometric and mental break up, difficult to approach and analyse, and gave it a free interpretation to which they added nature, movement and colour; thus cubism was turned into a school, a notion to which it was fundamentally opposed, and then, with time and generalisation, into an academicism.

Robert Delaunay,
La Tour Eiffel 1910,
(The Eiffel Tower 1910)
1911, oil on canvas,
202x138.4 cm,
Guggenheim Museum, New York.

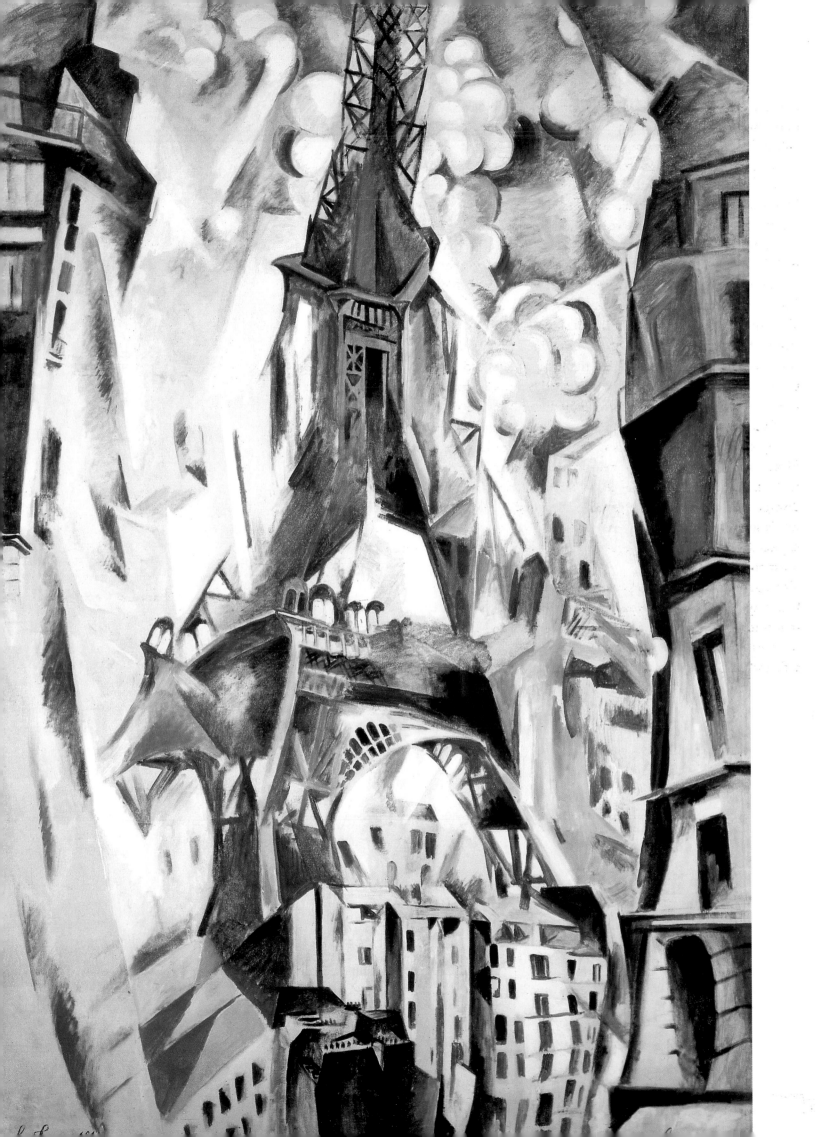

Another avant-garde: futurism

Cubism is the only artistic movement to stand for modernity in 1909 when the Italian author and poet Marinetti, an eloquent and picturesque character who lived in Paris and wrote in French, publishes in the *Figaro* of 20th February the " Manifesto of Futurism ". The terms are vehement, the declamatory tone, sometimes a little ridiculous, contains a number of peremptory assertions. "1. We intend to sing the love of danger, the habit of energy and fearlessness… 2. The essential elements of our poetry will be courage, audacity and revolt. 3. We intend to exalt aggressive action, a feverish insomnia, the athletic stride, the somersault, the slap and the punch…"

The Manifesto proclaims on "a shattering Nietzchean basis" (Jean Leymarie) the urgency of modernity, movement, technology, and celebrates "the beauty of speed", "great excited crowds", it glorifies war "the world's only hygiene", "the anarchists' destructive arm". It also demands "to destroy the museums, the libraries, to fight against moralism, feminism…"

The Manifesto has the effect of a bomb although the interest it aroused was limited by its redundancy; Marinetti's idea had been to present a specifically Italian movement in Paris, thus giving it a repercussion which can galvanise his compatriots and free, at least for a time, the artists of Milan, Florence or Rome, of their provincialism. For Cubism it represents a dangerous rival with its successive manifestos, particularly as the futurists do not hesitate to consider the latter as their own theoretical and practical justification in modernity.

Two friends of Marinetti whose Manifesto appears later in the Italian

André Salmon in front of *Three Women* by Pablo Picasso in the studio of the Bateau-Lavoir, Musée Picasso, Paris.

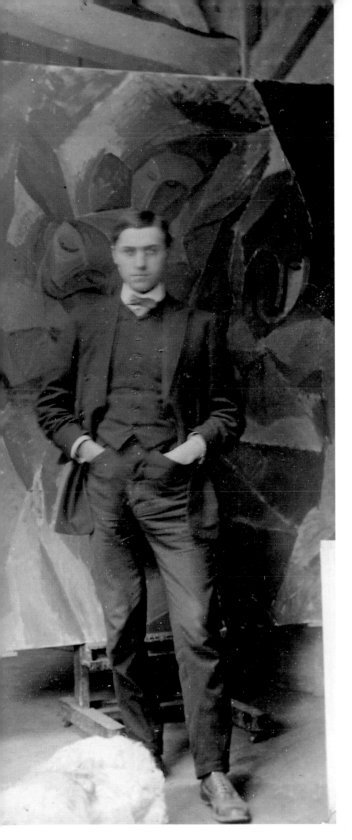

periodical *Poesia*, lived in Paris like him and moved in the artistic circles of the capital. Severini, a great admirer of Seurat's, paints canvases inspired by divisionism. Soffici, a writer and theoretician as well as a painter, publishes articles in *Le Mercure de France* and is friend with Max Jacob, Picasso, Salmon and the inevitable Apollinaire; they will both act as intermediaries between the avant-garde and the artists from across the Alps.

Marinetti declaims his Manifesto in Turin, at the Alfieri Theatre, shortly after its simultaneous publication in French and Italian, and meets Boccioni, Carra and Russolo who live in Milan, the last two having also stayed in Paris. Again in *Poesia*, he launches in August 1909 the "Lets Kill Moonlight" Manifesto, that he turns into a futurist address for the people of Venice printed on loose sheets and thrown from the top of the Clock Tower, Piazza San Marco on 27th April, 1910.

A short time earlier, 11th February, the Manifesto of Futurist Painters was signed by Balla, Boccioni, Bonzagni, Carra, Romani, Russolo, Severini; the Technical Manifesto of Futurist Painting, 11th April, bore only five signatures: Balla, Boccioni, Carra, Russolo and Severini; several other manifestos, exhibitions, performances, conferences and speeches will follow. On 5th February, 1912, at the Bernheim-Jeune gallery, the first futurist exhibition opens in Paris. The machine is started.

The preface triggers off hostilities. "Although we reject impressionism we energetically disapprove of the present reaction which, in order to kill impressionism, brings painting back to old academic forms… It is undeniable that several aesthetic assertions of our companions in France reveal a kind of disguised academicism… We feel and declare ourselves absolutely opposed to their art. They are determined to paint immobility, iciness, and all the static conditions of nature; they love the traditionalism of Poussin, Ingres and Corot, thus ageing and petrifying their art…"

One couldn't have made a more noticeable entrance.

Facing the cubists, the futurists present themselves as another avantgarde whose sociological ambitions rely upon provocation and scandal; the movement rapidly becomes associated with extravagance, polemic and audacity. However futurists are not always averse to adopting cubist structuration, for example Carra or Boccioni who are also attached to "pictorial dynamism". The word "cubo-futurism" will be used in order to describe the synthesis operated by Delaunay, or Gleizes' and Metzinger's explorations. In Italy the term will designate some of the works of Soffici or Boccioni. But its greatest popularity will be in Russia, Malevitch calls "cubo-futurist" the works he presents at the "Target" exhibition in Moscow in 1913, he takes syntactic elements from both movements and reuses then in his neo-primitivism inherited from Larionov and Gontcharova.

What does futurism owe cubism and in reverse what impact did the futurists have on the cubists? There were some exchanges but the confrontation of the two avant-garde movements mainly caused

confusion in spite of several obvious affinities in terms of ethics and technique. Cubism is a form of realism, the futurists on the other hand express symbols, moods; when the cubists paint an object they are less concerned with the object than with the means, whereas the futurists starting from impressionism, expressionism, divisionism and cubism, invent a new imagery, new subjects, the relationship between man and machinery, towns, speed, movements of the body, feelings…

On the whole, the futurist works shown in Paris were judged according to cubism which distorted the critics' opinion; this art which called itself revolutionary was disappointing and, in spite of the Manifesto's thundering declarations, unconvincing. Two avant-gardes at the same time, is one too many. Severini regrets that the futurists presented themselves in Paris in competition with cubism, and that others decided, precisely to avoid competition, to introduce cubist structuration into their works.

Apollinaire, indignant at the preface of the Bernheim Gallery exhibition, is the first to react, "Futurists… have hardly any plastic preoccupations, they are not interested in nature. They are concerned with the subject above all. They want to paint moods. It is the most dangerous form of painting that one can imagine…", he writes in *Le Petit Bleu* of 9th February.

"It will turn the futurist painters into mere illustrators…."

"However the exhibition of the futurist painters will teach our young painters to have more audacity than they have had so far. Without audacity, the futurists would never have dared to show their experiments with so many imperfections…"

Guillaume summarises as follows his colleagues' and his opinion: "As for futurist art, it's a bit of a joke in Paris…"

Guillaume Apollinaire, in the studio of the Boulevard de Clichy, in 1910, photographed by Pablo Picasso, Musée Picasso, Paris.

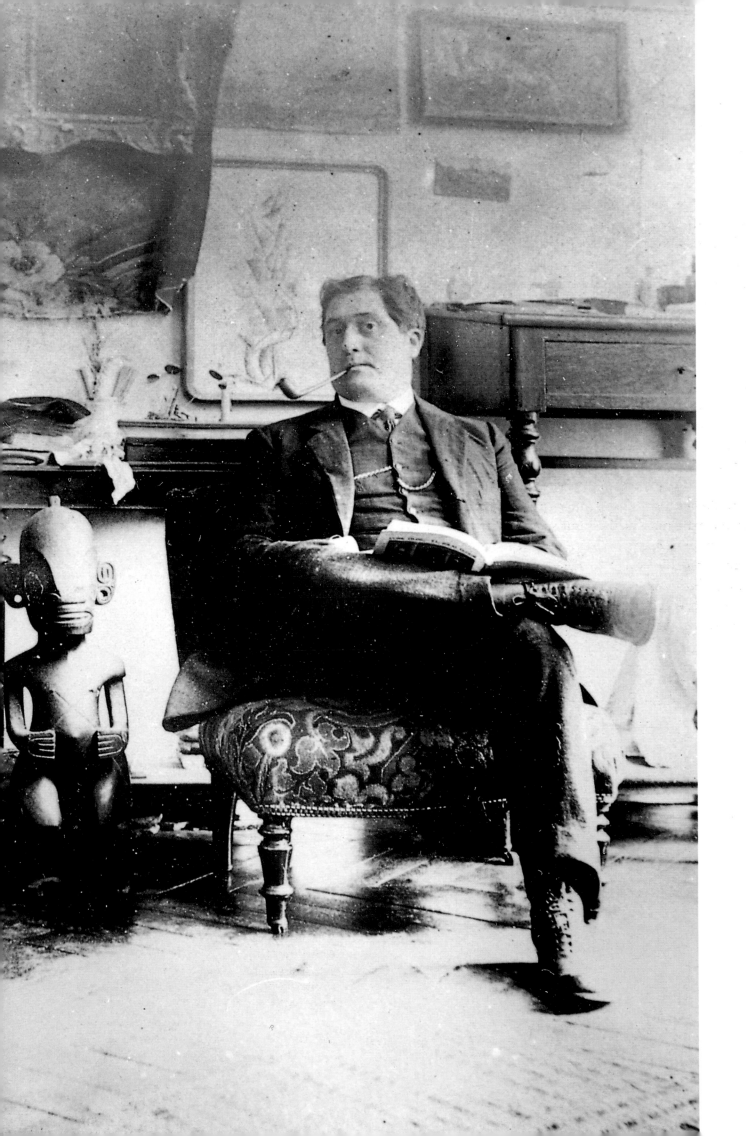

Braque ahead of Picasso

During the single year of 1912, from the *Caned Chair* to Picasso's *Guitar-assemblage* and Braque's papiers collés, a considerable evolution has occurred: it concerns the intrusion of heterogeneous materials into painting, the invention of open form in sculpture and the generalisation of collage through the intervention of the materiality of paper which creates a new flat non-illusionist space and a different apprehension of the pictorial content. The main role in the upheaval and conquests of 1912 has often been attributed to Picasso, but it was Braque with his experience as a house painter, who was the true initiator of this revolution. Several months will go by before the Spaniard is able to catch up on him.

Picasso and Eva return to Paris from Sorgues in mid-September; they move into n°242 Boulevard Raspail, in the heart of Montparnasse. Among the works he painted in Sorgues, *The Aficionado* (Kuntsmuseum, Basle), a composition with an octagonal structure instead of the pyramidal structure recently used, must be considered separately; with an incredible profusion of detail, it juxtaposes vertical and horizontal lines, and confronts several identifiable elements, the moustache, the wing collar and the bow-tie as well as the character's shirt front, a banderilla, a guitar with its pegs and different parts spread out, a bottle in the bottom right hand corner. The word "Nîmes", written in italics evokes the town where many bullfights are performed, the letters OR of Torero are in the centre and Le Torero, a bullfighting magazine is in the bottom on the left. The letters MAN written on the bottle probably refer to Manzanilla, a famous Spanish sweet wine.

The Man with a Guitar of the Philadelphia Museum, that Picasso finishes in the spring of 1913, is cut up according to clearly abstract lines, like *The Model* (private collection, New York) and the two pictures of the *Arlésienne* wearing her traditional head-dress, one very abstract, belonging to De Ménil Foundation in Houston, and the other with its double profile, more identifiable owned by a private collection. During the same period the artist produced several *Guitar* canvases, some of which are oval-shaped with imitation wood and stencilled letters, *Violin "Jolie Eva"* (Staatsgalerie, Stuttgart) that is cut up horizontally and a few still lifes.

The honey moon continues, Picasso keeps his word: "I love Marcelle (it is only in Sorgues that he will definitively call her Eva, to avoid confusion with Braque's wife who has the same Christian name) and I shall write it on my pictures", he declared to Kahnweiler. The painter forges ahead with a kind of creative rage, he explores from figures and particularly from objects, all the fields which can contain and exalt his recent conquests. Signs, form, colour, materials everything is a pretext for renewal; is it his love for Eva that drives him on in this fever where sensuality and joie de vivre mingle within his incredible diversity of inspiration? To Braque's steady reflection responds Picasso's boundless effusion.

In *The Poet*, of the autumn of 1912, whose hair and moustache are made

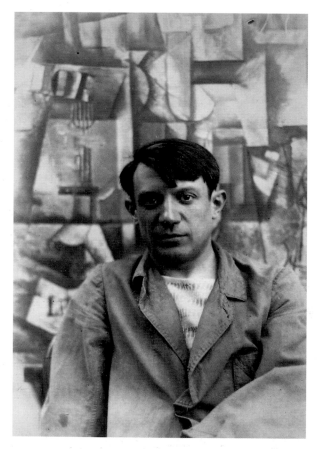

Pablo Picasso, Self-portrait with *The Aficionado*, Musée Picasso, Paris.

Pablo Picasso, **The Aficionado,** 1912, oil on canvas, 135x82 cm, Kunstmuseum, Basle.

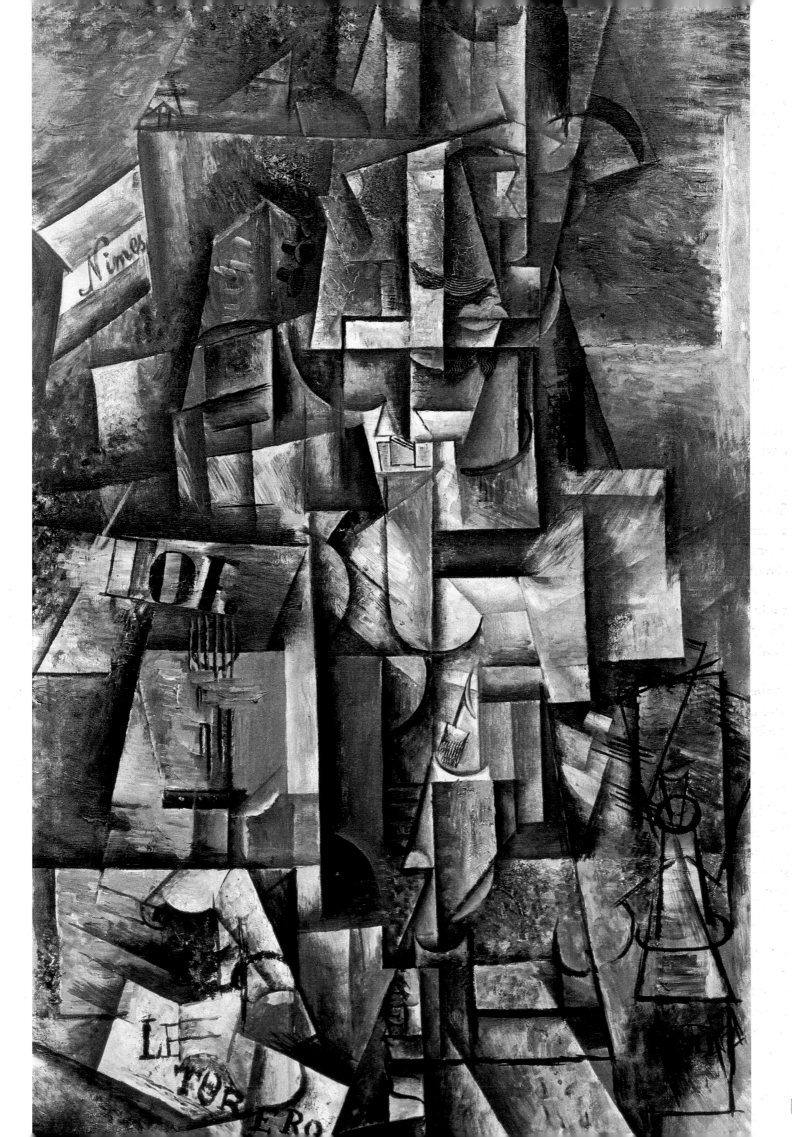

with a metal comb, the interwoven planes leave little room for the face which seems to be caught up in their inextricable network.

Guitar, Music Sheet and Glass (McNay Art Institute, San Antonio, Texas) combines on a background of wallpaper printed with lozenges and little flowers, an assemblage of papiers collés, with fragments of newspaper and sheets of music; the glass is drawn in charcoal. *Violin, Music Sheet and Newspaper* (private collection, New York) is on the same principle with the same elements, except that the violin replaces the guitar, the music sheet and the letters JOURN (from journal, newspaper) are painted in oil mixed with sand.

New materials and objects

"The papiers collés, imitation wood and other elements of similar nature that I have used… says Braque[34], are also simple elements, but *created by the mind*, and which are justifications in space.…" He produces during the autumn of 1912 an impressive series of papiers collés most of which are closely connected to his work in painting, like the *Fruit Dish* (private collection) in which a vertical strip of imitation wood fits into a framework drawn in charcoal where a number of realistic allusions subsist, fruit dish, fruit, underlined by shaded areas. The same process is applied in *Still Life with a Guitar* (collection Ricardo Jocker, Milan) and *Guitar* (private collection). In *The Man with a Pipe* and *Still Life with a Violin BAL* (Kuntsmuseum, Basle), the drawing plays more freely with the imitation wood of which the vein is also more loose. In *The Bock*, Braque uses a vertical strip of imitation wood, and a piece of the wrapping of a tobacco packet stuck onto a square of brown paper which contrasts with the orange tint of the imitation wood.

He progressively develops his papiers collés with a great diversity of form and materials: a square of imitation wood, a rectangle of brown paper marked with lines of chalk and charcoal in the *Guitar and Glass*, of 1913, belonging to Mrs. Thomas J. Hardman's collection; black paper also set off by white chalk and a charcoal structure in the *Black and White Collage* of the Yale University Art Gallery, with a "minimalized" framework. In *Aria de Bach* (Paul Mellon Foundation, Los Angeles) the cut out black and brown pieces of paper acquire pictorial resonance from their monumental simplicity whereas in counterpoint the allusive and transparent figure that carries the title "Aria de Bach" is drawn in a soft line.

To the increasing variety of materials corresponds a more subtle research on the juxtaposition of planes, and the opposition of colours. The drawn framework is now in the background and the space becomes more pictorial, for example in *Guitar and Bottle*, or in *The Clarinet*, both in the Museum of Modern Art in New York. The *Drafts' Board* (Rosengart Collection, Lucerne) with its black/white contrast is set into a very elaborate composition of schematic charcoal lines and fragments of brown wallpaper, in which Braque has introduced the letters JOURN, and the life-size poster of the Tivoli Cinema in Sorgues. The top part of another

34 Dora Vallier, *op. cit.*

Georges Braque,
Still Life with a Violin BAL,
oil on canvas,
Kunstmuseum, Basle.

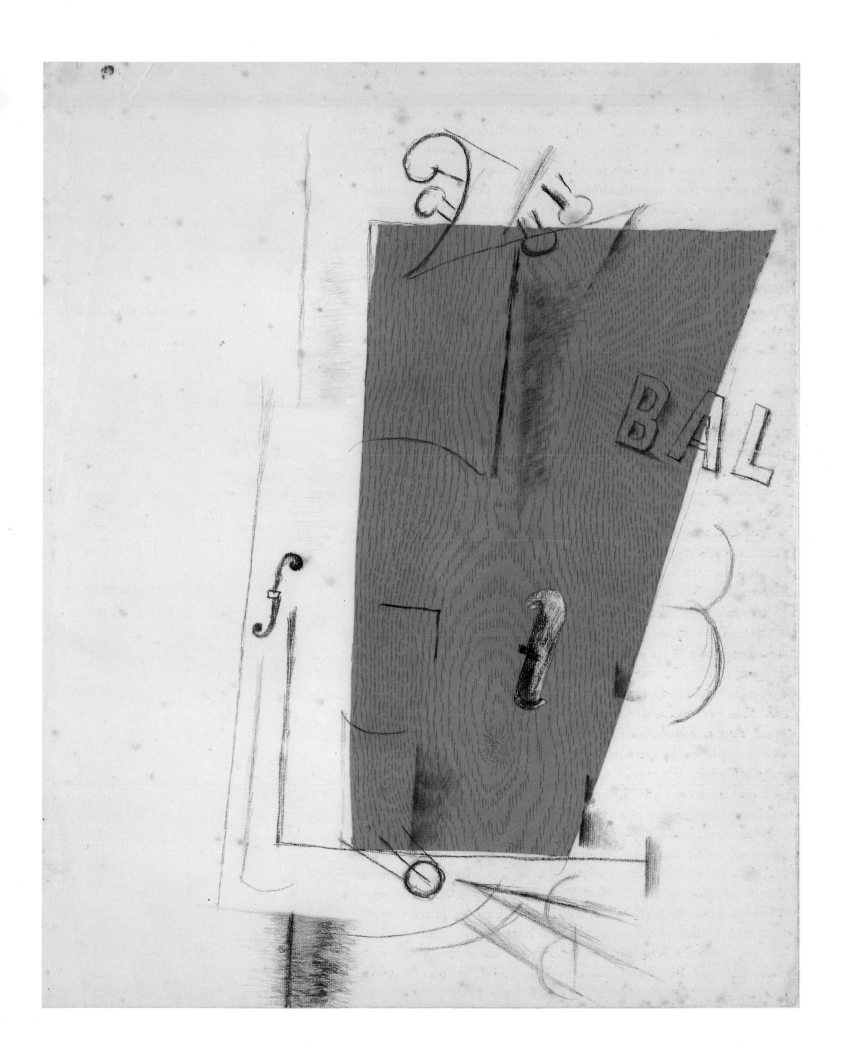

Georges Braque,
The Man with a Pipe,
oil on canvas,
Kunstmuseum, Basle.

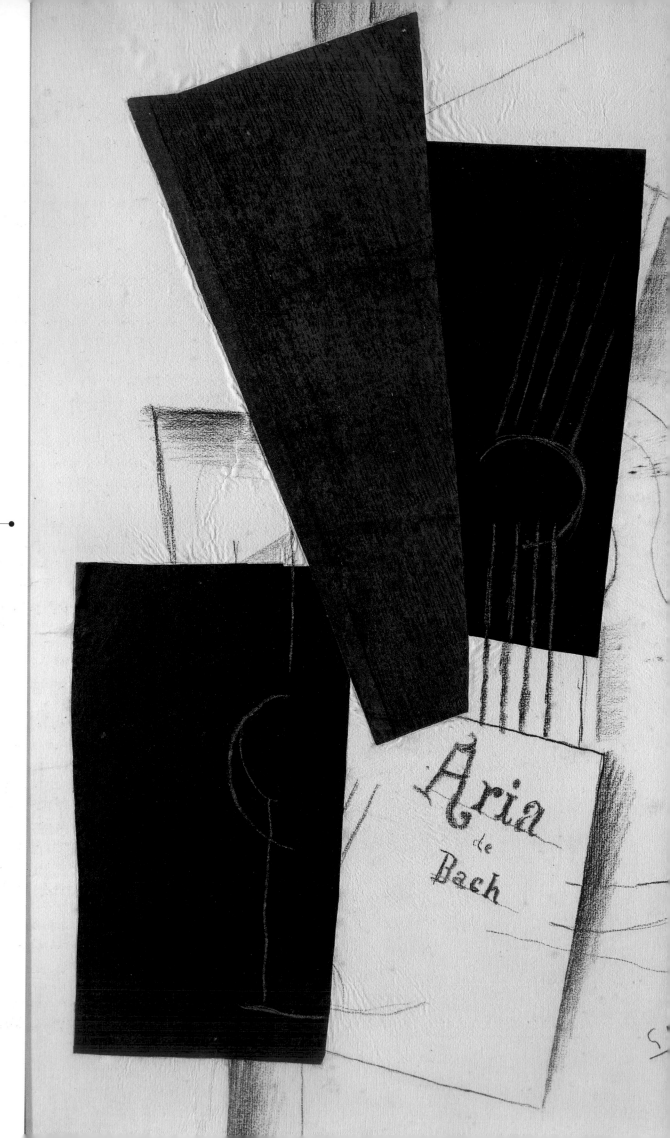

Georges Braque,
Aria de Bach,
1913, collage, pencil,
Musée National d'Art Moderne, Paris.

poster from the same Cinema is placed in a very complex oval composition containing various papiers collés and the shape of a guitar in the centre. *Guitar and Programme* (private collection) is the only one of Braque's papiers collés that was owned by Picasso.

The exploration of matter in painting, collage and papiers collés undertaken by the two friends, with Jansenist rigour for Braque, with lyricism and brilliance of colour and form in the case of Picasso, opens up the way to "synthetic cubism".

The offensive against cubism

The Salon d'Automne opens its doors on 30th September, 1912, Apollinaire writes in *L'Intransigeant,* that "this year it doesn't look like a battlefield as it did in 1907, in 1908 and last year…", and Olivier Hourcade, in *Paris-Journal*: "those who have been named 'cubists', nobody really knows why, by ignorant journalists, are no longer a source of indignation or mockery. We are beginning to see a logical evolution in the persistent efforts of these artists…"

Four of Braque's works are shown in the second post-impressionist exhibition of the Grafton Galleries in London, in October-December, and six of them go to the Modern Kunst Kring in Amsterdam together with twelve of Picasso's; in London the latter sends thirteen paintings and three drawings, ranging from 1906 to 1912. The reaction of the public to the two painters is less severe than in the past.

In his own very personal language, Picasso writes to Braque still in Sorgues on 9th October: "My dear friend Braque, I am using the latest paperistic and dusty processes. I am imagining a guitar and I am using a bit of dust against our horrible canvas…" No doubt he is talking about *Guitar on a Table,* bought by Gertrude Stein, or *Violin, Music Sheet and Newspaper* in which sand is mixed up with oil.

In France the hostility against cubism does not abate. On 16th October, the *Mercure de France* publishes an open letter by a certain Mr. Lampué, town councillor and photographer, addressed to Mr. Léon Bérard, under-secretary in the Ministry of the Arts, following his visit to the Salon d'Automne: "Go and see, Sir, and although you are a Minister, I hope you will leave feeling as nauseated as many people I know; I even hope that you will say to yourself: have I really the right to lend a public monument to a band of crooks who behave in the world of art like apaches in ordinary life…" Surprise: the sworn enemy of cubism, Mr. Vauxelles, protests in the name of freedom of art, and the committee of the Salon d'Automne declares that "the only reply is in the principle that governs this institution: accept all conscientious art efforts whatever they may be and however foreign they may seem to the old formulas". They claim to represent "the ground of generous contacts…"

A strange "cubist house"

The main attraction of the Salon d'Automne is the "Cubist House", imagined by the interior decorator André Mare and the sculptor

Raymond Duchamp-Villon, which in fact has nothing cubist about it! The plaster façade, built by Duchamp-Villon after a life-sized model, only shows the ground floor for lack of space; it serves as the entrance to the Salon and the public has to walk through it to get to the rooms. With its cornice and strictly cut out pediment, its balustrades and decorative geometric ornamentation, the façade is rather more in the line of classical taste. It opens out onto three very colourful fully furnished rooms, with wood panelling, fireplace, furniture, rugs, lights, pictures, ornaments, objets d'art made by La Fresnaye, Villon, Ribemont-Dessaignes, Paul Vera, André Mare, Marie Laurencin, Gleizes, Léger and Duchamp-Villon himself. Neither Picasso nor Braque had anything to do with this strange house. Is it because its rooms contain the works of artists who are showing in the "cubist" rooms of the Salon that this hybrid realisation has been given its name? In those days anything original, unexpected even incongruous is called "cubist".

The anti-innovation critics broke loose although it wasn't really worth it! All the same, they rightly criticised the interior for being over furnished and old-fashioned; oddly enough, several pieces of furniture and objets were better accepted than the architecture, and were bought by collectors such as the dress-maker Poiret who acquired La Fresnaye's clock – maybe also the picture of *The Card-Players* – and a few frames by Marie Laurencin.

Theory and exhibition of la Section d'Or

On 10th October, the Salon de la Section d'Or opens in the Galerie La Boétie in Paris, "for the first time, such a complete grouping of all the artists who have inaugurated the 20th century with works clearly representative of the tastes, the tendencies and the ideas which characterise it…", writes Maurice Raynal in the movement's bulletin. Fair enough, but once again neither Picasso nor Braque is represented.

We have already seen that the Section d'Or group was created under the initiative of Villon and that its members were reluctant to accept cubist orthodoxy. His brother, Marcel Duchamp, was victim of an incident which hastened events: the Salon des Indépendants refused his canvas *Nude Descending a Staircase* mainly because of Gleizes' hostility; embittered, Marcel declared that he wanted to "react against the growing influence of the already classified cubist influence…" A first exhibition of the Italian futurists in February 1912, had shown that there were other paths to follow, and Marcel who is interested in the problems of movement via Marey's chrono-photography, is just as anxious as Raymond Duchamp-Villon, busy setting up his "Cubist House", to escape geometrical dictatorship.

Jacques Villon declares: "Where cubism uproots, the Section d'Or implants. While the first is rethinking perspective, the other wants to penetrate its secrets…" Setting up the exhibition was a long and difficult task; the Section d'Or intends to follow a new route, to "release art from its tradition, from its outdated bonds, in other words to liberate it…",

Marcel Duchamp,
**Nude Descending
a Staircase n° 2,**
1912, oil on canvas,
146x89 cm,
Philadelphia Museum of Art.

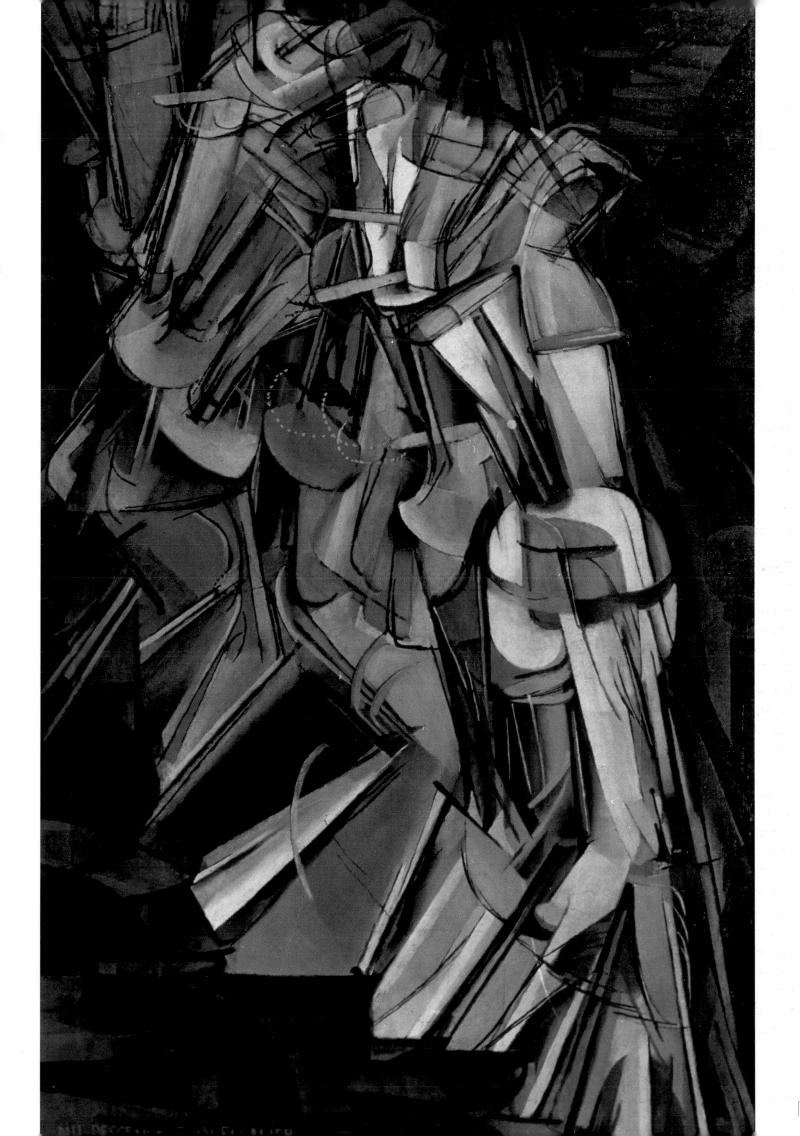

according to the preface of the catalogue. "The exhibitors owe everything to themselves. It is in their own sensibility that they will find the teachings and the inspiration… The painter is no longer preoccupied by a moment or a colour, his mind can offer him innumerable visions of shades and form. Nature is now only the suggestive element of his art…" Whereas cubism rejects the past as a whole, the artists of the Section d'Or and Villon who calls himself "impressionist cubist", discuss their respective ideas on the constructive principles of the Renaissance. When Duchamp, after having read the "Traité élémentaire de géométrie à quatre dimensions" published in 1903 by Esprit Joufflet, discovers the "Voyage au pays de la quatrième dimension" by Gaston de Pawloski, his fantastic imagination will add an ironical and humorous touch to the seriousness of their discussions.

Preoccupied only with the exploration of their respective conquests, Picasso and Braque remain resolutely out of these theoretical debates which do not concern them, and that Kahnweiler reproves.

The Salon de la Section d'Or, whatever Villon had intended, turns out to be merely the continuity of the famous "cubist" rooms 41 and 43 of the Salon des Indépendants and of the room XI of the Salon d'Automne, with a few additional realist painters; it is also the Puteaux circle enlarged. The exhibitors do not all adhere, far from it, to the laws of numbers and the harmony of proportions, or to their interpretation by the artists of the Renaissance, neither do they necessarily use the square and the compass. A hundred and twenty-four painters and sculptors fill up the picture rails of the Galerie La Boétie, including Archipenko, Duchamp who can at last show his *Nude Descending a Staircase*, Jean Marchand, Dunoyer de Segonzac, Valensi, Luc-Albert Moreau, Marie Laurencin, André Mare, Paul Véra, Duchamp-Villon, Gleizes, Juan Gris, Léger, Marcoussis, Metzinger, Picabia, La Fresnaye, Villon and many others, unknown or forgotten.

The critics who only take into account the cubists, or so-called cubists, break loose. Olivier-Hourcade is practically the only one who takes the exhibition seriously. *La Revue de France et des pays français* prints: "cubism may be the long-awaited French school…" and *Paris-Journal* on 23rd October: "I would give a true definition of cubism as: *the return to style through a more subjective vision of nature* (which can sometimes be conveyed by a firmer drawing of masses)".

"But actually, the choice of means does not matter much: I mean that the main interest of cubism lies in the absolute difference between the various painters… It is therefore completely false to write that all these painters have a single objective which is to produce pure painting, and to turn away from nature…"

Mr. Vauxelles, nettled, immediately reacts, but it seems now futile to dwell upon the quarrels that filled the newspaper columns; good old days when newspapers devoted so much space to jousts between Aristarchs, critics, serial writers and chroniclers.

The "break up" of cubism

Is Apollinaire taking his distance from the movement of which he only wrote the name for the first time in 1910? "It is too late to speak about cubism. The time for research is over. Our young artists now want to create definitive works…", he writes in the review of the preview of the Salon des Indépendants printed in *L'Intransigeant* on 3rd April, 1912. Had he so far considered cubist works to be ephemeral experiments? On 11th October, he gives a conference on "the break up of cubism", and between May and August, he starts writing a book, under the title, written in large letters on the manuscript, *Aesthetic Meditations*, with the subtitle "The new painters" which will be modified conveniently into "The Cubist Painters".

In fact the book is a "collage" of a number of already published articles, prefaces, essays or conferences, without any precise order consisting of scraps, additions, corrections, deletions and many modifications. Guillaume removes some names, adds others, crosses them out, and then puts them back as though he had kept changing his mind. He includes in the proofs a reference to Braque's papiers collés, and in order to give the two creators of cubism their due, he reverses the title which becomes *The Cubist Painters. Aesthetic Meditations*. Then he introduces Metzinger, "who exhibited the first cubist portrait" (Guillaume's) in the Indépendants of 1910, "and made the jury of the Salon d'Automne accept that same year a number of cubist works…", Gleizes… Marie Laurencin who is not cubist but is his mistress… Juan Gris. According to Guillaume, they represent *scientific cubism*; *physical cubism* comprises only Le Fauconnier "who created this tendency"; *Orphic cubism*, "the other great tendency of modern painting", is "pure art. The light in the works of Picasso contains this art, that Robert Delaunay invents on his own and which Fernand Léger, Francis Picabia, Marcel Duchamp also try to achieve". As for *instinctive cubism*, it "contains a very large number of artists…" but Apollinaire does not say which ones.

If the whole work, in spite of its disjointed aspect, gives an idea of most of the aesthetic options of the time as seen by the author, it is less through logical and coherent development than through the diversity of reflections and ideas. His amendments are surprising, is Guillaume so unsure of himself? The "break up" seems to echo his own uncertainties and doubts. Asked by an anonymous reader of *L'Intermédiaire des chercheurs et des curieux*", to answer the question "What is cubism?", he adds his reply to the proofs of his book: "Cubism is the art of painting new ensembles with elements taken not from the reality of vision but from the reality of conception". At the end of November 1912, Gleizes and Metzinger publish *Du cubisme*, a book entirely devoted to the movement of which they explain the theory when its main characteristic is precisely not to have any. "From the moment they began to define cubism, when they established its limits, its principles, I must admit that I ran away…", says Braque to Dora Vallier. Picasso remains indifferent. Apollinaire whose book will only come out the following year, does not

From left to right:
Juan Gris, Carlos Huidobro,
Jacques Lipchitz
and their wives,
Musée des Années Trente,
Boulogne-Billancourt.

calm down, and, to make things worse, Salmon publishes in the same period his *Jeune Peinture Française* in which he includes a previous work, *Histoire Anecdotique du Cubisme*. In fact it does not concern cubism, it is the "cubists", those exploiters, including incidentally Gleizes and Metzinger, who constitute the subject of his laborious digressions.

For some time now Guillaume has been friends with the Delaunays, Robert and Sonia, both artists; badly shaken up by the end of his love affair with Marie Laurencin, he leaves his "distant Auteuil", "charming quartier of my great grief" where he had been living and in August 1912 he takes an attic flat 202 boulevard Saint-Germain, but he will not move in there until the following month of January. In the meantime, the Delaunays have him to stay in the rue des Grands-Augustins; maybe it is their influence, because the poet is changeable, that brings about several more modifications to the proofs. *The Cubist Painters. Aesthetic Meditations* is published on 17th March, 1913, on the 29th Guillaume proclaims in the review *Montjoie*: "If cubism is dead, long live cubism. The reign of Orpheus begins," rectified on 14th April into "From cubism is born a new cubism". Little does it matter, the "break up of cubism" is accomplished.

Picasso's first "installation"

Braque leaves Sorgues for Paris in the middle of November 1912. Picasso, in his new studio Boulevard Raspail, continues his exploration of the different possibilities of papiers collés. The assembly of papiers collés, gouache, oil, charcoal and sand is followed by a series of pure collages: *Violin, Violin and Music Sheet, Violin and Score*, all three in the Musée Picasso in Paris, *Music Sheet and Guitar* (Musée National d'Art Moderne, Paris*), Glass and Bottle of Suze* (Washington University Gallery of Art, Saint Louis) in which is incorporated the text of one of Jaurès's pacifist speeches with the addition of gouache and charcoal. In *Fruit Dish with Fruit, Violin and Glass* (Philadelphia Museum) the fruit is cut out of colour printed sheets.

The cut-outs are outlined in charcoal with precise rigor: *Violin* (Allsdorf Foundation, Chicago), *Head of a Man with Hat* (Museum of Modern Art, New York), *Man with Violin* (Harold Diamond collection, New York). Picasso's imagination develops through many experimental discoveries and one doesn't know what to admire most: his virtuosity, his sense of coloured effects and signs which are incorporated into the decoupages and hold them together, or the diversity of his imagination stimulated by his extraordinary creative fervour. The attentive and patient preparation of painting is replaced by the immediacy of manual work, a kind of tactile gymnastics in which the fingers play an essential role to the benefit of what Jean Paulhan calls the "seeing machine".

It is the dynamism of Picasso's papiers collés which opposes them to Braque's, more classical, more artisanal; one works with poses, the other with snapshots, the two painters do not influence each other, they are complementary.

Pablo Picasso,
Violin,
1915, painted metal sheet
and wire, 95x66x19 cm,
Musée Picasso, Paris.

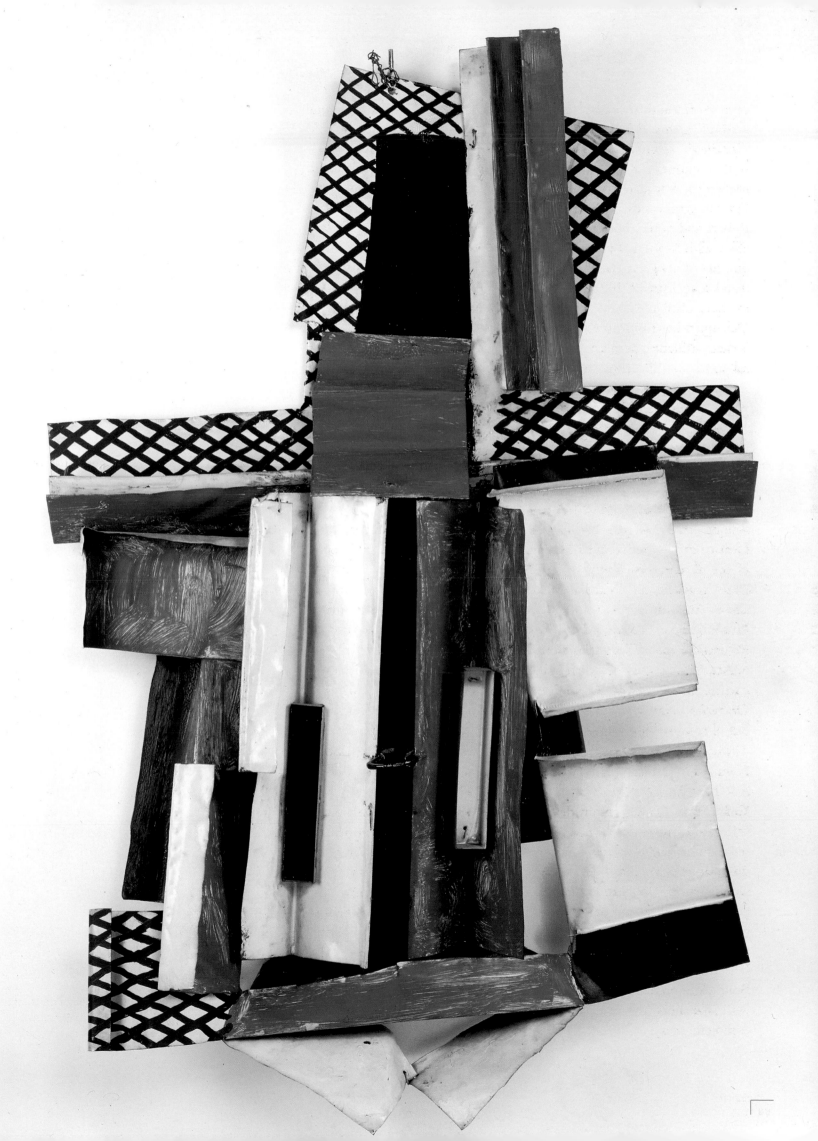

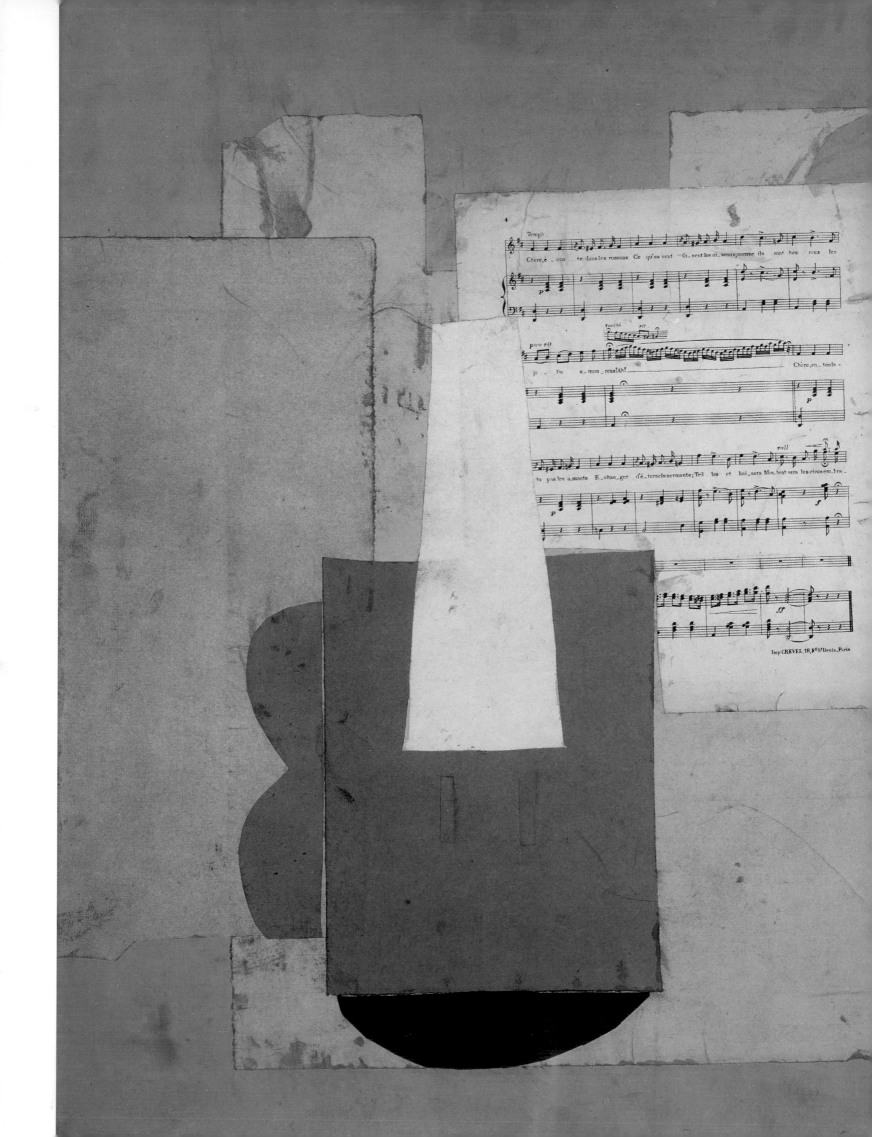

In 1912 and the beginning of 1913, schematic frameworks turn several of Picasso's papiers collés into informal constructions in space; yet they still represent a *Bottle, Glasses on a Table*, the *Head* of a men or women which can be identified by a few allusive signs; in *Nude Woman (J'aime Eva)* of the Columbus Gallery, Ohio, the painter juxtaposes the vertical architecture broken up by lines, in which is inserted a reminder of the Wobé mask, and contrasts of planes coloured with paint or sand.

His still lifes of early 1913 are characterised by large vertical strips and the use of oil mixed with sand, pieces of material, charcoal and plaster (*Violin and Guitar*, Philadelphia Museum), oil, plaster mouldings and papier collé on wood (*Guitar, "Ma Paloma"*, private collection, Switzerland), oil, plaster and sawdust on oval canvas (*Musical Instruments*, Hermitage, Saint-Petersburg).

To these large constructive strips are sometimes added a few unexpected objects, like in the *Gas-Jet and Guitar* (private collection, Prague) set against an oblique blue table with a cut out guitar and imitation marble in the background.

Picasso stages a *Guitar Player*, an astonishing assemblage that he photographs in his studio which consists of a real guitar hanging from the wall, two arms made of newspaper to represent the player whose conceptual silhouette is drawn on the wall. This "installation", in the modern sense of the word, is completed by a round table with a glass, a pipe and a folded newspaper, some pictures on the floor are turned against the wall on the left. The right side of a poster of one of Picasso's exhibitions hangs next to several small reproductions of paintings on the wall on the left. The painter touched up the photograph with the use of masks, probably in the same period.

Pierre Daix[35] writes: "At the beginning of 1913, Picasso must first of all verify the validity of the conceptual abstract space of his figure, by confronting it with a real three-dimensional object, like the guitar...."

Can we compare this improvisation which combines painting, drawing and objects, in a studio "more hallucinating than Faust's laboratory", assures André Salmon, with Duchamp's ready-mades produced only a few months later? Picasso does not "consecrate" his work, he experiments on the new functions of the relationship between the created abstract space and the real object that is integrated into it. In his own manner, he "breaks up" his cubism.

Several photographs of the *Guitar Player*, illustrate the first issue of the periodical *Les Soirées de Paris*, on 15th November, 1913, edited by Apollinaire. The young Russian artist Tatlin, in Paris at the time, is overwhelmed by the reproductions, to the extent that he immediately asks to meet Picasso. The latter receives him, probably at the end of the year, in his new studio of the rue Schoelcher, overlooking the cemetery of Montparnasse where he had moved with Eva in September. When he returns to Moscow, Tatline executes the assemblages in pictorial relief that he will call *Counter-reliefs*.

35 P. Daix, *Dictionnaire Picasso*, Paris 1995.

Pablo Picasso,
Violin and Music Sheet,
1912, paper collage, 78x65 cm,
Musée Picasso, Paris.

Jacques Villon,
Marching Soldiers,
1913, oil on canvas,
Musée National d'Art Moderne, Paris.

The "impressionist-cubism" of Villon

In 1913, Villon paints *Marching Soldiers* (Musée National d'Art Moderne, Paris), but, contrary to what was often believed, it was not under the influence of futurism (the painter declared that he had not seen the exhibition in the Bernheim Gallery). The canvas is characteristic of his research on movement associated with light colours and based on the concept of geometry; it was meant to convey the pounding of the military march inspired by some sketches that he had made during his military period. Villon himself said that he had tried to "express the synthesis of movement within continuity".

The rendering of movement, as we have already seen, was one of the preoccupations of the Puteaux group; Villon and his friends, talking about the *Bust of Baudelaire* by Duchamp-Villon, declared that if it exploded it would be according to certain lines of force; it is on these "major lines" that Villon builds the "regulating outline" of his compositions, cut up not in facets like with the cubists, but according to a pyramidal space in which the double vanishing point, one situated in the spectator's eye and the other at the opposite extremity, controls the geometrical rhythms of the different planes.

Of all the painters of the Section d'Or group, Villon is the only one to have established a logical and coherent language outside cubism but still related to it by its intention of construction away from all systems. Through the subtle interaction of lines and colours, he will reach a degree of refinement and the rectitude of his long matured reflections, comparable to laboratory work, will achieve the pure articulation of form, which appears in his remarkable engraving work.

Thus the *Mechanics' Workshop* (Gallery of Fine Arts, Columbus, Ohio), finished in 1914, kept him busy for two years with several painted and engraved variations; Villon gives of the subject based on compound harmonic division of the composition, a synthetic vision taken to the limits of abstraction. In the *Seated Woman* (private collection, Paris), he confers on the figure a minimalist simplification of which the powerfully geometrized monumentality is reminiscent of sculpture. During the same period Duchamp-Villon is working on a *Seated Woman* with a similar structure.

Exhibitor and member of the Section d'Or group, also from Normandy, like Villon, Roger de la Fresnaye comes from an aristocratic background. He received an academic artistic education until he discovered Cézanne and Gauguin. In the landscapes of La Ferté-sous-Jouarre, in 1911, he "cézannises" nature, the influence of cubism is beginning to appear in his work, he interprets it according to a sensitive articulation, very far both from Braque and Picasso's speculations and from Villon's reductions of pyramidal planes. His forms are dense, his colours sober, similar to Léger's which are heavier, or to those of Delaunay, livelier. The *Card Game*, shown in the "Cubist House" in the 1912 Salon d'Automne, *The Conquest of the Air* or the *Seated Man* of 1913 both in the Musée National d'Art Moderne in Paris, assert his singularity. As in his still lifes, La Fresnaye synthesises the subject, he does not analyse its interiority, he remains faithful to the geo-

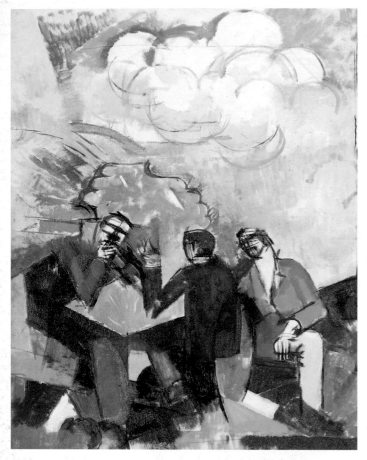

Roger de La Fresnaye,
The Conquest of the Air,
1913, oil on canvas,
94x92 (?) cm,
Musée d'Art Moderne, Troyes.

Roger de La Fresnaye,
Seated Man,
1913-1914, oil on canvas,
165x81 cm,
Musée National d'Art Moderne, Paris.

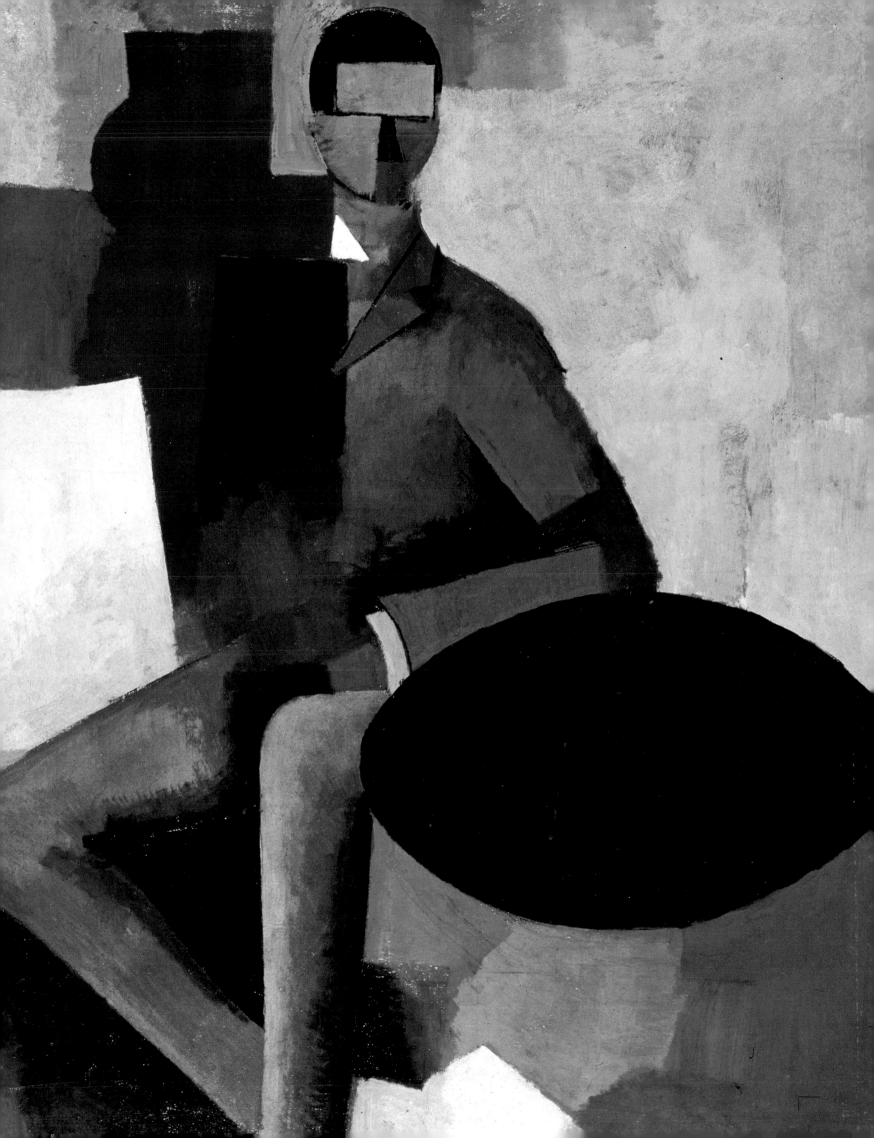

metrization of the surface via superposed coloured planes. His art is a mixture of idealism, of harmonious and well-balanced rhythms, of colourful planes where the local tone and the tone of light, form and atmosphere, are joined together, but most of all it is intellectual art, hardly speculative, his intellectualism being closer to music and poetry than to mathematics.

Like Lhote, Marcoussis, Gleizes, Metzinger and the cubists of the Salons, La Fresnaye refuses what he considers to be with Braque and Picasso, and even Juan Gris, an arbitrary destruction of accepted values; this prejudice prevents him from questioning things and traps him inside the "French" ambiguity, yet he is possibly the only one, had he lived longer (La Fresnaye will die of the after-effects of the war, in 1925), who might have been able to lead this neo-cubism in a new direction owing to a turn towards classicism that Picasso is also approaching at the same period.

Delaunay and "pure painting"

At the end of February 1913 the Moderne Galerie Heinrich Thannhauser in Munich presents Picasso's first retrospective in Germany, showing seventy-six paintings and thirty-seven watercolours painted between 1901 and 1912. In the middle of March, he goes to Céret with Eva where he soon starts a new series of papiers collés; his stay is interrupted by two trips to Barcelona, the second of which occurs at the end of April to be with his father during his last moments. He is deeply moved when his father dies on 3ʳᵈ May. His Catalan visit is nevertheless brightened up by the presence of Max Jacob, a picturesque poet and tightrope walker. Braque spends a few days in Céret before returning to Sorgues in June.

Delaunay in his pictures of *The Eiffel Tower* has achieved an interpretation of cubism based on movement with a most explicit symbol of modernity – also a sexual metaphor – and appears as a kind of go-between, between the cubist orthodoxy in which the architectonics of construction and destruction is an essential element, and a rhythmic approach to reality. Without disowning the geometry inherited from Cézanne, sphere, cylinder and cone, he turns to an optical form of painting, which makes light-colour the subject of the picture. Cubism is static, Delaunay confronts it with the dynamism created by the contrasts of simultaneous colours. The *Windows* that he starts to open from April 1912 onwards on the sights of the city, are light traps; the luminous chromatism which he used to disarticulate the Eiffel Tower, dissolves the objects that he brings to abstraction and contributes to a lyrical approach of the world.

Apollinaire who at the time is living with the Delaunays, in *Le Temps* dated 14ᵗʰ October, enumerates all the different tendencies of cubism and writes: "Delaunay, on his own, was silently inventing an art of pure colour. Thus we are moving towards an entirely new form of art, which will be to painting, such as we have considered it until now, what music is to poetry. It will be pure painting..."

In January 1913, Delaunay and Apollinaire go to Berlin for an exhibition at the "Der Sturm" gallery, where the poet gives a conference on "Modern Painting". He mentions the main trends of which the most important in his eyes are "on the one hand, Picasso's cubism, on the

Jean Metzinger,
The Blue Bird,
1913, oil on canvas,
250x193 cm,
Musée d'Art Moderne
de la Ville de Paris, Paris.

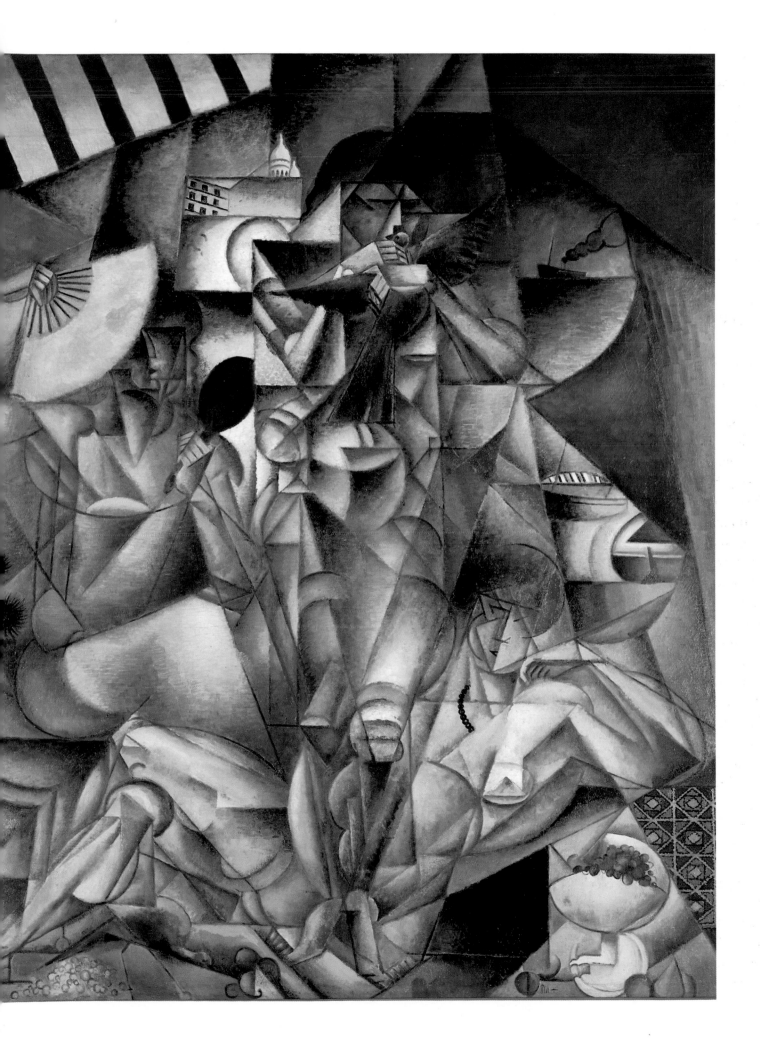

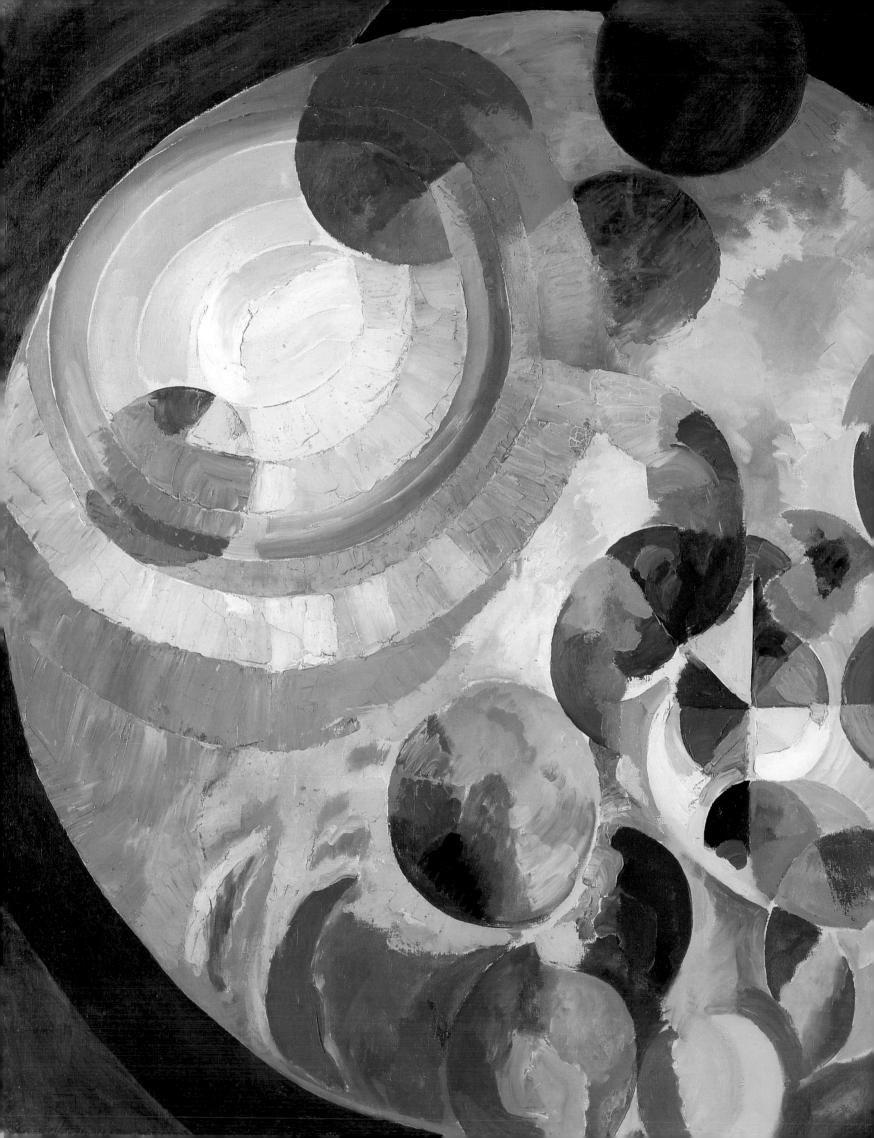

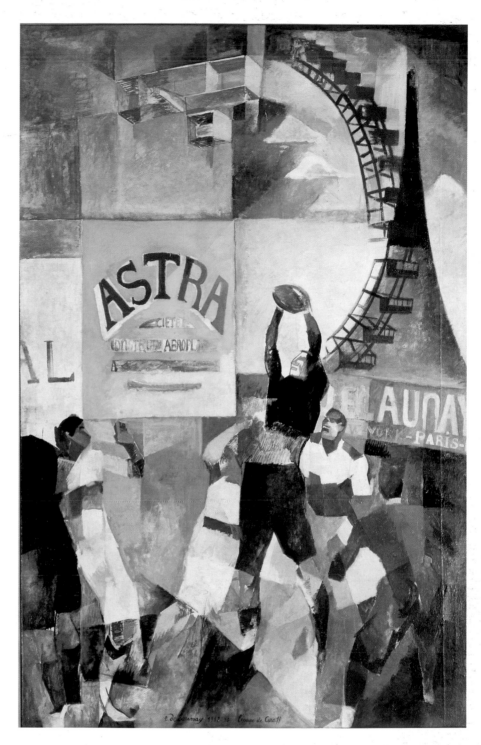

Robert Delaunay,
Formes circulaires
soleil et lune
(Circular Forms, Sun and Moon)
1912, oil on canvas,
200x197 cm,
Kunsthaus, Zurich.

Robert Delaunay,
L'Équipe de Cardiff
(troisième représentation),
(The Cardiff Team-
third representation)
1913, oil on canvas,
326x208 cm,
Musée National d'Art Moderne, Paris.

other Delaunay's Orphism" which "springs from Matisse and the fauvist movement, and in particular from their luminous and anti-academic tendencies…", imbroglio quite in character with Guillaume. The artist concerned did not appreciate the following paragraph, neither did Mr. Kahnweiler: "Picasso's cubism was born from a movement that comes from André Derain", a most debatable elliptical assertion. The dealer from the rue Vignon is not at all pleased to see the Delaunay couple taking control over the changeable Guillaume who is believed to have added under their influence — at least according to Kahnweiler — a paragraph concerning Robert, to the proofs of his *Cubist Painters*.

"Pure painting", the poet's new hobby-horse, leaves Braque and Picasso indifferent, yet their art dealer will not calm down. Apollinaire who does not want to quarrel with anyone, in *Montjoie*, dated 14th March, writes a vibrant praise of Picasso but, in his review of the Salon des Indépendants of 18th March, the space he devotes to Orphism and Delaunay "one of the most talented and daring artists of his generation", does not reconcile him with the painters of the rue Vignon or with their dealer.

Christened by Apollinaire "the heresiarch of cubism", Delaunay shows at the Indépendants *The Cardiff Team, third representation*, "the most modern canvas of the Salon", according to Guillaume, alongside *Nude Woman* by Léger, *Football* by Gleizes, *The Blue Bird* by Metzinger, and works of Lhote, Picabia, Marcoussis and "the very abstract cubism" of Mondrian. The art critic-poet notices the great number landscapes from Céret, the "Barbizon of cubism", he writes, considerably exploited by the "cubisters". Braque and Picasso "whose research work on matter is of such great interest at the moment" are of course absent.

The critics see in Orphism – André Warnod greets, in *Comoedia*, the "birth of a new school" – the euphoric revenge of colour over the static and austere aestheticism of cubism and a purely retinal reaction to its mental formalism. In September 1913, Delaunay exhibits in the Erster Deutscher Herbstsalon, galerie "Der Sturm" in Berlin, his abstract *Circular Forms*, together with several earlier pictures. Anti-cubist figures par excellence since cubism prefers straight angles, they are the product of prism effects of the sun, the moon, rainbows and memories of the first aeronautic meetings or Aviation Shows. Continuous colour whirls around the spatial field, confirming the purely optical approach of "pure painting"; it is simply a pity that Delaunay's abstraction, mocked by Kahnweiler, was marginalized by the German critics to the benefit of the spiritualist triumvirate Kandinsky, Malevitch and Mondrian. His dynamic lyricism which "broke him off" from cubism remains one of the first manifestations, through the disarticulation and breaking up of form, of a freely acquired non-objective painting which had mastered colour.

Picasso's papiers collés

While Braque is fitting up his studio in Sorgues, Picasso and Eva return to Paris on 19th June, 1913. In the early summer, he produces several pictures representing the *Head of a Man*, reduced to conceptual minima-

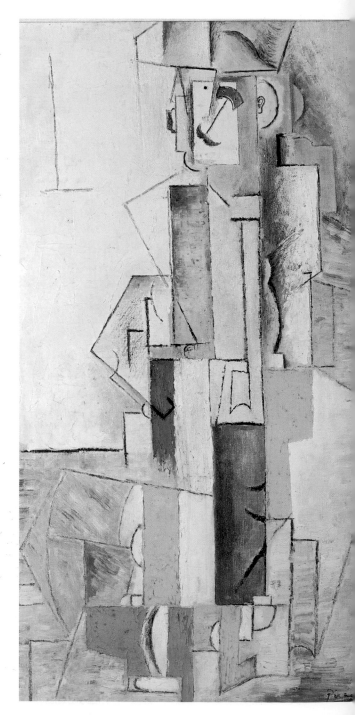

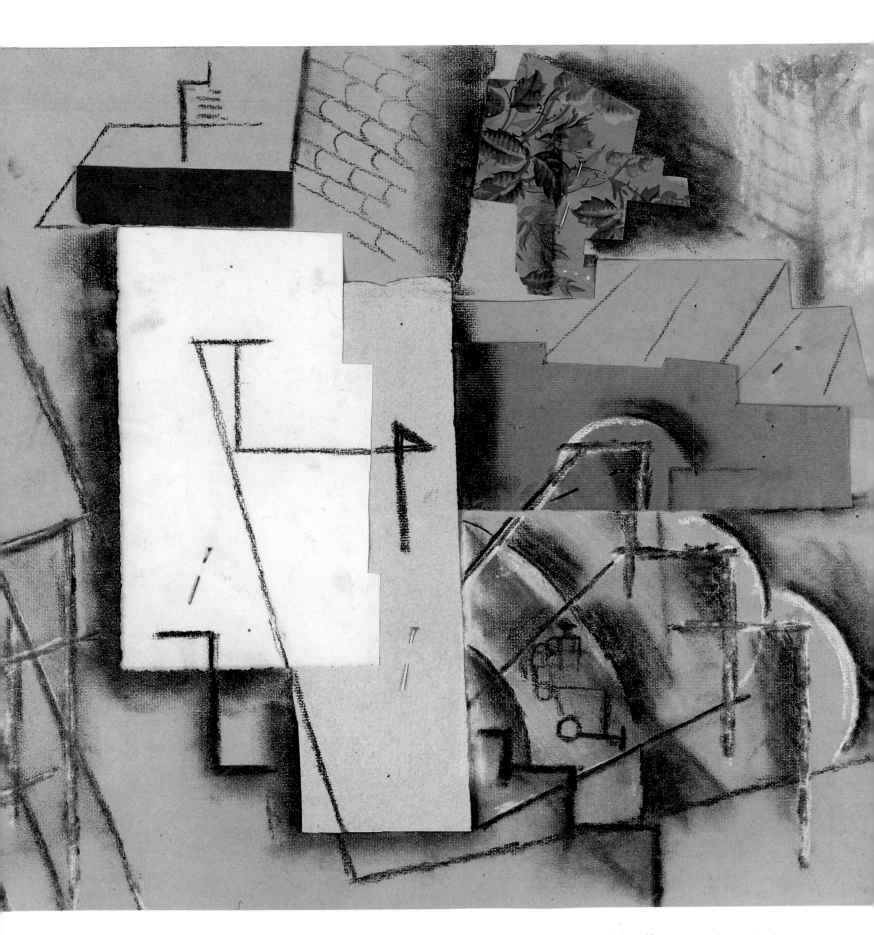

Pablo Picasso,
Harlequin,
1913, oil on canvas,
88.5x46 cm,
Haags Gemeentemuseum, The Hague.

Pablo Picasso,
Céret Landscape,
1913, pasted and pinned
paper charcoal and chalk,
Musée Picasso, Paris.

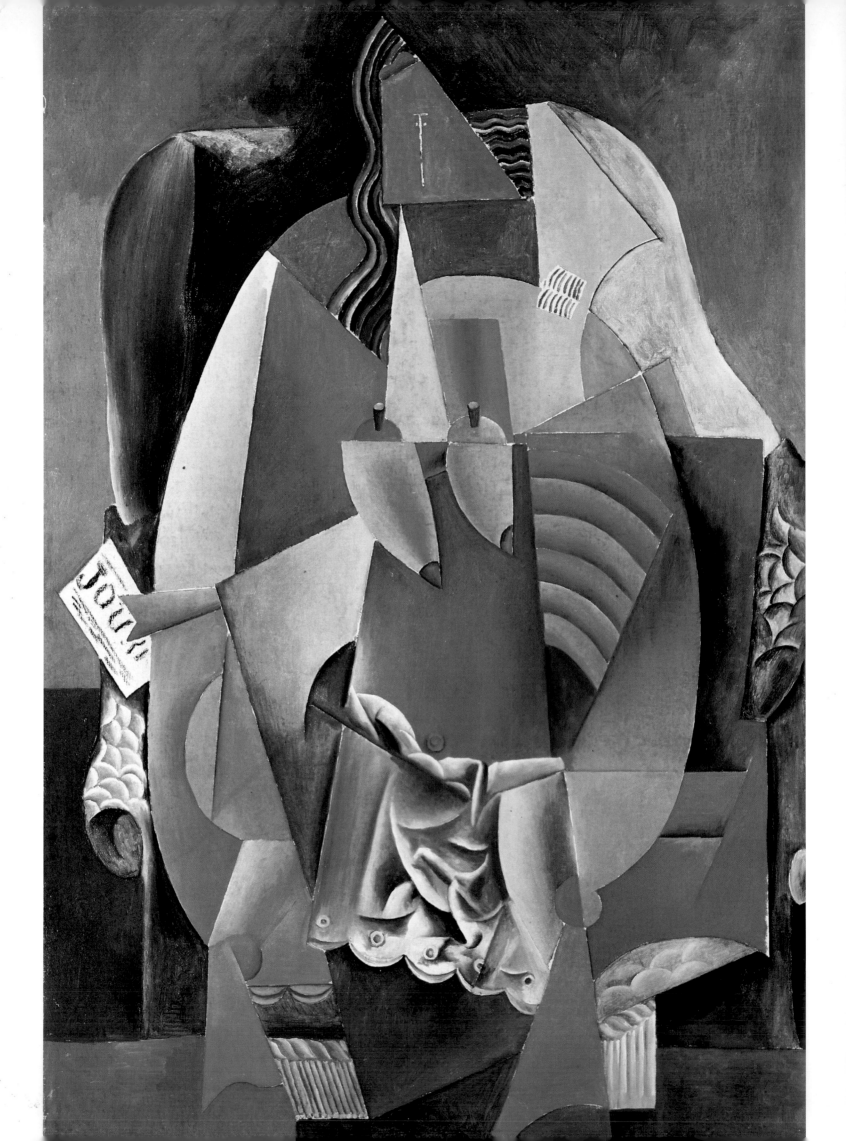

lism in which he retains a few allusive signs, moustache, ear, lines of hair or face, some others of the *Head of a Young Girl* also schematic and constructed, and a few triangular *Guitars* in papiers collés or paper pinned onto paper. The usual objects, bottle of Marc, guitar, glass, fragment of newspaper are represented together with decorative wall paper in a number of still lifes with geometrized structural variations. In the *Céret Landscape* of the Musée Picasso in Paris, the painter amuses himself by imitating the colourful "cubist" pastiches of his followers.

The *Harlequin* of the Gemeentemuseum in The Hague, also from the summer 1913, which according to Pierre Daix is "the most perfect achievement of conceptual figuration", returns to the composition with vertical strips of the previous year; it precedes two astonishing pictures of a *Student with Pipe* (Nelson A. Rockefeller Collection, New York) and a *Student with Newspaper* (private collection, Basle), papiers collés, oil, charcoal and sand on canvas. The collage which imitates the beret students wore at the time, is made out of crumpled paper which gives it a slight relief in one of the pictures, and painted a faded red colour in the *Student with Newspaper*. The first *Student* is signified, as in the previous Heads, by a simple conceptual construction, small eyes and a long vertical nose (reminiscent of the Wobé Masks?), a paper cut out pipe; the second is integrated into an environment of papiers collés; block capitals, imitation wood and pointillist effects.

Dadaists and surrealists will be very enthusiastic over Picasso's papiers collés even if for them they did not have any plastic intention; they will be reproduced for the first time, in the catalogue of the Galerie Goemans collage exhibition in 1930 in Paris, when Aragon gives them their true significance in "La Peinture au défi". The following year Tristan Tzara will publish another famous text, "Le papier collé ou le proverbe en peinture".

During the winter of 1913-1914, the last of the heroic years of cubism, in his new studio of the rue Schoelcher several of Picasso's major works were produced, among which the famous *Woman in a Chemise in an Armchair* which today belongs to an American private collection. This working period is made difficult by Eva's bad health.

Pablo Picasso,
Woman in a Chemise in an Armchair,
1913-1914, oil on canvas,
150x99.5 cm,
private collection.

Bottle, glass, pipe and cigar

Braque's 1914 papiers collés, his rigor of tone and matter, contrast with Picasso's interpretations full of variations. The Spaniard continues his experimentation with the diversity of his inventive imagination, and the Frenchman explores the intuitive reduction of sign; the first is not afraid of illusionism, the second tackles the combination or the association of form in a search for monumentality which will avoid dispersing the eye and confusing the mind. He confines himself to the relationship between gouache, pencil and charcoal, imitation wood and coloured wallpaper, newspaper fragments or printed letters, as in *The Clarinet* of the Museum of Modern Art in New York, *Bottle, Glass and Newspaper*, or *Violin and Pipe* of the Musée National d'Art Moderne in Paris, of 1913-1914.

The latter work, the only papier collé of the museum, contains charcoal, imitation wood, a border of wallpaper, black paper, newspaper, all cut out and stuck on paper pasted onto cardboard; two different newspaper elements are juxtaposed, one cut out from the *Quotidien du Midi* dated 15th November, 1912, the other from the *Journal* dated 28th December, 1913, which might mean that the composition, of austere beauty, was created in two separate phases; unless of course Braque used within the same working period old newspapers.

In *Newspaper, Bottle, Tobacco Packet*, of the Philadelphia Museum, the objects are spread out against an allusive oval guéridon contour in perspective inside the spatial field; for the first time the edge of the imitation wood is cut out irregularly and jagged, surrounded by with a shaded zone. A piece of newspaper is decorated with a cut out heart, virtual focal point of the composition.

Bottle, Glass and Pipe, is more complex; the materials, cardboard, imitation wood, black paper, newspaper are superposed and balanced in beige and brown tonalities on an ivory white background; the contour of the pipe is cut out in hollow from the newspaper so that, as John Golding remarked, it "stands out in its absence" while at the same time it creates a strange trompe-l'œil effect.

Juan Gris spends part of the summer and the autumn of 1913, from August to November, in Céret where he joins Picasso and the Catalan sculptor Manolo. He paints landscapes and still lifes with musical instruments and fruit in which colour predominates within well-balanced structures. His papiers collés, *The Table* of the Philadelphia Museum, *Guitar, Glasses and Bottle*, of the National Gallery in Dublin, *Book and Glass, Fruit Dish and Water Bottle,* of the Kroller-Müller in Otterlo, or the *Packet of Coffee*, gouache, charcoal and papiers collés on canvas, associate a great purity of expression with extreme rigour of composition. The newspaper fragment inserted into *The Table*, bears the subtitle "Le vrai et le faux", like an ironical allusion.

Juan Gris,
Packet of Coffee,
1914, gouache, 64.5x47 cm,
Ulmer Museum, Ulm.

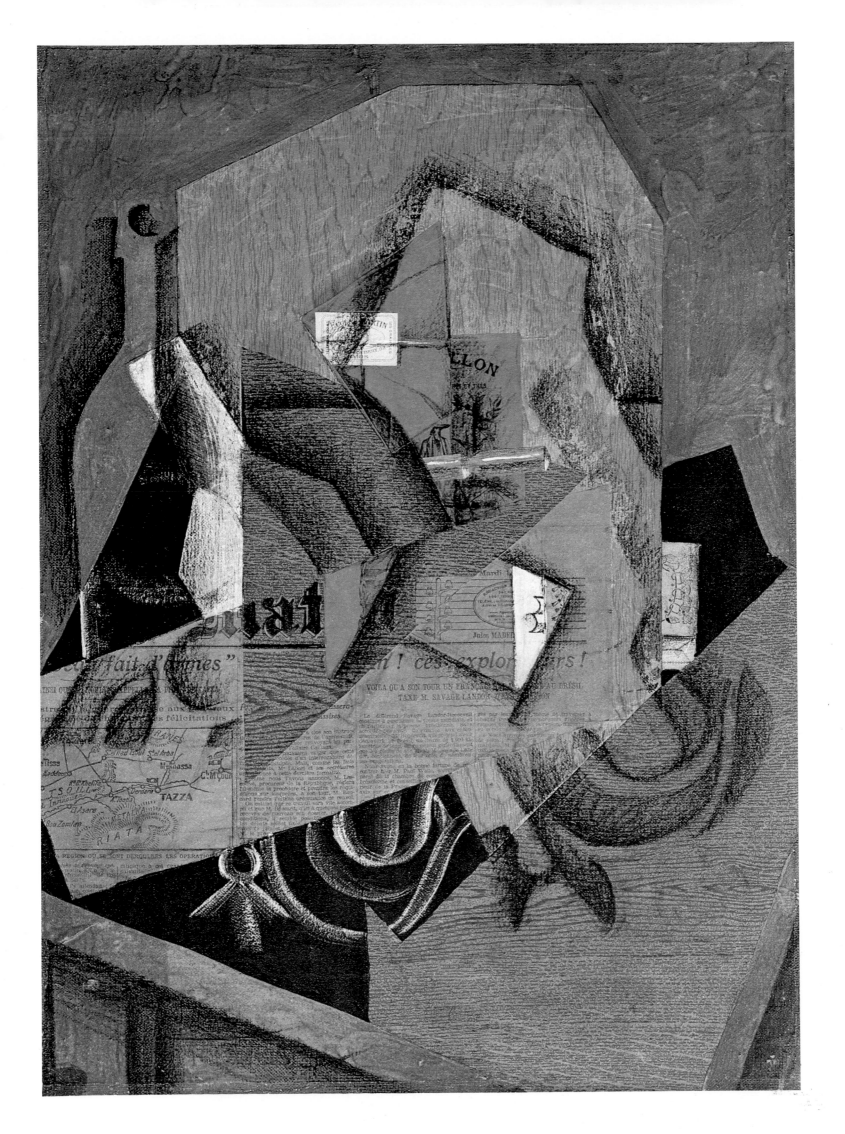

Georges Braque,
Woman with a guitar
1913, oil on canvas,
130x73 cm,
MNAM-Centre G. Pompidou,
Paris.

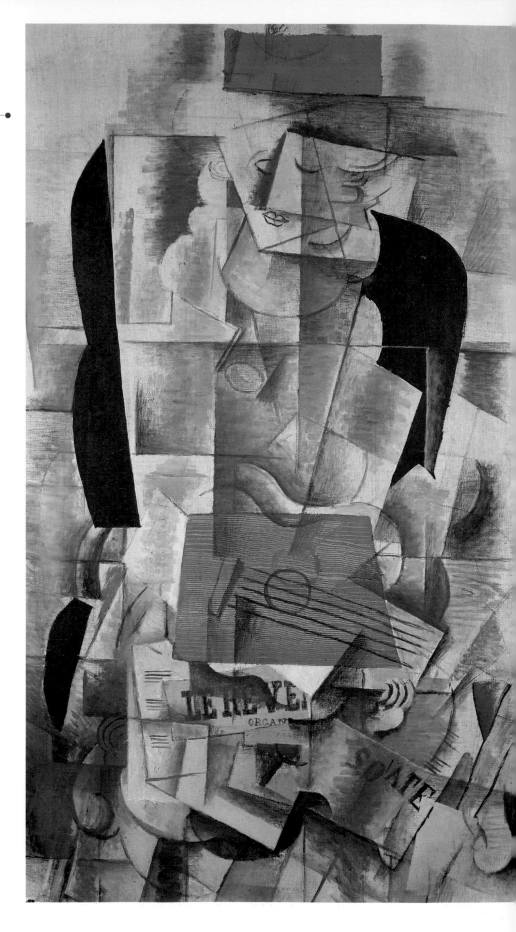

Braque's *Man with a Guitar,* of 1914, bought in 1981 by the Musée National d'Art Moderne in Paris, is the pendant of the *Woman with a Guitar,* owned by the same museum and painted a year earlier; these pictures are in the style of his papiers collés. Both figures are set into a network of vertical planes which are balanced against horizontal lines, monumental and hieratic bars from which a few allusive signs emerge: the curve of the woman's body, eyes, a finely drawn mouth… These double frameworks contain in *The Guitarist* fragments of newspaper, strips of papier collé and stencilled block letters, the rosette and strings of the guitar are represented in a rectangle of imitation wood, the whole arrangement which is a true synthesis of Braque's

recent experimentation is placed against a large frontal black shape evoking the back of an armchair.

The sinuous space of the composition is opposed to the geometrical distribution in steps of the *Man with a Guitar*, constructed according to an arrangement of vertical rectangles in the middle of which the figure takes form, with several anecdotal allusions, wing collar and bow tie, the arm of an armchair, music rolls, curves of the guitar; a large white volute in the bottom right hand corner, is doubled by a smaller one on the left, their meaning remains mysterious.

As in the *Woman with a Guitar*, Braque carries out a synthesis of his past experimentation; the two pictures, impressive and admirable fulfilment of cubism, of which the ease and intense truthfulness contrast with those of the previous hermetic period, open the way to new developments that will unfortunately be prevented by the war.

Scandal at the Armoury Show

In New York, in reconverted artillery barracks, the first great exhibition of contemporary art in the New World, the Armoury Show opens on 19th February, 1913, it will be presented afterwards in Boston and in Chicago. The "International Exhibition of Modern Art" gathers over one thousand six hundred European and American works, it will play a considerable part in the opening up of the United States to contemporary creation, and will cause huge scandals taken up by the press. Picasso is represented by eight canvases, ignorance is such that, christened Paul by the *New York American*, he was made responsible for "two marvellous futurist creations. One is called *Still life n°1*, and the other *Still Life n°2*. The first one shows us nature in full combat against death. The second shows us what Paul felt when he gave it the deathblow …".

Braque with three pictures on show, like Picasso, is also an object of sarcasm and caricature; Gleizes, La Fresnaye, Villon, Léger, Picabia, Duchamp-Villon, Archipenko, the "cubists" get their share, as do Brancusi, Matisse or Marcel Duchamp whose *Nude Descending a Staircase* creates a great uproar which brands him as the "missionary of insolence" when he lands in New York in 1915, and the most offensive representative of the European avant-garde. Delaunay who saw his neo-cubist *City of Paris*, well-noticed at the 1912 Salon d'Automne, turned down because it was too large, removed his two other canvases. Gris, Metzinger and Herbin announced on the poster – Picasso is not – are not represented. With regards to futurism which the Americans confuse with cubism, it has been completely omitted: maybe some artists, like Boccioni or Severini, were invited, but it is probable that they refused to go.

The Wedding by Léger

"But these people are painting cobwebs!" exclaims Léger looking at the paintings of Braque and Picasso shown at Kahnweiler's, nevertheless the latter takes him into his "stable". Cubism intrigues the "tubist" of the *Nudes in the Forest*, but the different processes of decomposition and reconstruction of figures or objects in multiple planes which, with Braque and Picasso, balance and dislocate space according to contrasting perspectives, do not suit him, neither does their monochromy. Léger partakes in Delaunay's concern for colour, they were neighbours at the time in "La Ruche", the odd artistic phalanstery of the XIVᵉ arrondissement, but it is the only point they have in common. "He was continuing in the line of the impressionists, by his use of complementary colours… I no longer wanted to put two complementary colours next to one another, says Léger[36]. I wanted to obtain tones that isolated themselves, red really red, blue really blue… Thus Delaunay was working towards shades, and I was going straight towards frankness of colour and volume, contrast…"

Colour and movement. These are more willingly taken into account by the Puteaux group than by the austere binomial of Montmartre. Gleizes, Metzinger, Kupka, La Fresnaye, Villon Duchamp, are closer to Léger in their research.

The latter had said of his *Nudes in the Forest*, that it was "a battle of volumes"; it is mainly on this level that he differs from Braque and Picasso. He combines fragments of reality with flats of pure colour, independent of one another, surrounded by a clear outline, the intensity of which he asserts with violence. The intention of dynamism, the aggressiveness of his chromatic range are in keeping with his idealistic desire to represent the modern world. A real kaleidoscope of form, *The Wedding* (1911, Musée National d'Art Moderne, Paris), shows the dislocation of volumes in which large flats are opposed to the exiguity of realistic elements, objects or figures, spread out into broken up areas. Léger controls his subject, an obstinate disrupted figuration, free from the attachment to appearance. In stead of indicating the continuity of space, he underlines its ruptures.

36 F. Léger, *Fonctions de la peinture*, Paris 1965 and 1995.

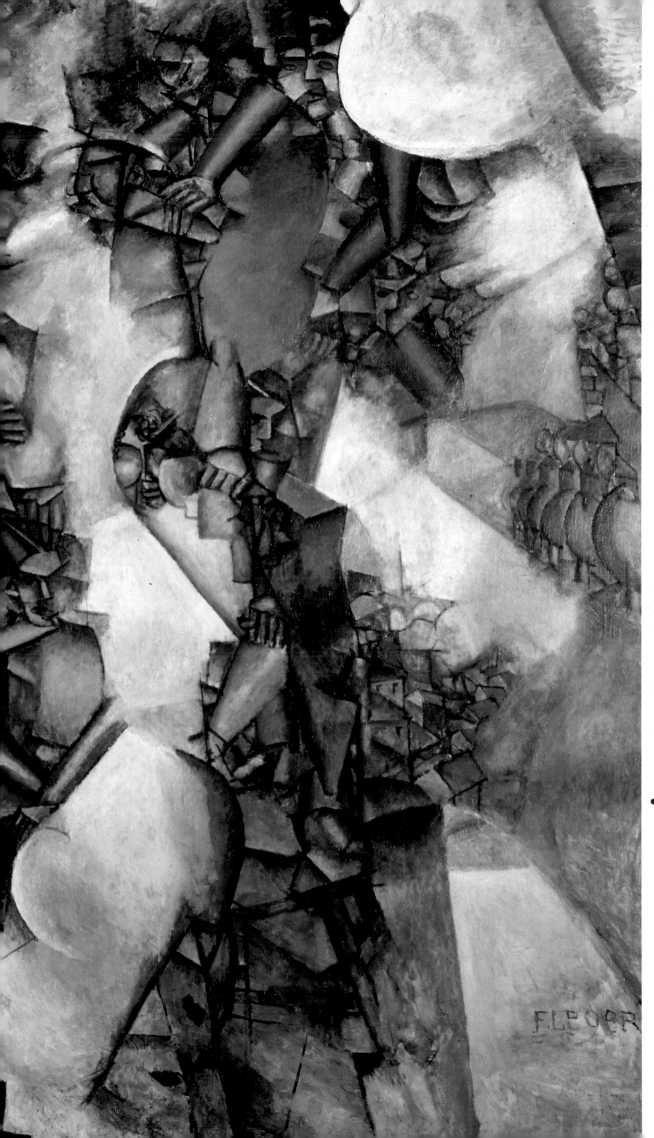

Fernand Léger,
The Wedding,
1910-1911, oil on canvas,
257x206 cm,
Musée National d'Art Moderne, Paris.

He continues his experimentation on the contrasts of geometric forms, of static or dynamic volumes and pure colours, fundamental elements of his art, which distinguish him from the "orthodox" cubists, Braque and Picasso. Moreover he uses the term "contrast of forms" to describe some of his 1913-1914 works, several of which are close to abstraction. In *Woman in Blue* (Kunstmuseum, Basle), from a figurative theme Léger asserts his intention of orchestrating coloured surfaces, ample volumes, and small geometrical forms that are spread out within a thus diversified and brightly coloured structure.

For colour with Léger, as with Delaunay with whom he shares a similar dynamic research, now plays a deciding part. Many years later he will declare: "colour was for me a necessary stimulation… Delaunay and I were far from the others, they painted in monochrome and us in polychrome…".

Unlike the cubists of the Butte Montmartre, little inclined to working outside, Léger paints landscapes; he draws his inspiration from the roof-tops of Paris, from the smoke rising from the factory chimneys, or from modest suburban landscapes, that he transforms into parallelepipeds or cubes from which emerge round shaped trees or the cone of a church steeple. He tattoos them in red, green or blue, opposing rhythms and volumes, and while Delaunay is disarticulating into space the Eiffel Tower, he is on the contrary articulating and condensing geometrical forms into static sketches.

These landscapes are not very far from the abstract "contrasts of forms" of the period, Léger expresses the same freedom of creation, and although he is not unaware of the upheaval that painting is going through, he remains attached in his singularity to nature and modern life. Therefore, even though he does not partake in their spirit or their means, he draws closer to the futurist theories.

On the eve of the war, Léger paints *Le 14 Juillet* (Musée Fernand Léger, Biot) where he synthesises in an arrangement of very colourful vertical and curved lines the dynamic intensity that a modern celebration inspires him.

Cendrars who is a close friend of Léger, as well as Delaunay, will write[37] that the former "had never been a complete cubist in that he never fell into the heresy … of the identity of the object and its representation… When he took up the cubist discipline… it was to his credit that he was among the few who never lost sight of the doctrine's first point: the search for depth… (his canvases) were more laboratory works than definitive paintings. In them, Léger studied the cube, and with the ponderousness that is natural and often essential to the painter, he constructed unavoidably with method, studying successively volumes, then measures…"

It is probably due to Kahnweiler's intervention that Apollinaire, who didn't like him, includes him in his *Cubists Painters* while he disparages him in his reviews of the Salons.

37 In *Cahiers d'Art* N° 3-4, 1933.

Fernand Léger,
Le 14 Juillet,
1914, oil on canvas,
73x60 cm,
Musée Fernand Léger, Biot.

Fernand Léger,
Woman in Blue,
1912, oil on canvas,
193x130 cm,
Kunstmuseum, Basle.

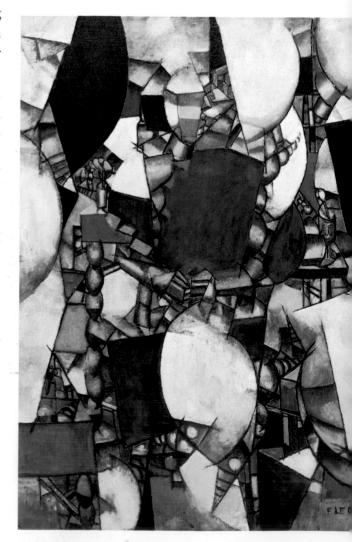

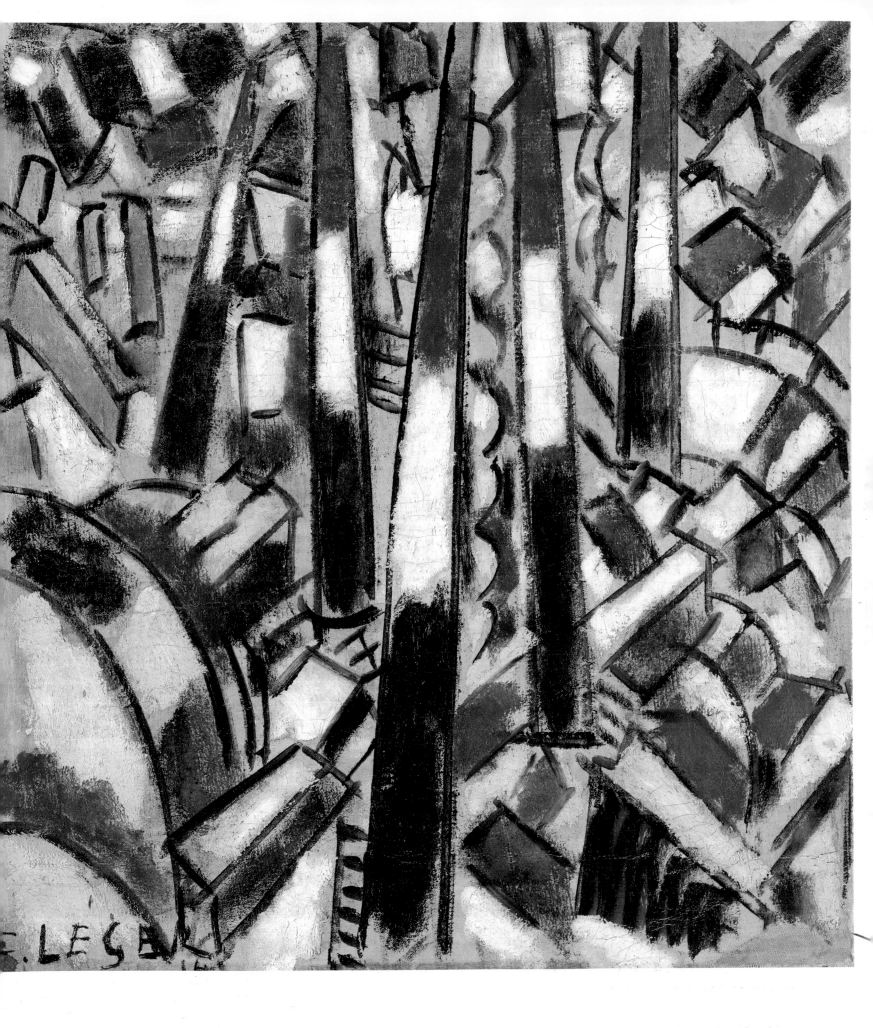

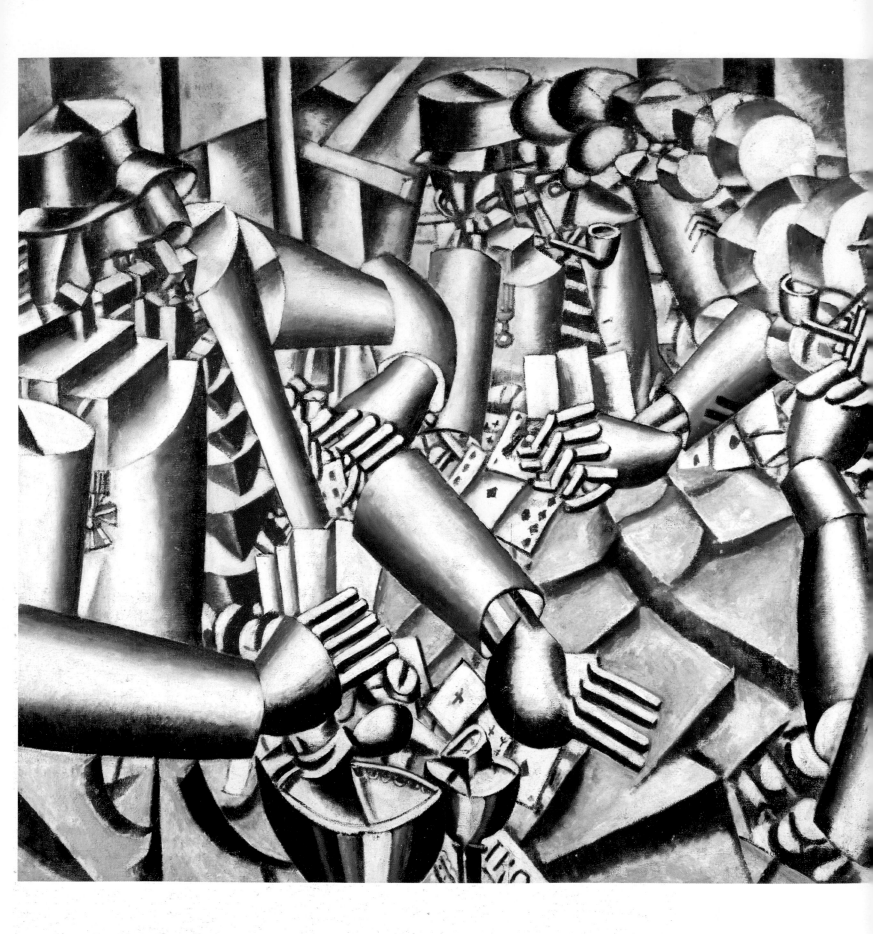

Fernand Léger,
Card Game
1917, oil on canvas,
129x193 cm,
Rijksmuseum Kröller-Müller, Otterlo.

Fernand Léger,
Nudes in the Forest
1909-1910, oil on canvas,
120 x 170 cm,
Rijksmuseum Kröller-Müller, Otterlo.

The success of the "Peau de l'Ours"

While the cubists of the Salons are multiplying geometrization and Léger and Delaunay are exploring movement and colour, Braque and Picasso are introducing into their works pieces of the futurist review, *Lacerba*, Braque in mid-January, 1914, in *Glass, Bottle and Newspaper*, papier collé and charcoal (private collection), Picasso in two papiers collés, *Guitar and bottle of Vieux Marc ("Lacerba")*, of the Peggy Guggenheim Foundation in Venice, and *Glass and Bottle of Wine, Newspaper, Plate, Knife ("Purgativo")* belonging to a French private collection. Still lifes take up Picasso's activity in the beginning of 1914, he combines papiers collés and cut-outs, wallpaper, watercolour, gouache, sometimes sawdust, and explores all the possibilities of the relationships between different materials in the spatial field. Two pictures stand out from the others during this period. *Woman in a Chemise in an Armchair* (private collection) preceded by a number of preparatory studies and followed by several variations, and *The Card Player* of the Museum of Modern Art in New York. We know the importance in Picasso's work of the time of this female figure, also known as *Woman with the Golden Breasts, Woman in a Chemise*, etc., which will fascinate Breton and the surrealists, with its baroque composition, the opposition of straight lines and curves, her triangular head with its features hardly indicated and her long wavy hair, her turned pear-shaped breasts, the drawn line of her ribs, the hair under her armpits, the piece of newspaper and the edge of her crumpled petticoat that occupies the "naturalist" space of the armchair. It is one of Picasso's most mysterious and frequently reproduced works.

It is contemporary with many still lifes and masterful, decorative, joyful figures *Head of a Young Girl Wearing a Hat with Grapes, Woman with a Guitar, Head of a Man...*, which follow one another. Picasso's love life with Eva is in a period of serenity which shows through the euphoric brilliance of his combinations of objects with many interchangeable elements, glass, bottle of Bass, pipe, guitar, tobacco packet, papiers collés, cut-outs, printed letters, pieces of newspaper, and some new additions, dice, the ace of clubs, the visiting card of "Miss Stein, Miss Toklas", etc., a true inventory of everyday life.

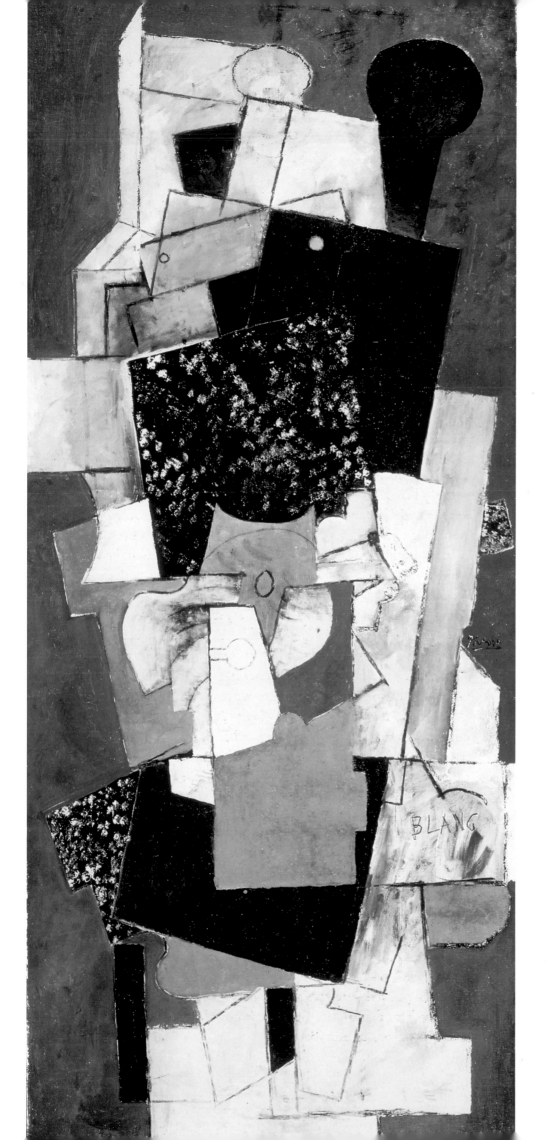

Pablo Picasso,
Woman with a Guitar,
1915, oil on canvas,
185x75 cm,
Norton Simon Foundation, Los Angeles.

Pablo Picasso,
**Pipe, Glass, Ace of Clubs,
Bottle of Bass, Guitar, Dice,
"Ma Jolie"**, 1914,
oil on canvas, 45x41 cm,
Berggruen Collection, Geneva.

During the spring of 1914, with the threat of war, the bright *Pipe, Glass, Ace of Clubs, Bottle of Bass, Guitar, Dice, "Ma Jolie"*, which is in the Berggruen Collection in Geneva, declines with baroque magnificence and a combination of flaked and speckled techniques, in amazingly tactile colours, the elements of his vocabulary full of joyful impulses. Picasso is not only inspired by love but also by the atmosphere of his artist's life in Montparnasse where he lives surrounded by friends and admirers.

The sale of the "Peau de l'Ours", an association of collectors created in 1904 by the financier André Level and a few of his friends, all art lovers, is held at the Hôtel Drouot on 2nd March, 1914, an event which was expected to increase the value of new painting. It had been agreed that the works that had been bought, one hundred and forty-five in all, would be sold by auction ten years later. Salmon, optimistic, saw in the sale "something like a first night of Hernani in painting".

The works on offer range from Picasso to Maurice Denis, from Bonnard to Valloton, Laprade, Vlaminck, Derain, Van Gogh, Matisse, Maillol, Utrillo, Vuillard, etc., but the paradox of the sale lies in the fact that none of Picasso's cubist canvases are there and that Braque and Juan Gris are both absent!

Much to the general surprise, the highest auctions are reached by: *The Three Dutchwomen*, of 1905, by Picasso, sold for five thousand two hundred francs to Emile Level, brother of André Level, the organiser of the sale; the gouache *The Family of Saltimbanques,* of 1908, beats all the records, to the great joy of the artist's friends, and goes for eleven thousand five hundred francs, i.e. more than two hundred thousand three hundred of today's francs. It is bought together with *The Man with the Greatcoat,* of 1900, by the German dealer Thannhauser, and it is the personality of the buyer, rather than the price obtained, that causes a scandal. A certain Delcourt calls his article in *Paris-Midi,* "Before the invasion", he condemns the fact that "large prices had been reached by the grotesque and shapeless works of undesirable foreigners, and it is the Germans who have raised and paid such prices! Their plan is becoming clear, naive young painters will certainly fall into the trap, they will imitate the imitator Picasso who having made pastiches of everything and finding nothing left to imitate, fell into the cubist bluff…"

The repercussion of the sale abroad is considerable, and the American art historian Michael C. Fitzgerald underlines its significance in the *Herald Tribune,* relegating the terrible blizzard which is blowing that day over New York to second position…!

The sculptors of cubism

Picasso, after his *Guitar Player* "installation" in the spring of 1913, creates several assemblages in the autumn, *Guitar and Bottle of Bass, Bottle and Guitar, Mandolin and Clarinet, Construction with a Violin*, etc., using cardboard or wood, pieces of string, wallpaper or papiers collés; he reproduces in volume the spirit and the relationships between the different

planes of his cubist still lifes containing the same objects. *The Absinthe Glass*, in the spring of 1914, is the only exclusively plastic sculpture of the period; Picasso makes an open shaped wax model with an absinthe spoon and a lump of sugar, of which he makes six bronze casts following the sand-mould method, and applies different polychromes to each one.[38]

Is this a revolution? "Picasso is the promoter of cubist statuary ", writes Zervos later on, but he is referring mainly to the *Head of a Woman* of 1909, he adds that the Spaniard had invented "his first sculpted work in the vein of the new order that he had just influenced in painting[39]…" For Werner Spies, "the first to create a "cubist sculpture" inspired by Picasso appears to be Auguste Agero[40]…" But Agero, a friend of Picasso's who will stay with him in times of difficulty, is a follower. Kahnweiler said to Werner Spies: "Agero is trying to assemble his sculptures from cubist constructions". Archipenko does the same, he arrived in Paris from Russia in 1908, his sensibility and knowledge developed on the art tradition of his country, icons, Byzantine mosaics and frescos which he enriched with his travels and discoveries in the Far-East, Africa, South America, etc. Confronted with the cubists with whom he makes friends in La Ruche and in Montparnasse, he starts to break up masses as early as 1912 by introducing geometric planes, then curved volumes and concave surfaces, he simplifies, decomposes, articulates and discovers that voids are as important as solids. He tackles structure, opens, stretches and twists volume, goes from arabesques to solids, he stylises more than he geometrizes (*The Gondolier*, 1914) and polychromes his "sculpto-paintings" of which the decorative rhythms are a long way from cubist aesthetics.

Archipenko is more of a user than a follower. Yet he is the subject of a controversy between Salmon and the journalist Maurice Delcourt who in *Paris-Midi* blames him for making French art ridiculous for the sake of the "sculpto-pictorial wild imaginings of Russian neurotics"! Apollinaire, who praised his presence in the Salon des Indépendants of 1914 in *L'Intransigeant*, is taken to task in the same periodical by a certain Emile Deffin; he counterattacks but is surprised to see *Medrano* published on the front page of the issue dated 2nd March, with the legend: "We are hereby reproducing the photograph of the work of art (?) appreciated below, under his own responsibility, by our collaborator Guillaume Apollinaire…" The snub is such that he resigns.

For Lipchitz, a Lithuanian Jew settled in Paris since 1909, cubism, from 1915 onwards, is a form of asceticism. Very close to Picasso and Gris he too simplifies and geometrizes form, his sculptures have more than painting a complexity of form residing mainly in the juxtaposition of fragmented elements visible from different angles; he gives an essential role to light. Like Archipenko he is attracted by elegance and, also like him, stylisation brings him closer to abstraction; although he always considered himself a cubist, the Baroque will turn him away from the temptation of transposing the paintings of his friends into sculpture.

Pablo Picasso,
The Absinthe Glass,
1914, bronze and sand,
Musée National d'Art Moderne, Paris.

38 The six casts are respectively owned by the Musée National d'Art moderne in Paris, the Berggruen Collection in the Staatliche Museum in Berlin, the Museum of Modern Art in New York and two private collections.
39 C. Zervos, *Histoire de l'art contemporain*, Paris 1938.
40 Werner Spiess, *Picasso sculpteur, Catalogue raisonné des sculptures*, Paris 2000.

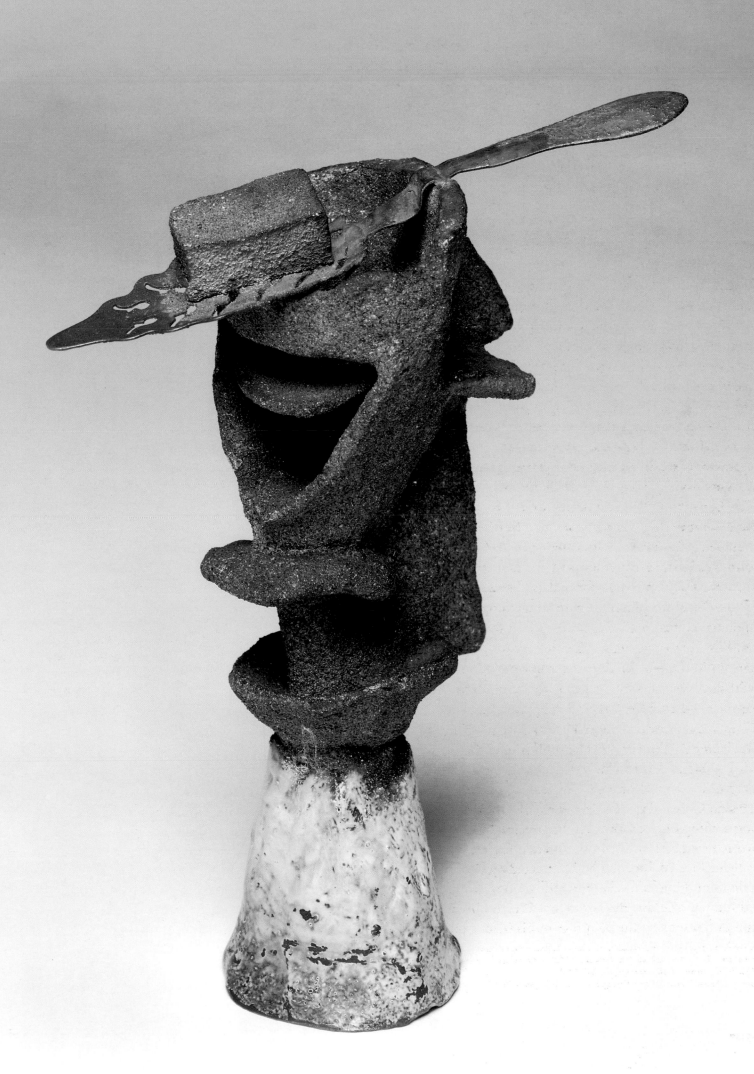

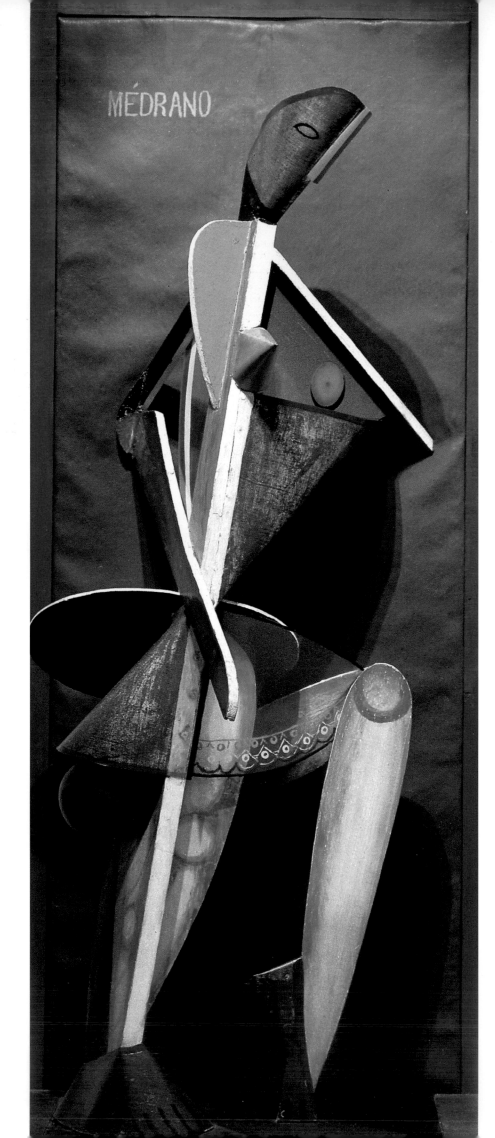

Alexander Archipenko,
Medrano II,
1913, tinplate, wood,
glass and oilcloth,
126.6x51.5x31.7 cm,
Guggenheim Museum, New York.

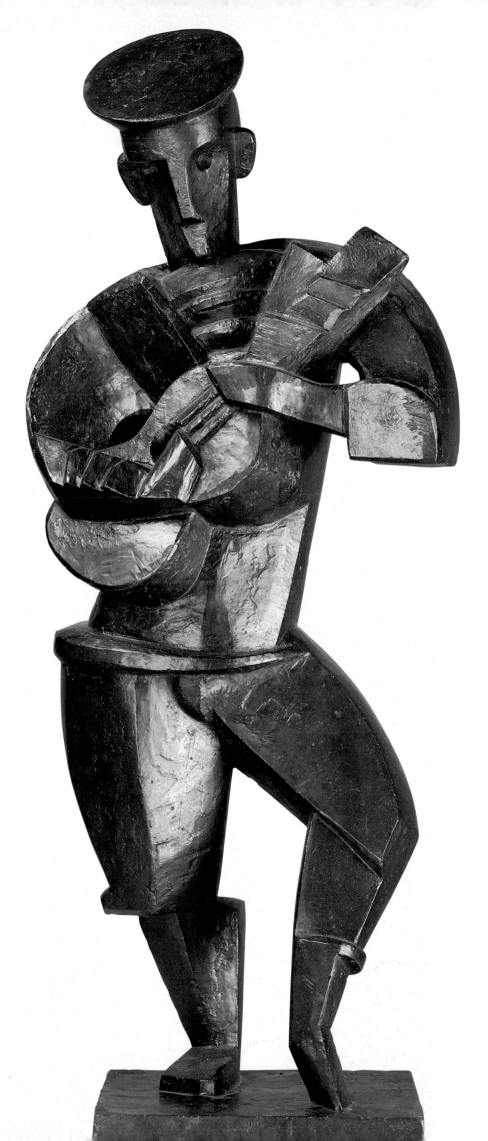

Jacques Lipchitz,
● **Sailor with Guitar,**
1914, gilt bronze,
97x21x21 cm,
Musée National d'Art Moderne, Paris.

Henri Laurens and Duchamp-Villon

"1911, Rimbaud and Cézanne had passed, trying to express the inexpressible and to give the subject some of the light and space that surround it, some of its movement and inner life. Braque and Picasso were at the height of their poetic period. One day, after a rather keen conversation between friends, a few lines were drawn on the studio wall; the meaning had been found. That was the first step which gave birth to a number works, destroyed or lost: the relief of a figure, another of two heads, some other figures built out of cones and cylinders juxtaposed with wood and iron..." In such words, Henri Laurens' wife, Marthe, describes[41] the moment of "illumination" which marked the starting point of his work; 1911 is also the year of the beginning of his friendship with Braque which will last all their lives.

Laurens approaches cubism slowly, the austere and rigorous cubism of his friend; he adopts its geometrical construction with self-control, in full command of his means, of the dimension, of the proportion and of the movement of his research, which reflects his methodical character and his craftsman's conscientiousness acquired during his apprenticeship, like Braque, in a decorator's workshop. His works are only known from 1914-1915 onwards, his previous attempts having been destroyed: they are polychrome reliefs, plasters, papiers collés, terracotta objects and constructions in wood or cardboard. Laurens gives his *Reliefs* very constructed and complex structures which express the same preoccupations as in the contemporary works of Picasso and Braque of whom he says that he discovered the principles like a kind of "hallucination". He also refers to Léger's "tubism" and to Archipenko.

The Clown, of 1915, in wood painted white (Moderna Museet, Stockholm), appears as a three-dimensional exploration of the different combinations in space of the cubist repertoire using a vocabulary of very articulated forms. In the *Fruit Dish with Grapes* (1916, private collection), iron and painted wood, the concave shape of the metal and the cut of the wood in the negative and positive, confer to the space a volumetric dimension in which the freedom of interpretation is in harmony with the relations of colour.

In his 1918 papiers collés, Henri Laurens confines himself to more simple compositions with an accuracy of balance infallible in their articulation, rhythmically controlled, which have nothing to fear from the "competition" of Braque and Picasso. Among the sculptors of cubism he is the closest to the painters.

Raymond Duchamp-Villon began with Art Nouveau, he had to give up his medical studies for health reasons, and became interested in cubism because he was involved in the discussions and exchanges between the regular visitors of Puteaux, around his brother Villon. In Baudelaire's head, strongly modelled and especially in the head of *Maggy* (1912) where the neck becomes a cylinder, the flats of the face and the ovoid skull emphasise the appeal of geometry. His participation in the "Cubist House" of which he elaborates the façade, shows that cubism for him

Henri Laurens,
The Dancer,
1915, collage pencil
and gouache,
31.5x24.5 cm,
Galerie Louise Leiris, Paris.

41 Marthe Laurens, *Henri Laurens sculpteur*, Paris 1955.

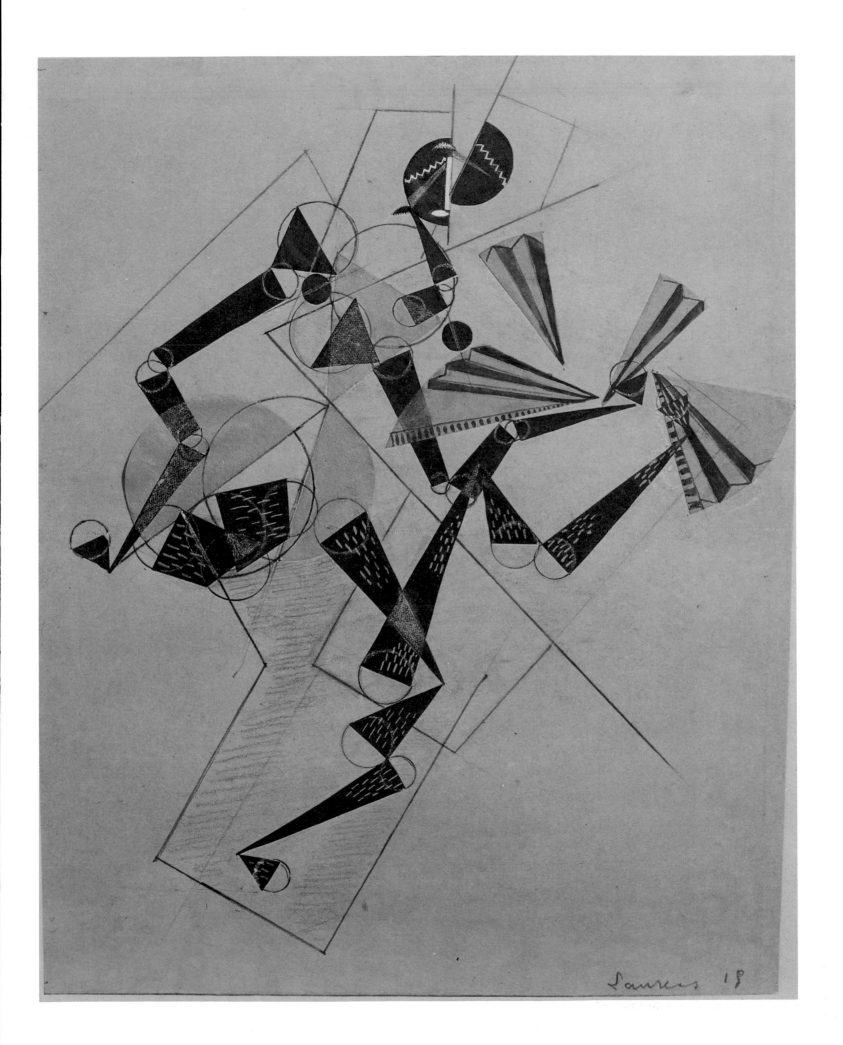

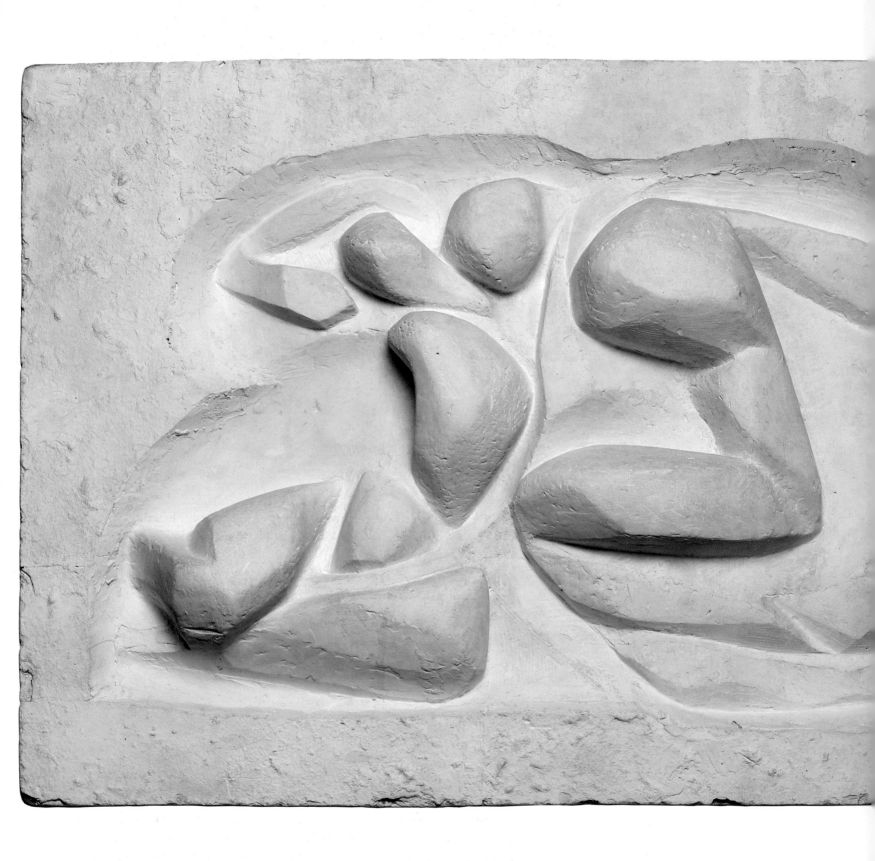

Raymond Duchamp-Villon,
The Horse,
1914, bronze,
Musée National d'Art Moderne, Paris.

Raymond Duchamp-Villon,
The Lovers,
plaster,
Musée National d'Art moderne, Paris.

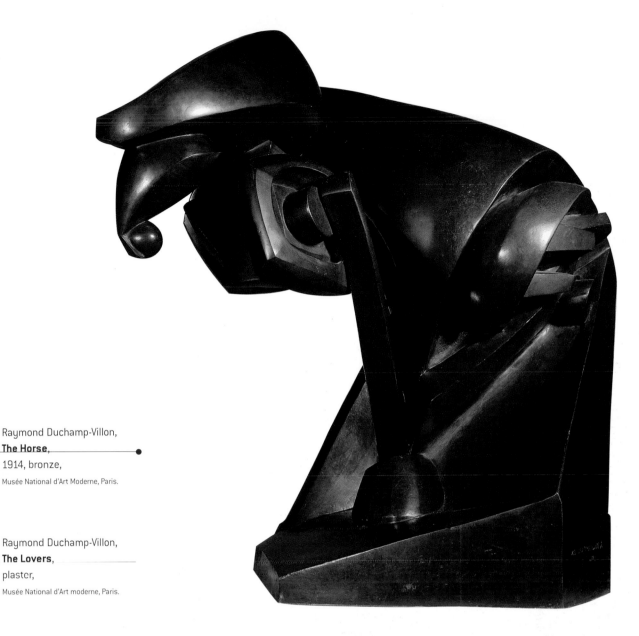

was then limited to geometric ornamentation, angular interlocking and triangular pediments, in other words to decorative elements.

In the 1913 Salon d'Automne in the "cubist room" he shows *The Lovers* in which he adopts a geometric stylisation progressively simplified stage by stage; with regards to this work, Salmon regrets that "Duchamp-Villon is paralysed by a certain timidity", yet he considers that his bas relief has "a pronounced movement, full of ardour which demands to be extended..." (*Montjoie*, November-December, 1913). Is he a cubist sculptor? Not really, but nevertheless he is concerned with on the one hand the decomposition and synthesis of form and on the other the expression of movement through simple rhythms.

After 1912, Duchamp-Villon produces many preparatory drawings for what will be in his short life (he dies in 1918, at the age of forty-two) his major work, *The Horse*. In the beginning he associates the rider with his mount, then he removes the human element and reaches a mechanism of forms thus creating a new being, anatomically unknown, fruit of the combination of the machine and the animal, mythical like the Bride in his brother Marcel's *Large Glass*. The outcome will be *The Large Horse,* cast in bronze in 1931, thirteen years after the artist's death, then in 1966, *The Major Horse*, on Marcel Duchamp's initiative.

Duchamp, movement and time

We know how the *Nude Descending a Staircase* was received at the Armoury Show, causing the first scandal of the avant-garde in the United States; the picture expressed in Duchamp's ironical and complicated way the preoccupations of the Puteaux group with regards to movement and the manner of conveying it in painting. After his work was refused at the Indépendants of 1912, he declared that he wanted to "react against the growing influence of the already classified cubist formula" and in a way, against the deviationism of its users.

The analysis of the object with Braque and Picasso was static, it was the spectator who moved around the turned planes treated in facets thus creating volumetric connections. In *Sonata* of 1911 (Philadelphia Museum, Arensberg Collection) Duchamp uses the decomposition and juxtaposition of the visual angle of cubism from which he also borrows the palette of cold or pale tones. His sisters are his models: Yvonne plays the piano, Magdeleine plays the violin and Suzanne listens pensively; their mother whose face is shown both from the front and from profile, is standing in the middle of the trio which fills the different facets of the diamond-shaped lozenge where it is inscribed. She maintains the symmetry of the composition and orchestrates its rhythms.

In *Dulcinea* (1911, Philadelphia Museum), a young woman seen a few times in the street walking her dog, is represented simultaneously naked and dressed five times, walking in five different directions. It is not the unknown young woman that Duchamp paints but the idea he has made of her through her movements and the desire she inspires him. He undresses her with his eyes and decomposes her physique into overlapping or juxtaposed planes in harmonies of grey and pale ochre, leaving only her hat as an attribute of femininity.

Yvonne and Magdeleine Torn In Tatters, also in the Arensberg Collection in the Philadelphia Museum, shows the four profiles of his sisters floating in space, as they are at the time and as they will become later, their features altered by age. "It was tearing apart rather than movement", he says later on[42]. "This tearing apart was in fact an interpretation of cubist dislocation." As in the *Portrait of Chess Players*, Marcel explores all the possibilities offered by analytical cubism of capturing simultaneously — but simultaneity is not cubist — objects that their respective situations would not allow to be totally apprehended in a normal monocular vision. He considers these pictures to be a "very lose interpretation of cubist theories…" In his conference "A Propos of Myself", given in Saint Louis, Missouri, in 1964, he adds: "In other words, I was very energetically trying to get away from all kinds of traditional composition, even cubist…"

Marcel Duchamp's contribution to cubism consisted mainly in giving it movement and time; concerning the *Nude Descending a Staircase*, both versions, dated December 1911 and January 1912, in the Philadelphia Museum, which originate in Marey's chrono-photography, he will say that it "still had a lot to do with cubism, at least in the harmony of

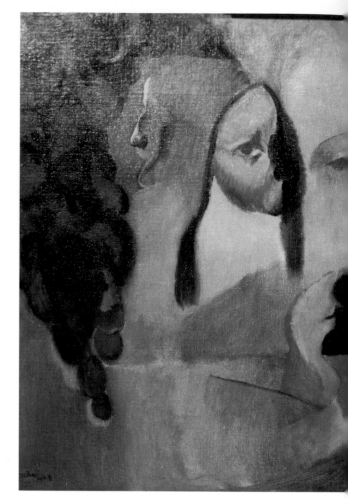

42 Marcel Duchamp, *Entretiens avec Pierre Cabanne* Paris, 1967.

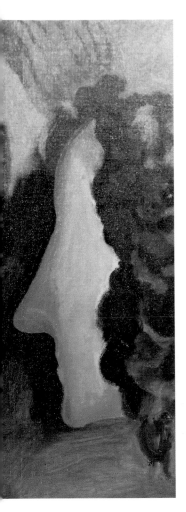

colours", but "that the distortion was another kind from that of cubism…"[43], and without the slightest trace of futurism. "Lets say, adds Duchamp, that it was a cubist interpretation of a futurist formula"[44]. A formula that incidentally he mistrusted.

The "abstract cubism" of Mondrian

Apollinaire who had noticed, in his review of the Salon des Indépendants of 1913, "Mondrian's very abstract cubism" adds that the latter "stemming from the cubists, does not limit them. He seems to be under Picasso's influence but his personality remains whole…" (*Montjoie*, 18th March). The Dutch painter discovered cubism at the Modern Kunst Kring exhibition in Amsterdam in October 1911; thanks to the impact it had on him he moves away from the attraction of impressionism, pointillism and symbolism combined with the love of

43 *Ibid.*
44 *Ibid.*

Marcel Duchamp,
Yvonne and Magdeleine Torn in Tatters,
1911, oil on canvas,
60x73 cm,
Philadelphia Museum of Art.

Marcel Duchamp,
Portrait of Chess Players,
1911, oil on canvas,
108x101 cm,
Philadelphia Museum of Art.

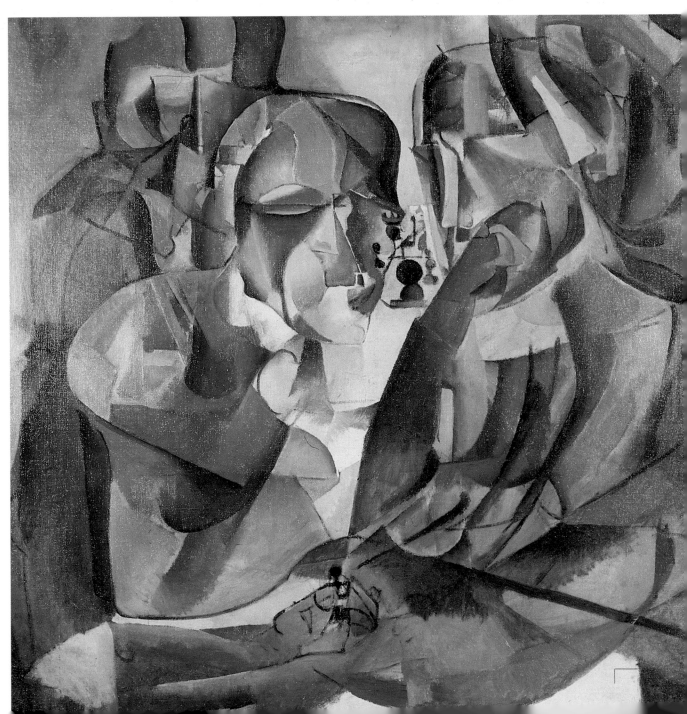

Piet Mondrian,
Still Life with Ginger-pot,
1911, oil on canvas,
65.5x75 cm,
Guggenheim Museum, New York.

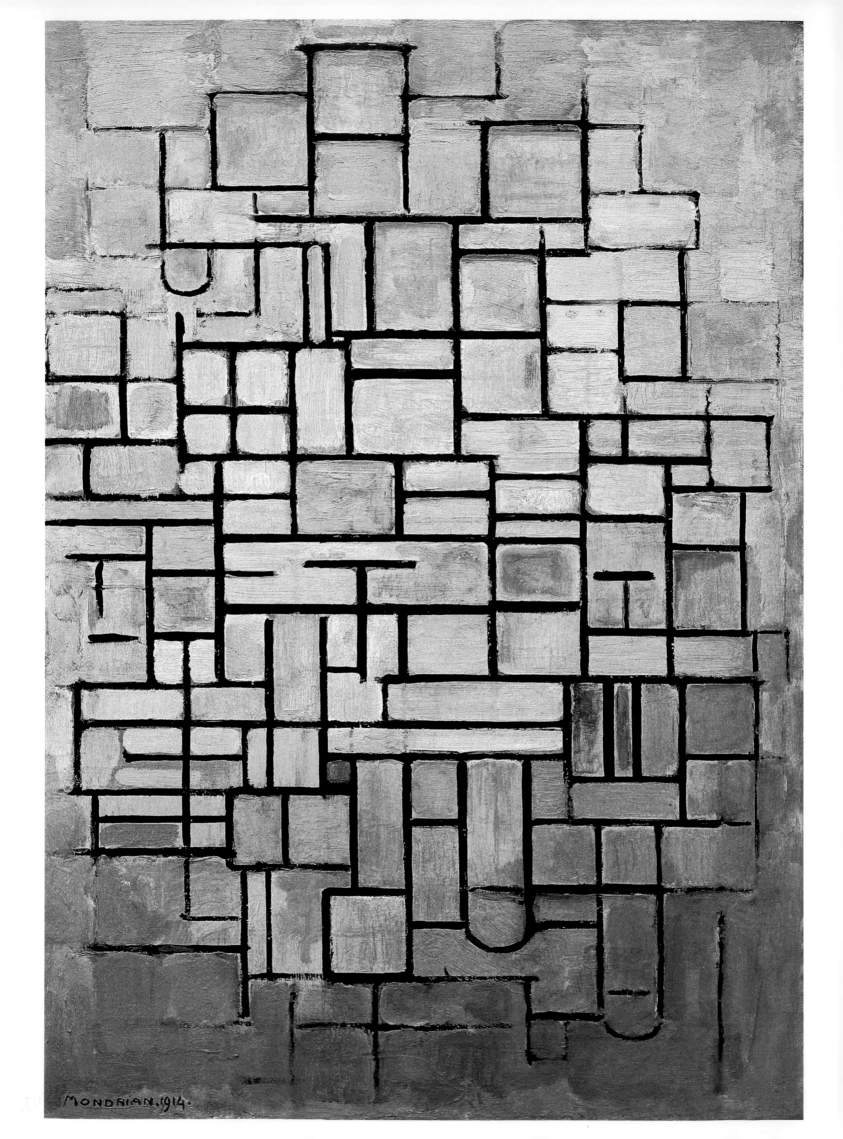

nature under the influence of the school of The Hague, and the tragic emotions it inspired him, his hesitations, his uncertainty.

In Paris, as early as 1911, in two pictures called *Still Life with Ginger-pot,* (Gemeentemuseum, The Hague), he goes from a descriptive reality in subdued colours to the decomposition of the object into plastic signs inserted into a cubist frame which ensures the cohesion of relationships. But he shall escape from cubism, as rapidly as he entered it.

Amsterdam was baroque, Paris is a geometrical town, therefore he geometrizes; but in his *Compositions* of 1913 which continue the series of the *Trees,* and where he adopts the oval shape, the picture consists of a profuse frontal series of small rectangular planes without depth, in which Mondrian progressively abstracts reality yet keeps a few reminders of reality, such as the ironical KUB advertisement for stock cubes that Picasso and Braque had already used.

"Little by little I became aware of the fact that cubism did not accept the logical consequences of my own discoveries, he writes in an autobiographical text in 1941[45], it didn't take abstraction to its ultimate goal, the expression of pure reality...." Indeed neither Picasso nor Braque will cross the line; while synthetic cubism was striving to restore the connection between geometric forms and everyday objects, starting from the form to get to the object, in the *Blue Façade* of 1914 (Museum of Modern Art, New York) Mondrian goes beyond the problematic by eliminating all indications of the presence of the object. The picture is an arrangement of geometric signs, which compartmentalises space in a harmony of blue and grey-blue abolishing curves and rigorously restricting the use of diagonals.

Composition n° 6, of 1914 (Gemeentemus., The Hague), also concludes, before Mondrian's return to Holland, the evolution of what has been called by antinomy "abstract cubism".

45 *The New Art — The New Life, The Collected Writings of Piet Mondrian,* London 1987.

Piet Mondrian,
● **Composition n°6,**
1914, oil on canvas,
88x61 cm,
Gemeentemuseum, The Hague.

Picasso surprises and disturbs Kahnweiler

On 15th April, 1914, eight of Braque's works are reproduced in the *Soirées de Paris*, on 5th May, Apollinaire writes in his column of *Paris-Journal*: "The last issue of *Paris-Journal* contains eight reproductions of the pictures of Georges Braque who, with Picasso, is one of the initiators of cubism… It is the first time that a French periodical shows representations of his work…" Braque called by Guillaume "the French innovator", moves to Montmartre, and then goes with Marcelle to Sorgues, Picasso and Eva leave Paris in mid-June for Avignon where the Braques join them with Derain and Alice who then settle nearby in Montfavet. The threat of war does not trouble them yet.

Braque has continued his series of papiers collés with its various elements, imitation wood, wallpaper, different kinds of paper, sometimes enhanced with gouache or pencil, pasted onto paper. Picasso does the same, but always more inventive, brilliant, also more baroque in his *Fruit Dish, Bunch of Grapes, Pipe*, or *Pipe, Glass, Bottle of Bass*, with at times, a fantastic element – one dare not use the word surrealistic – strange, almost visionary constructions, combining materials and techniques…

Contemporary with the *Absinthe Glass*, Picasso makes several constructions in painted wood and various objects [*Still Life (The Snack)*, Tate Gallery, London], in tinplate (*Glass, Dice and Newspaper*, Musée Picasso, Paris). He paints *The Smoker* (Musée Picasso, Paris) all in vertical rectangular planes, *Harlequin Playing the Guitar* (private collection, Basle) probably unfinished….

What is happening? In his *Entretiens* with Francis Crémieux, in 1961, Mr. Kahnweiler relates: "I must tell how in the spring of 1914 already, Picasso had shown me two drawings that were not cubist but classicist drawings, both representing a seated man. He had said to me: 'Really, this is better than before, isn't it?'" The famous dealer was stunned, but he did understand that these "classicist" drawings had not arrived inadvertently in Picasso's work, the figure had already appeared in several of his previous works. The revelation came when the inventory of the painter's production was made after his death with the discovery of *The Painter and his Model* (Musée Picasso, Paris), oil and pencil on canvas, which represents with careful realism, a man drawn, sitting on the left, looking thoughtfully at a beautiful young woman, painted, half-naked, holding a drapery up to her sex (perhaps a portrait of Eva), in front of a landscape, also painted, and than a wall on which hangs a palette. The work is unfinished and has remained unknown for over sixty years. Certainly the space is cubist, but the two figures, in particular the young woman's body, painted with love, are deliberately naturalist, and the combination oil-pencil suggests the multiplicity of materials as used in papiers collés.

There is nothing like it in the still lifes of Avignon. Picasso and Derain amuse themselves making a still life four-handed, with juxtaposed squares. The usual everyday objects appear in the pictures that the

Pablo Picasso,
Glass, Dice and Newspaper,
1914, painted wood,
tin-plate and wire,
18x13.5 cm,

Musée Picasso, Paris.

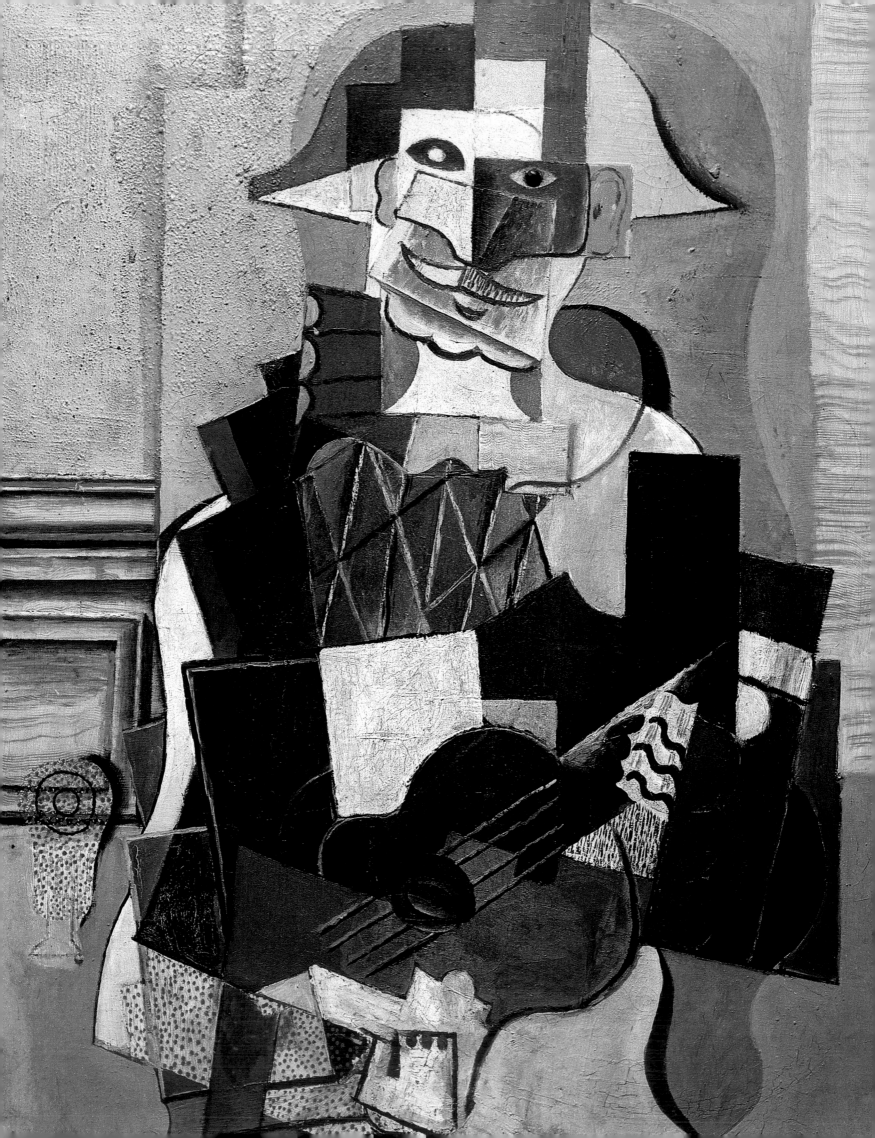

Spaniard multiplies during this period of intense production and friendly relations. The *Portrait of a Young Girl* (Musée National d'Art Moderne, Paris), which belonged to Mme Errazuriz, an art patron who lived in Biarritz in 1918, achieves perfect illusionism. Is it a painting or a papier collé? Is it a real piece of wallpaper on the right, or an imitation? An imitation of imitation marble, imitation fringes of the armchair, mouldings, frame of the fireplace on the left, fruit dish with fruit, model head of the young girl; Picasso is summing up his experience of the previous years, puns, combination of images, visual witticisms, collages, pictures in relief, different techniques, all directed with stunning brilliance. Or else is it the conclusion of a period when the author enjoyed underlining the ambiguity between painting and papier collé, juxtaposed and not integrated, in a brightly coloured joyful atmosphere? The works of the Avignon period have been called "rococo cubism", for their decorative profusion, and their sparkling baroque inventions full of free fantasy.

Picasso also carries out another large canvas with a figure, *The Seated Man with a Glass* (private collection, Madrid), the man's body with a supple volume and a fine contour, is set into a strange whirl of forms and pointillist elements with extraordinary inventiveness. Of the same period, *Playing Cards, Glasses, Bottle of Rum* (Mr. and Mrs. Leigh B. Block Collection, Chicago), also called *"Vive la France"*, which is written on a glass with two little crossed French flags on either side, sums up with the same creativity the decorative fantasy of the preceding still lifes. Left aside at the declaration of war, the painting, oil and sand, will be finished in Paris the following year.

War is declared, mobilisation is immediate. On 2nd August, Picasso takes Braque and Derain to the station in Avignon to join their corps. Meanwhile on 9th December, opens in New York, at Steinglitz's "291" Gallery an important exhibition of works by Picasso, Braque and Duchamp, partly owned by Picabia and his wife Gabrielle, together with a collection of primitive art. Léger is mobilised as a sapper in the Engineers in Argonne. Kahnweiler, a German subject, and a deserter, was in Rome when he heard about the declaration of war; in December he settles in Bern where he will be told about the sequestration of his business. Apollinaire, although he is foreign, enlists and is affected to a regiment of artillery in Nîmes. The Delaunays, who were in Spain, will remain there until 1920. In 1915, Marcel Duchamp, reformed, goes to New York.

"The old life was over", writes Gertrude Stein.

Pablo Picasso,
Harlequin Playing the Guitar,
1914-1918, oil on canvas,
98x77 cm,
private collection.

Pablo Picasso,
The Painter and His Model,
1914, oil and pencil
on canvas, 57.5x55.6 cm,
Musée Picasso, Paris.

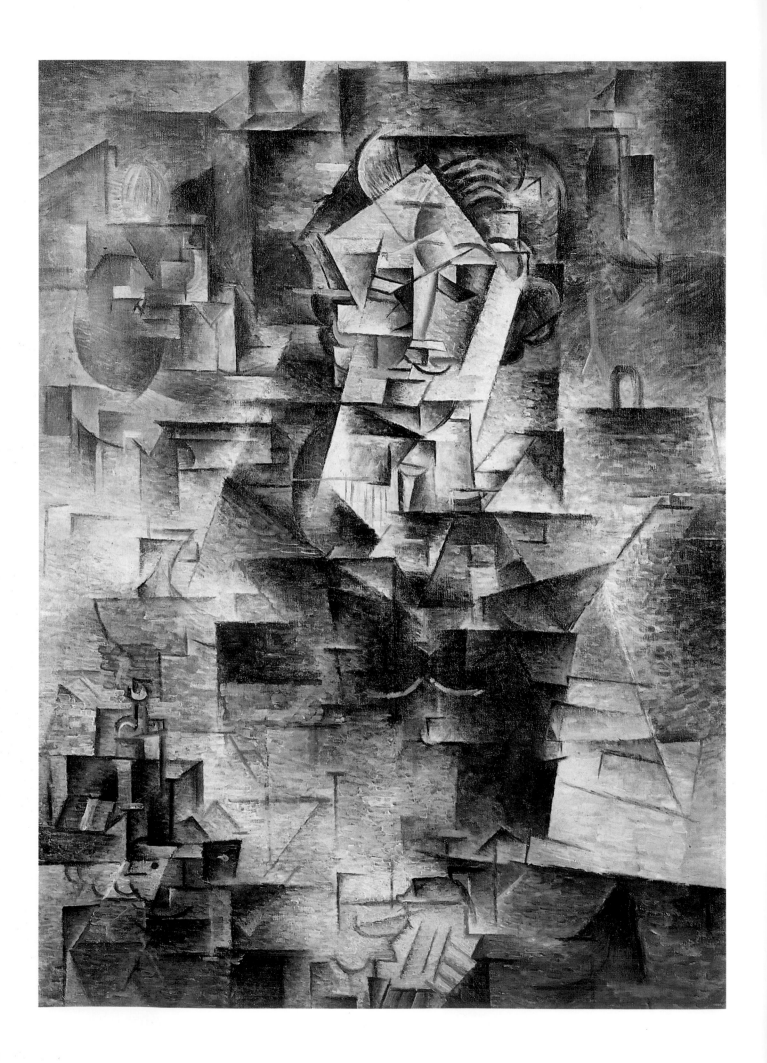

Collectors and dealers of cubist art

Kahnweiler had signed with Picasso, Braque, Léger, Derain and Gris, contracts in which he bought their work and was committed to dealing with its promotion. He was in touch with several art collectors who were interested, the Americans Gertrude and Leo Stein, the Russian Stchoukine, the Swiss Hermann Rupf, the Czech (Austrian at the time) Vincenc Kremar. In France one of the first to become involved in the "new painting" is an industrial from the North, Roger Dutilleul who started going to the gallery of the rue Vignon when it opened. He greatly admired Cézanne, from his interest in the Aix master who was too expensive for him he acquired a wonderful collection of Braque and Picasso's first cubist pictures. Continued by his nephew Jean Masurel and his wife, the collection is today in the Musée d'Art Moderne du Nord at Villeneuve-d'Ascq.

Among the first in France to be interested in cubism, is the poet and critic Alexandre Mercereau, friend with Gleizes (who paints his portrait in 1908), Léger, Metzinger, Delaunay, and whose main contribution was to introduce cubism into Russia, in particular in the exhibitions of the "Knave of Diamonds" group in 1910 and 1911, and then in Budapest and Prague. The financier André Level who founded as early as 1904 the association "La Peau de l'Ours", is also, together with his brother Emile, to be included in the early collectors of cubism.

Wilhelm Uhde, of German origin, who had been living in Paris since 1904, bought his first Picasso in 1907 for ten francs, *The Tub* or *the Blue Room*, today in the Phillips Collection in Washington, from the old Soulié, a mattress maker who sold various second-hand objects. In the Indépendants of the same year he buys five out of six of Braque's works on show, and he is one of the first people to see *Les Demoiselles d'Avignon* invited by Picasso. In 1910, the latter paints his cubist portrait. Uhde continues to buy pictures from him until 1914 when he had to return to Germany. His collection, like Kahnweiler's, will be sequestrated and later sold by auction. When he returns to Paris in 1921, he does not understand the "classicist" evolution in Picasso's work and turns towards the naive painters.

Justin K. Thannhauser is the first foreign art dealer to be interested in cubism. In 1909 he sets up his gallery in Munich which he calls two years later the "Moderne Galerie", and becomes the correspondent in Germany of his compatriot Kahnweiler; Braque and Picasso exhibit there in 1911, and the latter participates in the twenty-second Secession of Berlin. The cubists, initiators and followers, will take part in several exhibitions in Germany, which will nevertheless cause some confusion: at the Berliner Secession in 1910 and 1912, at the Neue Kunstlervereinigung of Munich, the Sonderbund or "German Autumn Salon". Herwarth Walden's gallery, "Der Sturm", in Berlin, will play an essential part in their diffusion in Germany, its name is taken up by an artistic movement and an art review which will last until 1914.

Pablo Picasso,
Portrait of Daniel-Henry Kahnweiler,
1910, oil on canvas, 101x73 cm,
Art Institute of Chicago.

Pablo Picasso,
Portrait of Wilhelm Uhde,
1910, oil on canvas 81x60 cm,
Joseph Pulitzer Collection, Saint Louis.

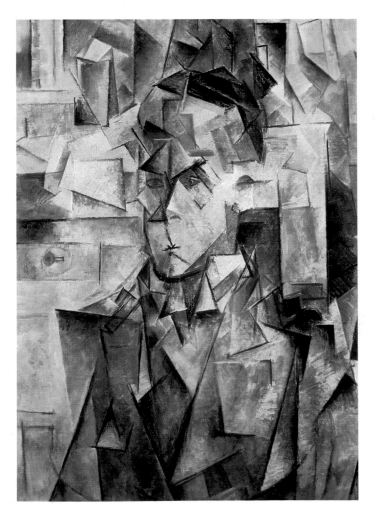

3

Cubism
outside
France

In Germany Klee translates Delaunay

Thanks to Mr. Kahnweiler's social relations, cubism is established from the very beginning outside France, in Germany with the dealer Thannhauser, in Switzerland with the collector Hermann Rupf: it is the first cubist circle around the central core of la rue Vignon.

In 1911, Delaunay is invited by Kandinsky to show his work in the first "Blaue Reiter" event in Munich; two years later the "heresiarch of cubism" exhibits about twenty of his pictures in Berlin at the "Der Sturm" gallery, and Apollinaire gives in his presence a conference published in German in the review of the same name; three hundred and twenty copies will be printed on the painter's initiative, under the title "La Peinture Moderne".

Among the cubists, Delaunay is the one who is most in regular contact with German artists. In Berlin he makes friends with Franz Marc and Auguste Macke whom he has to stay in Paris, and Klee on whom he has a strong influence. It is thanks to him that Marc gives up geometrization and turns to simultaneous abstract rhythms close to Orphism. With Macke, coloured volumes are organised in depth according to an architecture in which the represented object disappears into abstract colour.

Klee translates Delaunay's text "On Light", published in *Der Sturm* in 1913; in his review of the "Moderner Bund" exhibition in Zurich, he shows how well he understood Delaunay's intentions in the *Windows* series. Thanks to the latter he frees himself from the conflicts between constructive forms and the imitation of nature, taking as sole object the synchronised action of colours; he opposes this to cubism which he criticises for bringing about "destruction for the love of construction". For him, Delaunay had solved the problem "in an extraordinarily simple way, by creating a type of self-sufficient picture which, as it does not take anything from nature, possesses on the level of form an entirely abstract existence…" A fundamental text because through the criticism of cubism of which it condemns the immobility, it underlines the principle of an autonomous art based on movement, containing in itself its own finality.

Delaunay's influence is apparent in the works painted during his stay in Tunisia in April 1914 in which Klee asserts the supremacy of colour; but the architecture of the little Arab houses bring him back to cubism. And, as if he wanted to be forgiven for his deviationism, he paints a *Homage to Picasso*, which is made up of several brown and grey squares and rectangles enclosed in an oval.

Prague: Kramar collector and pioneer

Cubism is introduced in Prague by the art theoretician and collector Vincenc Kramar. Brought up on occidental culture, he became interested very early in new artistic movements thanks to the exhibitions organised in the first years of the century by the Manès Society which presented works by Cézanne, Gauguin and Rodin.

Kramar comes to Paris for the first time in the autumn of 1910 and meets Kahnweiler who greatly appreciates the art historian, specialist in

Bohemian Gothic art as well as fascinated by the avant-garde; his scientific approach to art is shared by the young dealer. The first Picasso he buys, on 22nd May, 1911, is a gouache *Harlequin* of 1909, sold to the benefit of a monument to be raised in honour of Cézanne. Then he buys from Vollard, on 26th May, one of the bronze casts of the Head of Fernande, the first cubist sculpture, and on the 31st, according to Mr. Kahnweiler's account books, three Picassos, one *Bust of a Woman* from the beginning of 1908 with a rigorous stylisation of volumes, a small gouache of a *Seated Nude Woman* and the *Port of Cadaquès* painted in the summer of 1910. His choice confirms the opinion Kahnweiler had made on their first meeting with regards to Kramar's lucidity and perspicacity. From now onwards, whenever Picasso brings him new works, the dealer sends a telegram to the collector who instantly arrives from Prague; he also buys some Braques and some Derains. Until his death in 1961, Kramar kept a precious relic, a shrivelled, dried up apple, wrapped up in tissue paper, that Picasso had given him after he had used it in a still life. Kramar's collection also contains many works by Czech cubists that he left to the Narodni Gallery, the museum of modern art in Prague.

The czech school interprets cubism

It is indeed a proper cubist school, satellite of the Paris movement, that is constituted in Bohemia, started by the group of Eight (Osma); its two exhibitions in 1907 and 1908, the first events of contemporary art in the country, give rise to the same hostility as in France, with the exception of Max Brod, all the critics are furiously antagonistic. In 1911, a violent polemic opposes the young representatives of "new painting" to the conservative elements of the Manès Society, they decide to quit and set up in Prague the Group of Plastic Art, Skupine Vytvarnych Umelcu, which will publish its own review and organise several exhibitions in Bohemia and abroad. Picasso, Braque, Derain, Gris, Munch, Kirchner, Heckel, etc., are represented.

The young painters, who feel close to the Eastern European spiritual life, are nevertheless attracted by the new ideas of the West; they travel a lot. Kubin and Feigl, who went to the art academy of Antwerp, stay in Paris in 1904 and 1905, where their fellow countryman Kupka introduces them to his neighbour Villon and his group of friends. In 1906, Feigl, together with Filla and Prochazka, sets out on a long journey which will take them to Germany, Holland and then to Paris; they make contact with many people, in 1907 Filla is back in Paris where Benés joins him. In 1910, the Capek brothers also go there and find Kubista whose surname delights Apollinaire. Kramar meets several of the painters and takes them to the rue Vignon; thanks to him they will return to their country well informed of the evolution of Picasso and cubism; they will become "cubisters" rather than creators.

Kubista and Filla are among the first to draw their inspiration from the examples of Braque and Picasso; with Kubista, geometrical decomposition is based on autonomous plane-surfaces, very accentuated in light and

shade (*Quarry at Branik*, 1911) whereas Filla who goes through all the evolutionary stages of cubism, will reach a kind of rigidity in the schematism with which he divides into facets *The Autumn*, of 1910. Prochazca makes use of cubist research on structure, which inspires his *Still Life on a Table*. Bénés tries to introduce a rather awkward lyricism (*Suzanne in the Bath*, 1911). For these painters, the interpretation of cubism is restricted to the fragmentation and the geometrization of space, they do not analyse or go deeper into its problematics.

Otto Gutfreund is one of the great sculptors of cubism; formed in Paris by Bourdelle and gothic art that he discovered in the Musée des Moulages of the Trocadéro in Paris in 1911, he applies his strong personality to internal three-dimensional decomposition. One of his most powerful works, *Anguish* of 1911, is characterised by the crystallisation of plastic volumes through opposite angular planes, projections and hollows, emanating from the interior of the form. The experimentation of form gives way to expression in the head of *Vicky* (1912-1913) in which the elements are interwoven, undulated and swirled like flames. In the *Cubist Bust* of 1912-1913, Gutfreund uses crossed planes with vertical structures, sometimes acting against one another, and possessing a powerful plastic intensity, related to Picasso's constructions that he has not seen.

Although he is enlisted in the French army, he is interned as an enemy subject; nevertheless he continues working on assemblages as is testified by his *Seated Woman*, in wood, of 1917.

Cubism will be continued in architecture and the decorative arts. As early as 1911, several architects, members of the group of the Plasticians decided to apply in their own field the relationship between volume and space using the planes in facets of analytical cubism. Most of them studied under Otto Wagner from Vienna and his Czech disciple Jan Kotera and had been taught the rationalist principles in which form and décor were subordinate to function, but these they reject and they proclaim the superiority of art over function. The influence of Gutfreund and "cubisted" planes within a three-dimensional volume, is analysed in the theoretical reflections of the aesthetician Theodor Lipps and the art historian Vaclav Stech.

Pavel Janak is the dominating character of the group. In 1912 he founded the artistic Ateliers of Prague, among the group of architects he was the one who was most concerned with the problems of cubism, but his work prior to 1914 never left the stage of plans or projects. He created pieces of furniture which give the impression of being foldable, ceramics and everyday objects. The sofa designed by Josef Gocar in 1914 is a tour de force in cabinetwork.

Josef Chochol designed in 1913 the block of flats in the Neklalova street in Prague, one of the most original realisations of cubist architecture; it seems to be sculpted from the block in facets, carved like a diamond, the way the angle is treated, cut out by the superposed balconies, recalls the undulatory movements of Gutfreund's sculptures. But as in the other

Bohumil Kubista,
● **Quarry at Branik,**
1911, oil on canvas,
Narodni Gallery, Prague

Otto Gutfreund,
Cubist Bust,
1912-1913, bronze,
height 60 cm,
Narodni Gallery, Prague.

Otto Gutfreund,
Anguish,
1911, height 148 cm,
Narodni Gallery, Prague.

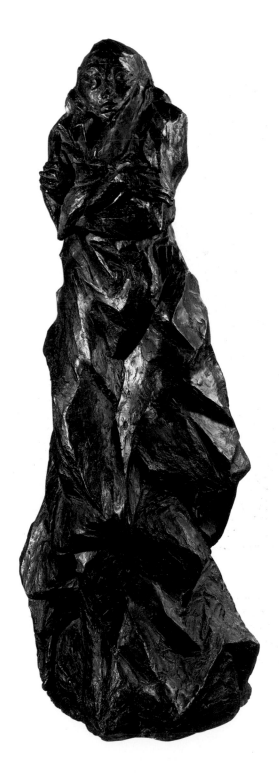

contemporary buildings the cubist elements are only ornamental or consisting of sculptural work on the facade, they do not affect either the plan or the typology.

The russian cubo-futurists

Cubism developed in Russia relatively late, at the end of 1912 and in 1913, but it had a great influence there. Without the examples of Picasso and Braque whose *Nude* of 1907 was shown two years later at the Golden Fleece exhibition in Moscow with three other works of Cézannian geometrization, the evolution of Malevitch and Tatlin would not have been the same. In 1912, Alexandra Ekster brings to Moscow some photographs of cubist works given to her by Burliuk, the author of an essay entitled "Cubism", published in the collection *La Gifle au Goût Public*. Nadezhda Udaltsova, future wife of Malevitch, and Liubov Popova who had worked in Paris with Le Fauconnier and Metzinger, act as go-betweens, as does the poet and critic Alexandre Marcereau who was actively involved in spreading new French painting in Russia.

Paradoxically, the Russian artists read about cubism in Gleizes and Metzinger's theoretical work long before, with one or two exceptions, they had seen the pictures. Yet in 1908, the collector from Moscow, Stchoukine already owned several pictures by Picasso, including *The Woman with a Fan*, one of the most characteristic of the "Negro" period, bought that year, and *The Seated Nude Woman*, of primitivist geometrization, and in 1913 he started opening his private house every Saturday to the public who, often sceptical or horrified, had the opportunity of seeing these paintings. Therefore it is rather surprising that the Russian artists had not seen the Picassos of their enterprising compatriot especially as his acquisitions had caused quite a stir at the time in the circles of Moscow, and that the authors who write about cubism after 1913 still refer to Gleizes and Metzinger's theories rather than to the works themselves: is it because the primitivism of Stchoukine's Picassos disturbs them? On the whole, these texts are as abstruse as their model, like the *Principles of Cubism and Other Contemporary Currents…* published by the artist and theorist Alexander Sevcenko, in Moscow, in 1913, or Nicolas Kublin's essay printed in *The Archer* in Saint-Petersburg, the same year. Confusion settles in, further aggravated by the activism of a small group of avant-garde poets and artists, led by Burliuk, the cubo-futurists who combine cubist, primitivist and futurist inspiration.

Pablo Picasso,
Composition with Skull,
1907, oil on canvas, 115x88 cm,
Hermitage Museum, Saint Petersburg.

Pablo Picasso,
The Woman with a Fan,
1908, oil on canvas,
152x101 cm,
Hermitage Museum, Saint Petersburg.

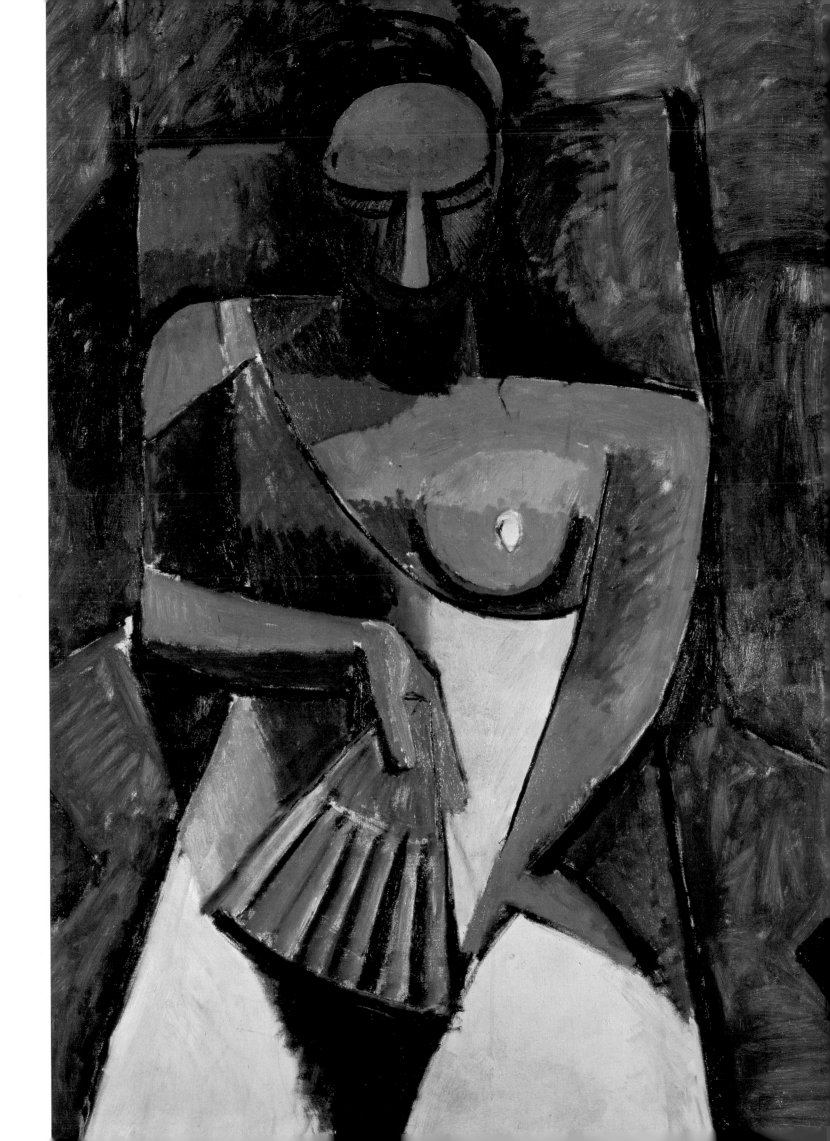

The temptations of Malevitch

The two exhibitions of the Knave of Diamonds, in 1911, and Léger and Delaunay's growing popularity, the futurist exhibition in Paris, the Salon de la Section d'Or in which Alexandra Exter participates with six works, and the philosophical and spiritualistic interpretations – or so-called – of cubism as seen by Gleizes and Metzinger, all these events combine to produce a growing interest in the two movements. In the 1912 exhibition of the Knave of Diamonds, Léger's *Three Women* exert a great fascination over the artists of Moscow; its influence will be particularly noticeable on Malevitch and a few other painters such as Klioun and Baranoff-Rossine.

Larionov and Natalia Gontcharova, who had come to cubism through futurism, still use in their work inspiration from the popular art of their country. "Russian art, they say, has always renewed itself through its oriental inheritance against the vulgarising influence of the West." In a manifesto published in 1913, in The *Donkey's Tail* and *The Target*, Larionov claims the invention of Rayonism, one of the first forms of abstract expression in which he denounces what he calls, rightly or wrongly, Picasso's realistic cubism. At the same time, Malevitch begins his investigation of analytical cubism from which he borrows directly. *Samovar* (private collection) presents a crystallisation of structure with Cézannian "passages", which differs from the French works in its rectilinear aspect. If the *Knife-grinder* (Yale University Art Gallery, New Haven) is nearer to the futurists' works – Malevitch calls himself cubo-futurist, and will exhibit under this label at the Indépendants of 1914 – its "pulverisation", to use his own words, will remain unique in his work. With his *Head of a Peasant Girl* (1912-1913, Stedelijk Museum, Amsterdam) seen from several monochrome angles that break up into sharp facets, he adopts synthetic cubism according to a method described in his book *From Cubism and Futurism to Suprematism*. Neither the head nor the face is discernible, and this irregular polyhedron comes as a surprise considering that there are so many experiments to the contrary to attract Malevitch. With the *Portrait of Ivan Klioun* (1912-1913, Russian Museum, Saint Petersburg) contemporary with Larionov's *Manifesto on Rayonism*, shown at "The Target" exhibition in the spring of 1913, Malevitch creates a rebus assemblage of geometrical planes with very few realistic allusions in which the play of shades and gradations is quite different from the clear opposition of colours in *The Woodcutter* (Stedelijk Mus., Amsterdam) of the same period, or the *Portrait of Matiouchine* (or Matjucin) in which the interwoven and juxtaposed structures remain well-balanced in spite of the accumulation of planes. In collage, with its element of reality, Malevitch produces the *Soldier of the First Division* (1914, Museum of Modern Art, New York), after *Partial Eclipse with Mona Lisa* (1914, Russian Museum, Saint Petersburg) related in its humour to *An Englishman in Moscow* (Stedelijk Mus., Amsterdam) the most characteristic of Malevitch's alogical works: refusal of perspective, frontality, fragmentation of the object, introduction of letters....

Kasimir Malevitch,
An Englishman in Moscow, •
1914, oil on canvas,
88x57 cm

Stedelijk Museum, Amsterdam

Kasimir Malevitch,
Lady in a Tramway,
1913, oil on canvas,
88x88 cm,
Stedelijk Museum, Amsterdam.

Malevitch is going through the same questioning as the other young Russian artists and so many writers and poets; some, such as the Rayonists, may be opposed to "the vulgarising influence of the West", or proclaim, like Khlebnikov that "Russia is not an artistic province of France", but Malevitch is not alone in no wanting to turn down everything that comes from Europe while at the same time he retains the inspiration from his own origins. It is from this combination that he intends to create universal art.

His oscillations between futurism and cubism are not moving in opposite but in complementary directions, Malevitch takes what he can where he thinks he can make progress in his own style in the midst of the general effervescence. He can sense but is not yet quite sure of the fact that from cubism and futurism, perhaps even from Léger's "tubism" which influenced him in the past, and Larionov's Rayonism, a tremendous mutation is about to take place. A new world, expression of a new form of art, will be born, and although the written work which tries to express it is often obscure, its concept is luminous.

From cubism is born suprematism

During the summer of 1913, Malevitch has made the scenery and the costumes of a cubo-futurist opera, written by the painter and composer Matiouchine and the poet Kroutchenykh, *Victory over the Sun*, which will be performed in December in Saint Petersburg. In two acts and six scenes, it symbolises victory over the old aestheticism, a "vast lyrical bragging in which the action is not easy to grasp either as a whole or in detail", writes Serge Fauchereau. In addition to the scenery and the costumes in a style of radical geometrical simplification, Malevitch stages the opera; in it the famous "black square" is introduced for the first time under the appearance of "Gravedigger Mr. Black Square" whose body is in the shape of a square. The image acts as a revelation; during the following months, Malevitch goes back and forth between cubism and futurism; his oscillations materialise at the end of 1913 in the exhibition of the Youth Union, in two groups of pictures, one dating from 1912, with metallic forms called "trans-mental realism", the other from 1913, called "cubo-futurist realism".

In January 1914, Malevitch sends three cubo-futurist works, including the *Portrait of Matiouchine*, to the fourth exhibition of the "Knave of Diamonds".

He also presents several cubo-futurist paintings, *The Aviator, Lady in a Tramway, An Englishman in Moscow*, in the first futurist exhibition, Tramway V, organized in Saint Petersburg in the spring of 1915, but, unexpectedly, he sends non-objective works to the second futurist event called O.10, in December. Although these paintings have been called "suprematist" the word is not in the manifesto published by Malevitch on this occasion. It appears for the first time in the press reviews, which would imply that he had probably used it in conferences or debates. A year later, in 1916, he publishes his cult book, *From Cubism and Futurism to Suprematism*.

Cubism and abstraction in the United States

In 1910, in *The Architectural Record*, the journalist Gelett Burgess reproduces for the first time, together with a series of articles on French painters, Braque, Picasso, Matisse, Derain, etc., *Les Demoiselles d'Avignon* (called *Study by Picasso*), the *Three Women* and the *Seated Woman* of the spring of 1908. The following year, Marius de Zayas sets up in the "291" Gallery in New York, the first exhibition of the painter's cubist drawings; two years later, he opens the Modern Gallery and shows works by Picasso, Braque and Picabia.

At the time, in spite of a few modernist groups, America is caught up in the most reactionary academicism. The Association of American Painters, which took over from The Eight and the Ashean School, tries to impose a typically American style based on themes of everyday life, and only an isolated group of Europeanised artists some of whom had stayed in Paris, John Marin, Alfred Maurer, Marsden Hartley, Schomberg or Halpert, aspire to take up the challenge of the European avant-garde. The Armoury Show in 1913 is decisive for the future of art in the United States because it confronts the young artists with the choice between the new vision and forms brought over by the European participation, and academicism. Several of them like Joseph Stella, Marsden Hartley or Stuart Davis, are ready to transform their art completely, combining the lessons of cubism with abstract vision.

Joseph Stella at first influenced by the futurists, in particular Severini, later adopts the geometrization of form and the expression of industrial life inspired by the "precisionists". In 1919, he turns Brooklyn Bridge into the archetype of his experiments on the renewal of cubist construction and makes it progressively more and more abstract.

John Marin, admirer and imitator of Whistler, after six years spent in Europe, when he returned to New York discovered at Stieglitz's Cézanne's watercolours which he had not really noticed in Paris and Picasso's cubist drawings. He radically changes his style, drawing his angular and oblique "lines of force" from futurism, and his spatial density, in particular in his watercolours, from analytical cubism.

Marsden Hartley, at first inspired by expressionism, evolves towards abstraction with clearly cut out planes and pastel colours (*Movement N° 2*, 1916, Wadsworth Atheneum, Hartford) which he then gives up to return to nature.

The Chinese Restaurant (1915, Whitney Museum, New York) by Max Weber, evokes Picasso's paper cut-outs in a maelstrom of colourful forms in which the urban dynamism appears via a number of realistic details.

Man Ray was also under the impact of the Armoury Show; in the same year of 1913, he discovers cubism at Stieglitz's and starts organising space from the geometrization of very colourful forms, then figures of which he renders the movement (*AD-MCMXIV*, 1914, Philadelphia Museum). The schematic and heavy volumes of *The Rug* (1914) or *The Black Widow* (1916), painted in stylised flats, disorientate the few people who appreciate his work. The series of *Revolving Doors* (1916-1917),

Max Weber,
The Chinese Restaurant,
1915, 101.5x122 cm,
Whitney Museum, New York.

EiAi ITR

Man Ray,
Revolving Doors III Orchestra,
1916-1914, collage.

collages with simple torn forms reduced to the three primary colours, red, blue and yellow, marks the limit of the experimentation that he calls "romantico-expressionist-cubism", a few assemblage-sculptures will follow (*New York*, 1917). The revelation of photography from stereotype plates then from photograms and airbrush, and meeting Duchamp will change his life.

One english cubist

Cubism is never really implanted in Great Britain; the only avant-garde movement which develops there, in 1914, Vorticism (from vortex), publishes a manifesto which tries to distinguish itself from futurism and cubism but it is unable to produce a spirit or a style of its own, or any original works. Among its adepts is David Bomberg, the only English painter that can be called cubist. In 1913, he is in Paris, he meets Picasso with whom he makes friends, Derain, Braque, etc.; he applies to his figures a very colourful geometrization, criss-crossing the surface, and gives them, with these schematic frontal decoupages, a singular aspect (*The Mud Bath*, 1914, The Tate Gallery, London). In fact, Bomberg only takes from cubism the decomposition of the surface, the reduced arrangement of forms and the limited number of colours. After 1914, he abandons his experimentation and returns to figuration. A short cubist resurgence, influenced by Braque and Picasso, appears around 1920, in Ben Nicholson's stylised monochrome still lifes.

Man Ray,
New York,
1917, assemblage,
private collection, Paris.

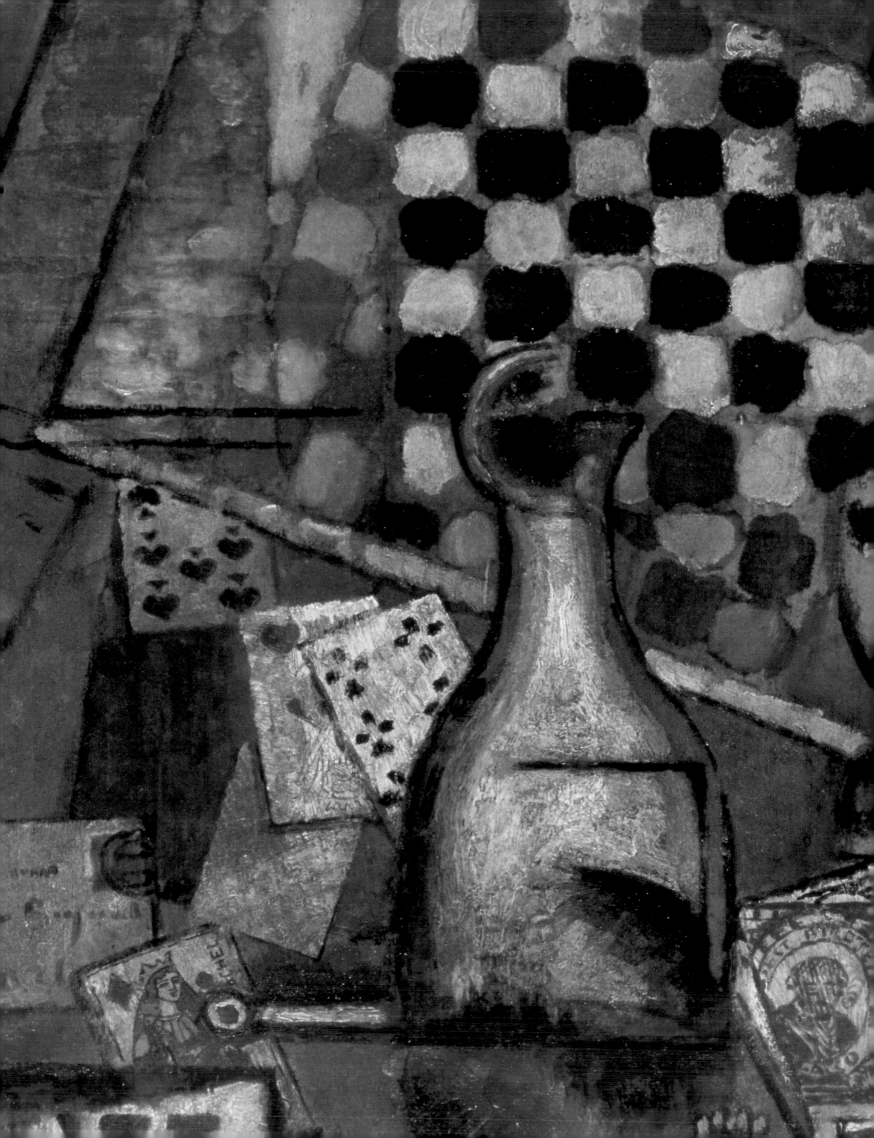

4 After cubism

Is there a "literary cubism"?

Apollinaire, in "Les Cubistes et les Poètes", published in the *Mercure de France* dated 16th September, 1912 writes that "Delaunay, Gleizes, Le Fauconnier, Metzinger, Léger, etc., in other words most cubist painters, live in the company of poets. As for Picasso… he has lived only among poets of whom I am honoured to be …"

Guillaume, according to a method that he favours, is generalising rather quickly; there are not many poets around the painters before 1914. However, in *L'Effort Libre* of April 1911, the writer and painter Gaston Thiesson, in an article called "Le Salon des Indépendants et la Critique", attacks the "poets' criticism" expression invented by Salmon to distinguish artistic or temperamental criticism from the dogmatic and scholarly, professional criticism of art historians or academics. Gaston Thiesson is mainly attacking Apollinaire who reacts in *Paris-Journal* "The poets' criticism did not exist when Gauguin was living in great poverty in Tahiti, and Van Gogh, unknown to anybody, was painting his passionate pictures. Today the poets have left neither Matisse nor Picasso in the shade…"

Guillaume does not possess a great artistic culture, a fact that was often held against him, but he perceives, senses, feels painting rather than understands it or analyses it, and he is stimulated by novelty. He becomes attached to the painters, with his prolix, worried, expansive and passionate nature. The poets' criticism is not dogmatic, it is searching for illumination and keeps up a conviviality of inspiration with the painters. The poet does not pull their work to pieces, he enriches its resonance by accompanying it with a poetic reflection; he does not retain its provocative aspect, on the contrary, it is in the name of tradition, of "antique harmony" and Ingres' drawings, that he becomes the apologist of cubism when the adversaries of modernity only see in it a short-lived adventure. In *La Tête d'Obsidienne*, Malraux quotes Picasso: "Apollinaire, he didn't know anything about painting, yet he loved real painting. The poets often guess. In the days of the Bateau-Lavoir, the poets used to guess…" The relationship between cubism and literature gave rise to much questioning, if not exegeses. Georges Polti in the review *Les Horizons* of 15th February, 1912 conceives the idea of a "literary cubism". The expression is written for the first time; it will be pronounced by Paul Dermée in a conference on Max Jacob at the end of 1916, then widely used after 1920 by various gossip columnists.

Apollinaire, Cendrars, and simultaneity

In 1917 a new character came to join the group of poets who were contemporary with the beginning of cubism, Pierre Reverdy. He arrived in Paris from Narbonne at the age of twenty-one, and settled in Montmartre opposite the Bateau-Lavoir where he will live later on; he soon meets Picasso, Braque, Juan Gris, Henri Laurens, Max Jacob, Apollinaire. "We are living, he writes, the last years of the antediluvian era…"

Manuel Ortiz de Zarate,
Moïse Kisling, Max jacob,
Pablo Picasso and Paquerette
in front of La Rotonde,
photographed by Jean Cocteau
on 16th August, 1916

Pablo Picasso and Moïse
Kisling in Montparnasse,
photographed by Jean Cocteau
on 16th August, 1916.

In the middle of the war, reformed, he founds the periodical *Nord-Sud* which, with Ozenfant's *L'Élan* (1915-1916) and Pierre Albert-Birot's *Sic*, will be among the rare avant-garde publications of the time after the disappearance of *Soirées de Paris*. *Nord-Sud* will be the link between the generation of Apollinaire and Max Jacob and the generation of Breton, Aragon and Tzara. In the very first issue Reverdy sets the tone by publishing a front-page article, "On Cubism".

He differs from Apollinaire in that, instead of pouring out long panegyrics interspersed with shock formulas, he analyses with rigour cubism's contribution to the art of the period, its origins, motivations, and efforts. For him it is not only a style of painting, a demanding and conquering language, but also a form of morals. He writes: "Cubism is true painting just as much as the poetry of today is the one that is true poetry…." That is all the chroniclers and critics need to qualify the review as "cubist", to which Reverdy objects, even though with his "plastic poetry" as he called it, his words, his images and his thoughts, by a sort of occult decision of destiny, were always accompanying cubist painting, in particular that of Braque and Picasso.

The analogies between the poems of Apollinaire, Max Jacob or Salmon and cubism are not only due to the fact that they are contemporary; the

Manuel Ortiz de Zarate
gives alms to Max Jacob
in front of the church
Notre-Dame-des-Champs.
Photograph by Jean Cocteau
on 16th August, 1916.

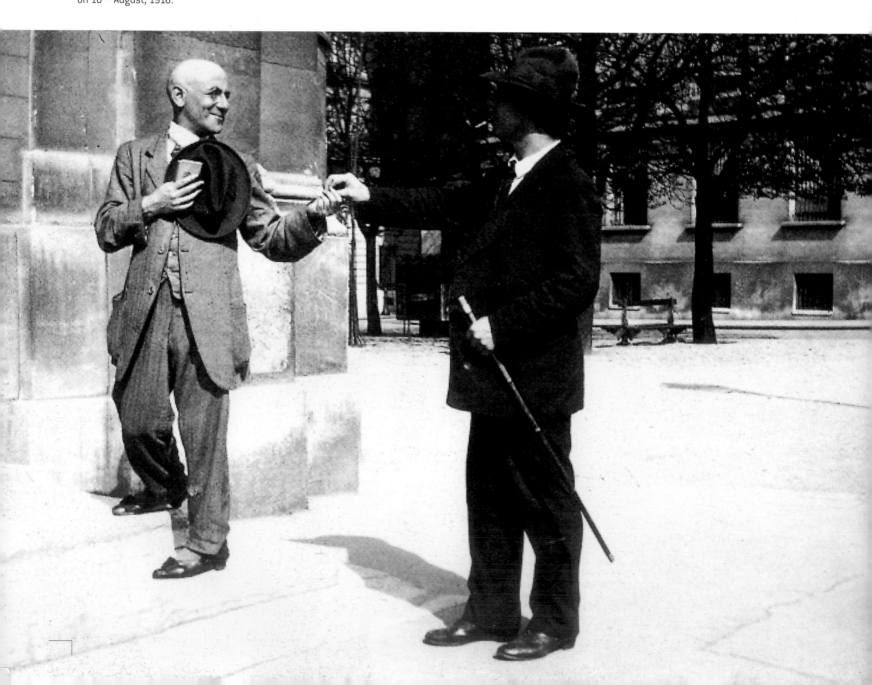

boldness of the images, typographical inventions, the lack of punctuation, loose words, partake, like the painters' experimentation, in the "new spirit" of which surprise is the main impulse. But for Reverdy, there is no reciprocal stimulation between the plastic arts and poetry which according to him followed its own evolution. Painting is reflection, meditation. Poetry is immediacy with adherence.

In 1913, Cendrars publishes *La Prose du Transsibérien et de la Petite Jeanne de France*, the cover in simultaneous colours is made by Sonia Delaunay, and marked "First simultaneous book". The notion of simultaneity had been preoccupying the artists for a long time, and Apollinaire in the *Soirées de Paris* dated 15th June, 1914, in an article called "Simultanéisme-Librettisme", writes that from 1907, Picasso and Braque "endeavoured to represent figures and objects from several angles at the same time". He is deeply moved by the new tone, the unpolished, bright and vibrant images of Cendrars. It inspires him "Lundi rue Christine", called "conversation poem" – Cendrars had published in *Paris-Midi* "telegram-poems"; the application of pictorial Simultaneism to poetry creates a cacophony rather like walking into a crowded café

From left to right: Amedeo Modigliani, Pablo Picasso and André Salmon in front of the Métro station Vavin, photographed by Jean Cocteau on 16th August, 1916.

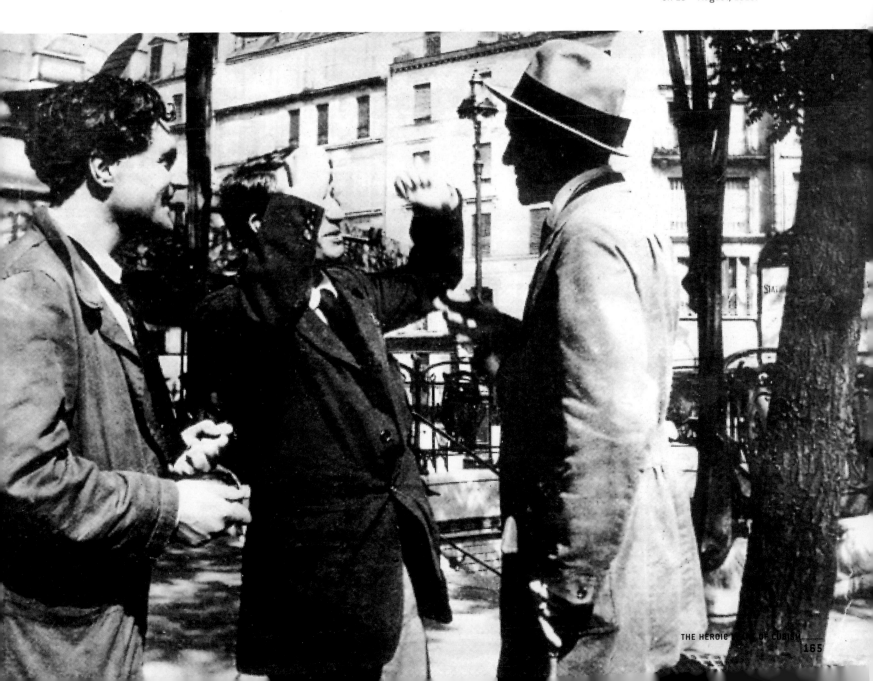

and being caught all of a sudden by the noise, the shouts, the laughter, the violent colours, the accumulation of faces, gestures, words and sounds…

The "literature-cubism" of Gertrude Stein

Alfred Stieglitz published in August 1912, on the occasion of the first Matisse and Picasso exhibitions in his "291" Gallery, Gertrude Stein's first texts on painting, "*Portraits*", immediately condemned by the establishment judging that it was "nonsense devoid of literary value". Some authors, outraged, wanted to put an end to their collaboration with the brave art dealer.

The following year, in 1913, during the Armoury Show, the avant-garde journalist Mabel Dodge, considering that Miss Stein's modernity in literature was related to that of the French painters on show – Leo and Gertrude had lent three Matisses – wrote that "Stein could do with words what Picasso did with paint". An opinion shared by most of the critics: for them both Gertrude Stein's literature and Picasso's painting were stupid and incomprehensible. Even Matisse with *The Blue Nude* was not spared…

Miss Stein's admiration for Picasso could only be reinforced by these attacks which, in her opinion, confirmed the correspondences that existed between them; she admired him and said: "Picasso is the one". Together with Leo, she had taken Matisse, curious but suspicious, to the Bateau-Lavoir, and while the Spaniard was painting her large portrait in 1907, she wrote down in her notebook: "Picasso and Matisse both have a maleness that belongs to genius. Me too perhaps…"

The analogies between the writer and the painter are obvious in the decomposition of images, the juxtaposition of planes, and the syntactic combinations and dissonance, the repetition of words comparable to the multiplicity of points of view, as well as in their search for a certain form of hermetism. Can this be called literary cubism? "G. Stein and the cubists converge because they are aware of their materials in the same way as she is of hers, writes Claude Grimal in his study *Stein cubiste intégrale*. They consider the pictorial sign inside their pictures; she considers the structures of language inside her poems. They are subtle, so is she, and if they let signs and structures become visible, they immediately confuse them again."

Gertrude Stein's writing expresses total freedom, it does not call for readability or exegesis; without self-indulgence it does not seek enlightening explanations. Miss Stein said she had learnt from Picasso that the habit of seeing and feeling objects prevented one from seeing them and feeling them in depth, and that one had to deform them in order to apprehend their reality and their totality. When she speaks of "continuous present" and "prolonged present", she is referring to cubist painting and to the notion of time-space at least as much as to the writers of her time who were conscious of these problems, such as Joyce or Proust, or to the cinema.

Gertrude Stein

Words with Gertrude Stein do not present themselves to her according to a well-ordered syntactic system following a given mechanism but as an apparently disordered means, an instrument of knowledge with subtle detours to attain truth, discover other people's and reveal its essence. Words for her contained an intimate savour; that is why she used repetitions, not boring ones, but lively, bright ones, sometimes humorous, often ambiguous, she multiplied them in facets like in a cubist picture.

Miss Stein also played with the association of ideas, with little concern for where they started and where they ended, unworried about connections; these singularities and novelties make her a writer out of the ordinary. America only appreciated her work much later on. "Words come from very far away and even more sublime and revelatory at last...", wrote Max Jacob to her when he read her *Portraits*. "This is the real literature-cubism..."

Originality and continuity of cubist poetry

Literary cubism becomes topical again towards the end of 1917 and beginning of 1918, with a relatively dull book full of vague approximations by the journalist Frédéric Lefèvre, *La Jeune Poésie Française* which gives rise to the reactions of Reverdy contemptuous, of Pierre Albert-Birot who mocks "such total incomprehension", of Jean Paulhan, unconvinced by "literary cubism", and of André Malraux.

The latter publishes in the first issue of *La Connaissance*, in January 1920, an article called "Des origines de la poésie cubiste", he situates the origins in Rimbaud and Mallarmé and considers Apollinaire, his friend Max Jacob, Reverdy whose "surgical simplicity" he admires, and Cendrars, as poets "who have abolished the aesthetics that were searching for beauty in life, and written creative works full of original sensations...." He does not commit himself too much.

Drieu La Rochelle takes a firmer stand. He publishes in *L'Europe Nouvelle* dated 13th January, 1920 an article in which he considers that if labels do not mean much, cubist literature prolongs symbolism and goes further by abolishing the subject and giving way to the subconscious; thus it results in an opposite method to that of symbolism. "The substance of their poetic language lies in the network of association of images, of ideas, which emerges step by step from the unknown."

Drieu La Rochelle finally imagines a chain of poets who, starting with Rimbaud, Lautréamont, Mallarmé and Apollinaire, leads on the one hand to Max Jacob, Cendrars and Cocteau, via Reverdy, the great solitary, and on the other hand to the "young troop", Breton, Aragon, Soupault; thus cubist poetry is contained in a movement in which it finds originality and continuity.

Realistic portrait of Max Jacob

Picasso comes back from Avignon in November 1914 with Eva whose health has not improved, and returns to work. Most of his friends are on the front or abroad like Kahnweiler. His return to nature which had surprised the latter when Pablo had shown him in the spring *The Painter and His Model* and probably a few other drawings in the same vein, precedes or accompanies a series of still lifes of which the cubism has been described as "cold", repetitive and lacking in plastic inventiveness. Some of them are simply drawn. The discontinuity in the inspiration of the painter, his first "classicist" drawings and the very naturalist *Head of a Young Man* (private collection, New York), and the two watercolours of

Pablo Picasso,
Portrait of Max Jacob,
1915, 32.5x24.5 cm,
Musée Picasso, Paris.

an apple very carefully represented (Mr. And Mrs. David Rockefeller Collection, New York, and Musée Picasso, Paris) reflect a troubled period of contrasting research which Picasso has never explained. One of the apples, the one in the Rockefeller Collection, has a dedication on the back "Souvenir pour Gertrude et Alice/ Picasso Noël 1914"— the young women were not in Paris at the time — so it is possible that their friend painted the watercolour and wrote the inscription at a later date.

In the beginning of January 1913, Picasso draws in lead pencil a very classical *Portrait of Max Jacob*[46] which begins the series of portraits known as "Ingresque"; on the 7th the poet writes to Apollinaire: "I am posing for Pablo in his studio. He is making a portrait of me in pencil which is very beautiful; on this drawing I look like my grandfather when he was young, an old Catalan peasant, and my mother…" There is indeed in the portrait a reminiscence of the peasants of Gosol that Picasso drew during the summer of 1906; the face, the collar and the top part of the bust is drawn minutely, delicately shaded and the rest of the body is left as a rough drawing.

It seems that this drawing, despite the renown of the model and the publicity Max felt he ought to make over his friend's change of style, was not well known at the time, and rumours were beginning to spread. Although she had not seen the portrait, the poet Beatrice Hastings, Modigliani's companion, wrote in the periodical *The New Age* of 28th February, 1915, that Picasso's "new style" had become "almost photographic". The rumour grew worse when *L'Élan*, Ozenfant's review, published the portrait in December 1916, the avant-garde circles were laughing, and the enemies of cubism congratulated themselves that the flash in the pan was over.

Nevertheless when the art galleries reopened in 1916, and exhibitions were shown once more, cubism, or rather the different forms of cubism, were still in the forefront, even if, partly due to lassitude, there were not so many quarrels as in the past. *Les Demoiselles d'Avignon*, shown for the first time in the Salon d'Antin in July 1916, in the rooms of the dressmaker Poiret, didn't create any scandal, but the title "L'Art Moderne en France" gave rise to a few sarcastic remarks.

Apollinaire, on leave, organised a literary matinee in which he read poems in front of works by Picasso, Rouault, Van Dongen, Severini, Matisse, Dunoyer de Segonzac, Ortiz de Sarate, Pierre Roy, etc. Mr. Vauxelles who now signed his articles "Pinturrichio" felt obliged to write in the "Carnet de la Semaine" of 6th August: "Picasso might have made himself a name among the artists of his generation, had he not been overcome, around the age of forty, by a deep horror of nature. I shall not dwell on the case which may be pathological…" When in fact, the painter had returned to reality but, apart from Mr. Kahnweiler, nobody knew about it…

The Card Players by Léger

Léger was first mobilised as a sapper in the Engineers, then he became a stretcher bearer; he faces the full horror of war when he is picking up the wounded on the front line under enemy fire. "I used to leave my work,

46 Musée Picasso, Paris.

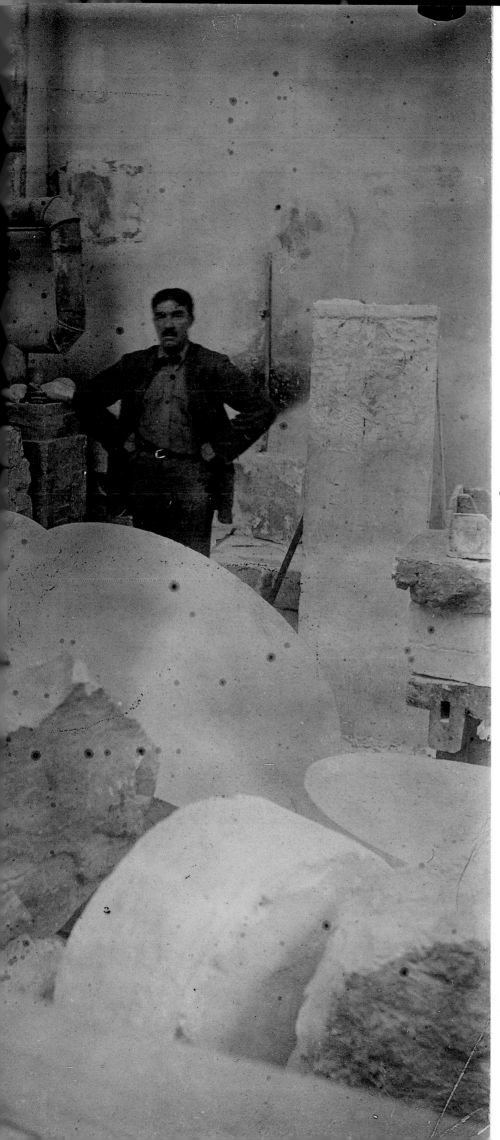

Fernand Léger
photographed by Constantin
Brancusi around 1920.

Musée National d'Art Moderne, Paris

my abstract explorations, in the studio, he declared, and I was thrown amongst these men for whom the question of life or death was no longer an issue… I was dealing with harmonies of colour, and each day I went to see my companions who had to kill to stay alive…"

He draws a lot. "Four years without colour…", said Léger who was dazzled by the impact of the metallic object, "the breech of a 75 millimetre gun which was standing uncovered in the sunlight", and the contrasts of forms, in the ruins of a house with its dislocated stone masses, in torn apart signposts with huge letters standing out against the sky. A world shattered to pieces, mutilated, and spotlights searching the sky for enemy aircraft. But also men who discover fraternity inside hell…

The Card Players (Kröller-Muller Museum, Otterlo) painted by Léger in 1917, after several weeks in hospital, is a confrontation of articulated robot-men whose bodies are constituted of interlocking geometrical volumes. It justifies the appellation "tubist". The fragmentation of forms reflects the war that tears men and things to pieces. "It is the first picture in which I deliberately chose my subject in the times…", says Léger. That is what inspired him his production of the twenties, in which he exalts the plastic beauty of the machine that imposes its norm on the vision of the world…

Picasso imitates himself

The *Harlequin* of the autumn of 1915 (Museum of Modern Art, New York), asserts its geometrical dehumanised stature decorated with colourful lozenges, under a tiny black head with a round eye and a wry grin, against an assembly of oblique polychrome rectangular shapes which set the composition off balance. Very much affected by Eva's illness, Picasso takes the Metro every day between his studio and the nursing home in Auteuil where she is being taken care of; on 9th December he writes to Gertrude Stein: "All the same, I've made a picture of a (*sic*) harlequin that I believe, in my opinion and in the opinion of several (*sic*) others, to be the best I have done. Monsieur Rosenberg has had it…" Leonce Rosenberg is trying to take over from Kahnweiler as Picasso's dealer, he has bought several pictures from him since 1914.

On 11th May, Braque was seriously wounded at Carency in the Pas-de-Calais; he was trepanned and recovers with difficulty, it will take him two years before he will be able to paint again. Picasso's "classicist" turn surprises him and saddens him because an epoch, together with their complicity in spite of a few storms, is over.

On December 14th, Eva dies, Pablo is desperate.

During this chaotic period, Harlequin represents a kind of curiously obsessive figure which appears in several pictures set into assemblages of oblique planes; then are produced a number of disarticulated figures like pastiches of older inventions with the return of *The Seated Woman with a Mandolin*, the *Seated Woman with a Guitar, Woman in an Armchair, Man with a Bowler in an Armchair*, diversions in which cubism imitates itself, against sadness and loneliness…

Kahnweiler is in Italy and the "cubist boutique" (Derain) of la rue Vignon is closed. Refugee in Switzerland, he has lost all contact with his painters; to appease his restlessness he writes on what he knows best: cubism. He is furious to see Léonce Rosenberg exhibit in his gallery "L'Effort Moderne" the works of Picasso, Braque and Gris that he had bought from him before the war and try to reassemble the other "cubists".

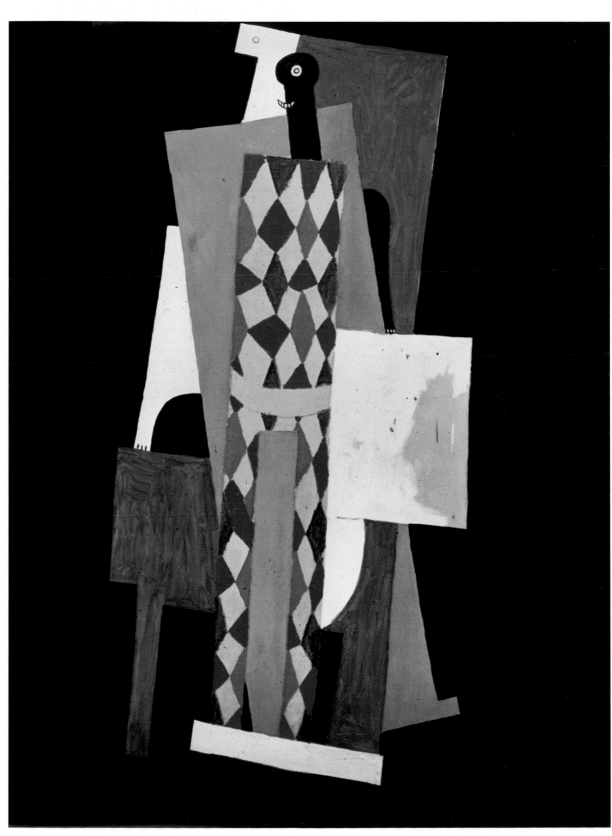

Pablo Picasso,
Harlequin,
1915, oil on canvas,
183.5x105 cm,
Museum of Modern Art, New York.

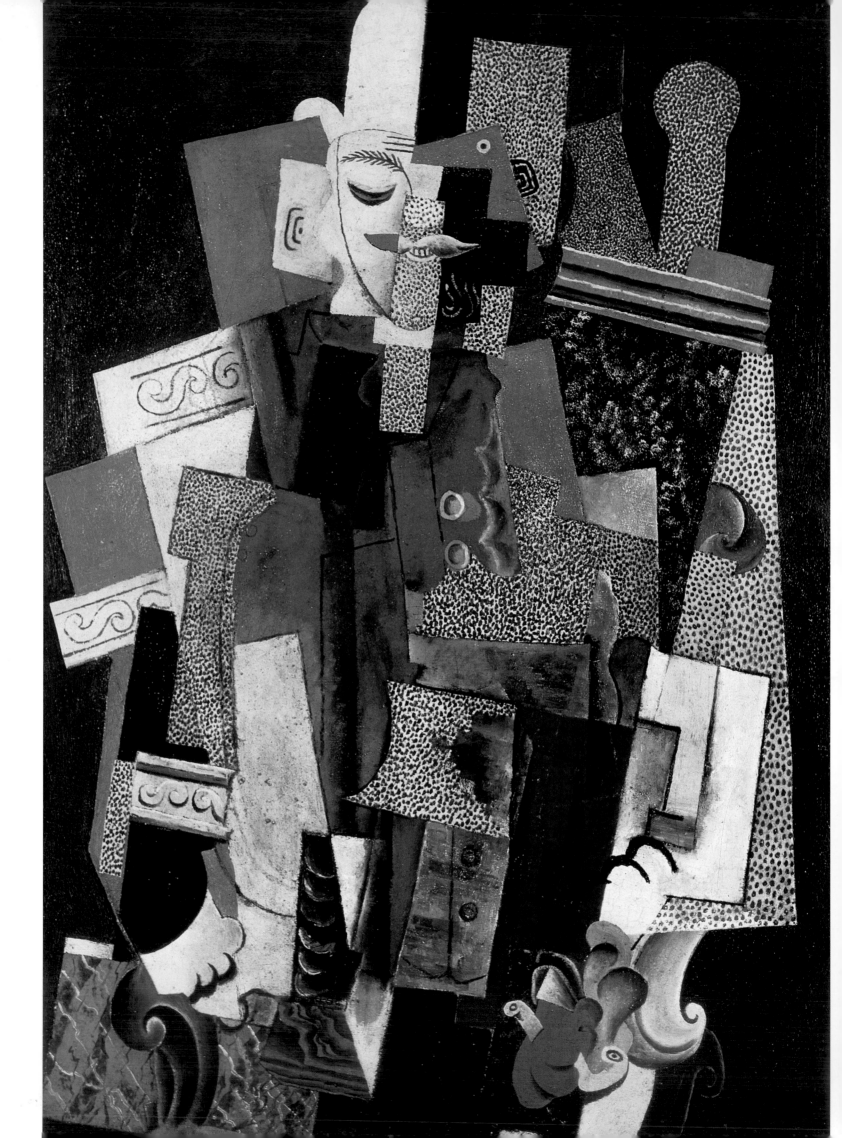

Pablo Picasso,
**Man with a Bowler
in an Armchair**, 1915,
oil on canvas, 130.2x89.5 cm,
Chicago Art Institute.

The scandal of *Parade*

"Picasso is making *Parade* with us!" Jean Cocteau's cry of victory astounds Montparnasse, art galleries and studios. *Parade* is a ballet written by the fashionable young poet, a close friend of Anna de Noailles and the Rostands, the music is composed by Erik Satie and the choreography undertaken by Léonide Massine of Diaghilev's *Ballets Russes*. The echo to this surprising news is immediate, Picasso has given up cubism! The "première" in the theatre of the Châtelet in Paris on 11th May 1917 caused quite an uproar. Apollinaire in the presentation he wrote for the programme of the opera tries to explain; he welcomes Picasso's participation and for "the first time, the union of painting and dancing, of plastic arts and music, which is the sign of the advent of a more complete form of art…." He assures that "Picasso's scenery and costumes reveal the realism of his art…"

"This realism, or this cubism, as one prefers, is what has most profoundly agitated the arts during the past ten years…"

Realism and cubism, or both at once – "above all, it is a matter of conveying reality…", adds Apollinaire – Picasso is not concerned with such preoccupations. The austerity of expression and conception of cubism, its analytical and synthetic exploration, have had their day; the painter does not change his language, he opens it up to a new world of forms, that of the stage where he sets into movement the acrobats of the pink period, the assemblage-constructions of 1912-1913, and the harlequins of the previous months.

Cubism is no longer just a style of painting but also the expression of a living whole, it moves, and thanks to the Managers, key characters in the animated assemblages created by Picasso's exceptional power of invention, it can leave the hidden laboratories of the studios and escape the problematic geometry of painting. From now on his field of investigation appears to be boundless. While he reinvents himself through the magic of the stage, his public is at the same time renewed and widened. Cubism is demythified and demystified.

Picasso, who has always liked the circus, is delighted to come back thanks to *Parade* to some of his favourite themes. The curtain that he paints with the scenery in Rome in February-May 1917 and which is judged either "old-fashioned" or "romantic", shows entertainers and acrobats, Harlequins, bullfighters, Negroes, sailors and the dancing circus rider on her winged Pegasus, in a festive atmosphere where magical fantastic elements are mingled with popular imagery. The other side of the show is an introduction to its phantasmagoria; maybe also an appeal to the future. The intuitive Apollinaire evokes "a sort of sur-realism" where he sees "the starting point of a series of demonstrations of the New Spirit which today has the possibility of expressing itself, and will most certainly seduce the elite, it promises to radically change the arts and customs in universal jubilation…"

Unfortunately, the elite does not understand at all, it roars against the outrage and calls the protagonists of the ballet "Boches"; that is the real scandal of *Parade*.

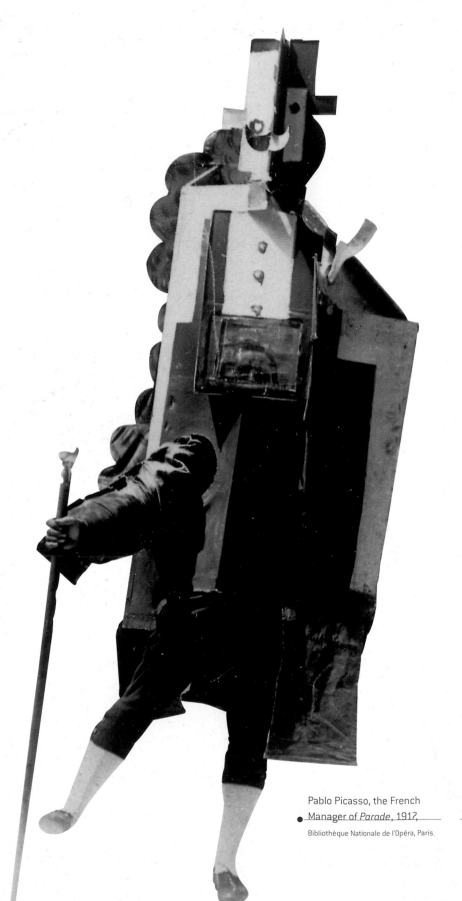

Pablo Picasso, the French
Manager of *Parade*, 1917,
Bibliothèque Nationale de l'Opéra, Paris.

Pablo Picasso, the American
Manager of *Parade*, 1917,
Théâtre Royal de la Monnaie collection,
Brussels.

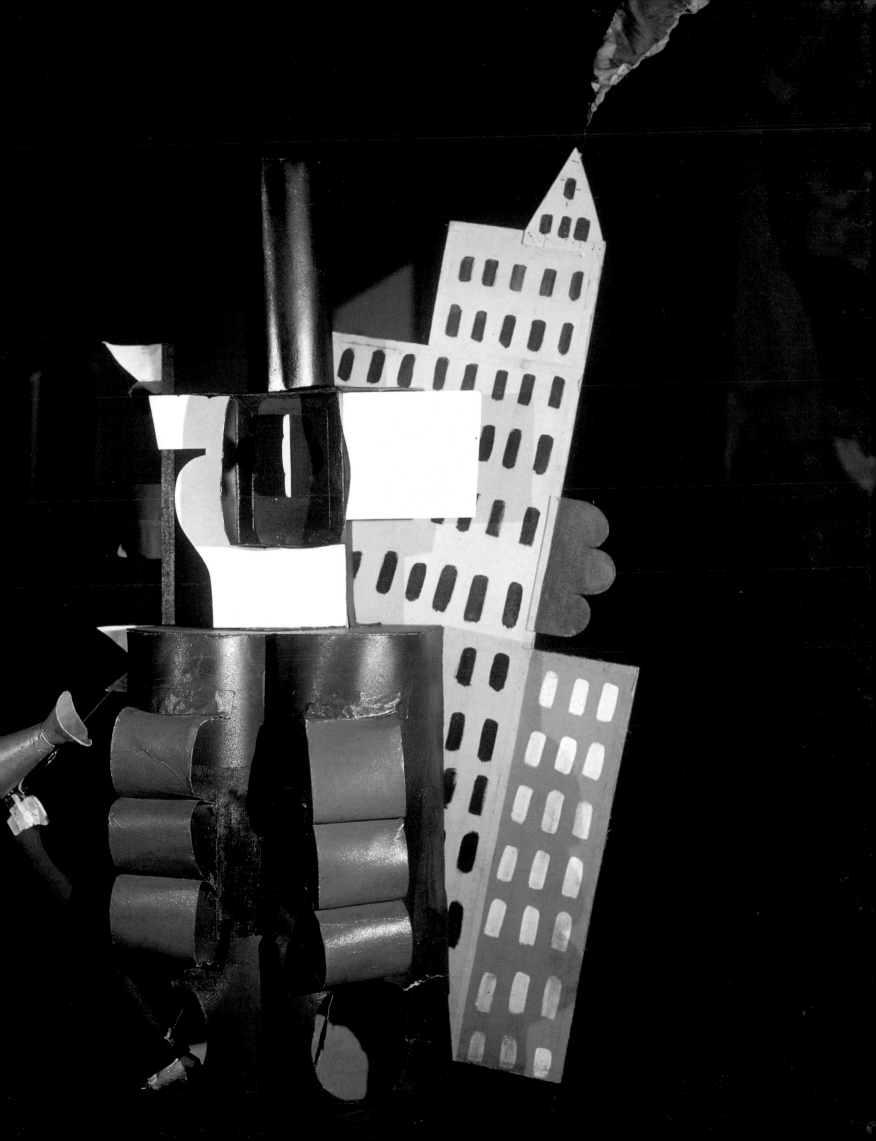

Braque exibits at "L'Effort Moderne"

Cubism has entered a period of ambiguity and confusion, which will last until the end of the thirties. During the "roaring twenties", the austere, enigmatic and complex language of the heroic period will become a decorative vocabulary and for many just a sign of fashion.

One cannot expect a reaction from Picasso, he has never confided himself, his only language is his painting. As for Braque, after his trepanation wound it takes him a long time to get back to active life and return to painting. The mountaineers' rope is severed, the exchange between the two men is finished, if however their friendship survives. The "classical" turn taken by his friend has disconcerted Braque. And upset him. He also is changing but without any break. He pursues his "methodical adventure" that his friend Reverdy will analyse later; his "Pensées et Réflexions sur la Peinture" written during his convalescence, published by *Nord-Sud* in 1917, illustrate the continuity of his personal conquest, more flexible, more refined, more affirmed in its means. It is materialised by his return to the object.

Braque exhibits at Leonce Rosenberg's "L'Effort Moderne", in March 1919 – it is his second personal exhibition ten years after the first "cubist landscapes" shown at Kahnweiler's – around ten still lifes, including three of 1918: *The Guéridon*, today in the Museum of Philadelphia, *Guitar, Pipe and Fruit Dish* and *Still life with Fruit Dish* respectively in Eindhoven and Basle, in which the composition layered vertically stands out in geometric planes against a dark background. In the beginning of 1919, he painted *Le Café-Bar* (Basle) and *Guitar and Fruit Dish* (Musée National d'Art Moderne, Paris). This series is neither a reaction nor a relay to the baroque still lifes made by Picasso in 1916-1917. Braque constructs, organises according to synthetic cubism, reviving old emotions instead of searching for new sensations. "My concern is to put myself in unison with nature rather than to imitate it", he says.

He appears as Cézanne's true successor; he has always enriched and gone deeper into his teachings that for Picasso, Matisse, Derain or Gris had only been a phase of their development. Some people talked about a "new manner" regarding the canvases shown by Braque at "L'Effort Moderne", but there is nothing of the sort, the continuity in his work remains logical, it has developed from the experimentation he carried out alone and in collaboration with Picasso. The craftsman and the demiurge are no longer supporting each other, neither are they in opposition; while Braque is continuing his pictorial quest, the Spaniard is undertaking graphic experimentation with his portraits.

In these portraits Picasso combines cubist geometrization with writing, precise like a statement, fine, or dancing as when he reproduces on the walls of "La Mimoseraie", Mrs. Errazuriz's villa in Biarritz, Apollinaire's hedonistic verse accompanied by cheerful bathers. He had married Olga Kokhlova, a dancer in the *Ballets Russes*, on 12th July, 1918, and they went to stay with his beautiful Chilean friend on their honeymoon. He is leading a busy social life, it is the period of his new classicism, half-

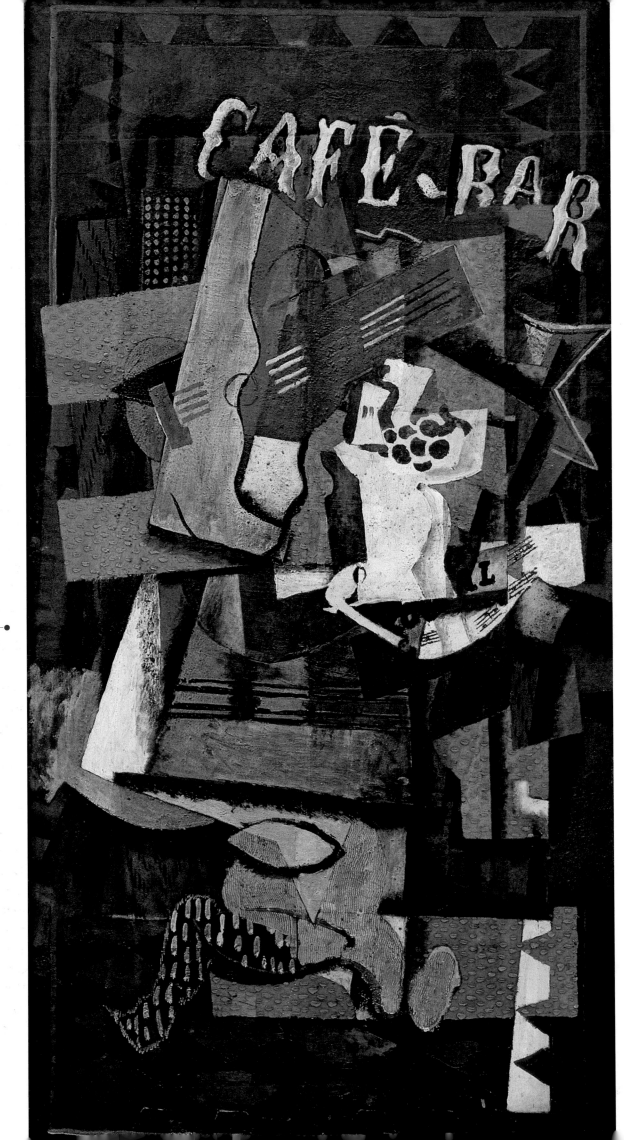

Georges Braque,
Le Café-Bar,
1919. Oil on canvas, 160x82,
Kunstmuseum, Basle.

Ingres, half-Corot – of the *Dreamy Bohemian* and *Agostina* – of his loving portraits of Olga, and happy times.

Picasso does not disown anything, he is pausing, the detractors of *Parade* were wrong, the embers are still glowing under the warm ashes.

On 9th November, 1918, Apollinaire dies.

Roger Bissière, a young painter who makes a living as fine art and literature editor of *L'Opinion*, reacts to Braque's exhibition at "L'Effort moderne". On 26th April, 1919, he writes that cubism brought "painting back to its traditional means from which we had moved away over the last fifty years. It will have taught us to respect matter and the profession of painter…". And he continues: "Cubism …'a call to order'… has contributed to save modern art…" It is the first time that the expression which is as famous as it is ambiguous, was used; André Lhote, restless "cubister" and pedagogue who thanks to his friend Jacques Rivière, writes as an art critic for the *Nouvelle Revue Française*, takes up the formula in June. From the "call to order", or "return to order" is elaborated a new appreciation of cubism as a link within a tradition of harmony, clarity, plastic intelligence, in short of order, which, according both to Lhote and Bissière, originated in Fouquet and Poussin. After the shock of *Parade*, when its creators were called "Boches" and Picasso was accused of repudiating, or betraying cubism, the exhibition of Braque's still lifes comes for some people just at the right moment; it proves that if cubism still exists it has providentially adopted more serene, more readable, in other words more "French" formulas which respect the profession and reassure good taste. The neo-cubism of the years immediately after the war was born from this confusion and from the ambiguity it created.

Cendrars, critic of cubism

The "poets' criticism" had been keenly debated. Cendrars adds his voice. "The cubist block is crumbling away, he writes in the first issue of *La Rose Rouge*, dated 3rd May, 1919. A thousand different trends are appearing. There is new beauty." In anticipation of the reopening of the Salon des Indépendants, the first since the war, which will only happen the following year, he already refuses the processes of synthesis and compromises of the critics. "The formula, the different cubist formulas are no longer sufficient" because "the aspects, the contrasts of modern life, are too complex. They will not let themselves be scientifically coded or included in a technique, however individual…"

On 15th May, under the title "Le Cube s'effrite" he writes: "it would be stupid and imbecile not to recognise the importance of this movement, just as stupid as to continue laughing at it…", it is also "imbecile and silly to want to stop on a doctrine that today marks a date, and to refuse to accept that cubism no longer offers enough novelty and surprise to provide nourishment for another generation… "

"The Salon des Indépendants opened its doors with some success for the Cubists who are taken seriously by all or almost all the press…", writes Juan Gris to Kahnweiler three days after the preview on 28th January,

André Lhote,
The Painter and His Model,
1920, oil on canvas,
97x130 cm,
Musée National d'Art Moderne, Paris.

1920. Mr. Vauxelles, Pinturrichio, has changed his colours; what before the war to him was nothing but a short-lived mystification, with time, has revealed its importance; he now sees cubism as a "useful constraint", and he has some consideration for "those who made use of this discipline..."

All the same Mr. Vauxelles still has some doubts. "Are there any cubists?" he asks in *L'Excelsior* of 20th February, 1920. And he includes, among the "uncompromising cubists", Gleizes, Braque, Gris, Léger, Metzinger... "Their talent, their taste, their knowledge (of which they are not devoid), can accommodate what they used to reject, and now they are concerned with matter, with covering, in other words with pictorial elements..."

No, Mr. Vauxelles has not turned his coat, he does not admit his blindness and his errors, he blames the painters who had been mistaken and had misled him.

Gleizes, Metzinger, Marcoussis

Gleizes, Metzinger and Marcoussis are among those who, starting from cubism, have used it or prolonged it with their personal research but without offering new outlets to its creative ferment.

Gleizes, at first guided by Cézanne's teachings, was one of the least receptive of the cubists to the influence of Braque and Picasso whom he accused of intellectualism; he was among those who geometrized their pictures — as from 1910-1911, in his case — and pretended that that was what cubism was about; they spread the formula around the Salons where, as we know, neither Picasso nor Braque were represented, they adopted the name and deviated its spirit. Gleizes' cubism consisted in dividing up his canvas into angular interlocking triangles and trapeziums into which he fitted elements of reality true to his subject.

In the Indépendants of 1911, the *Woman with Phlox* (Boston Museum) illustrated the painter's efforts to reduce figures and objects to elementary geometric and synthetic forms. In July 1915, Gleizes embarked for New York, the following year he was in Barcelona, then he returned to the United States where he remained until 1919. He was surprised and disconcerted by the monumentality and verticality of the American city, as a result he breaks up the geometric networks of his pictures with contrasting rhythms; further to his encounter with Duchamp and Picabia he develops a form of dynamism, sometimes close to abstraction. In New York, Delaunay's disks in simultaneous colours, which had inspired him in 1912, become huge and blinding neon signs in movement; Gleizes tries to find plastic equivalencies for one of his favourite themes, the town and the river, as shown in the three pictures of *Brooklyn Bridge*. His evolution is particularly noticeable in *Stunt Flying* (The Solomon Guggenheim Museum, New York) which derives from the *Acrobats* of 1914 only that to the expression of flying rhythms he substitutes exalting sensations of height and speed.

Back in France in 1920, Gleizes publishes several essays including *Tradition et Cubisme, Du Cubisme et des Moyens de le Comprendre,*

Albert Gleizes,
Brooklyn Bridge,
1915, oil on canvas,
private collection.

La Peinture et ses Lois, in which the titles alone express the theoretical intentions of a naively speculative mind stimulated and, in his opinion, justified by the "return to order". His attachment to the Christian faith turns him towards the Middle Ages, and his cubism that he brings down to the status of a "style of tradition" will be petrified in arrangements of which the circular rhythms, inspired by the Romanesque symbolical iconography, fit into an illusory regeneration of "sacred art".

André Lhote, paladin of "French cubism", like Gleizes is a herald of the "return to order" for which his articles in *La Nouvelle Revue Française* serve as a platform. Prolix "pedagogical siren" who endeavours to be the mentor of several generations of dutiful followers of his careful juxtapositions of coloured geometrical flats, he carries out a basic kind of painting rather than a scholarly one, but at times brilliant, which tends to reduce cubism to a set of simple rules. His dogmatism can only result in an academicism which will have effects on architecture and the decorative arts throughout the twenties.

At first influenced by neo-impressionism and fauvism, Metzinger's research in the fragmentation of volumes according to different, if not contradictory, projections leads to a form of "closed" cubism, inspired by Picasso, of whom he has retained only the superficial aspects. He participated in the famous "cubist room" in the Salon des Indépendants of 1911, and wrote with Gleizes *Du Cubisme*, further to which like the latter he was regarded as at theoretician. Geometrical formulas are also applied by Le Fauconnier whose contribution to "physical cubism" as defined by Apollinaire, will not go further than his best known work, *Abundance* (Gemeentemuseum, The Hague); the luminous shimmering of volumes is reminiscent of impressionism. Metzinger abandons cubism in 1921 for what he calls "constructive realism", and Le Fauconnier continues his work with expressionist tendencies in Holland and Germany.

Of all the users of cubism, they will be numerous in the pre-war Salons and joined by quite a few new recruits during and after the conflict, Louis Markous, christened Marcoussis by Apollinaire, is the one who left the most homogeneous work. It is limited in time, from 1910 to 1914, and also restricted to research on construction, which leads him to adopt the cubist vocabulary out of a kind of structural necessity. This he translates, further to a decisive meeting with Braque, into a strong cohesion of forms set within rigorous drawing which never gets lost in superfluous polyhedrons and obeys the primacy of light. Marcoussis participates in the 1912 Salon de la Section d'Or, and the following year in the German Autumn Salon; after the war, he continues his experiments with painting "under glass" in which the tones of oil applied to the rear side of glass create effects of multiple correspondences.

Marcoussis is also an excellent engraver; a friend of the poets, he produced at first cubist then realistic portraits of many of them in etchings or engravings; they constitute a remarkable document on the artistic Tout-Paris of the time.

Louis Marcoussis,
**Still Life with
a Draughts Board,**
oil on canvas, 1.39x93,
Musée National d'Art Moderne, Paris.

Some neo-cubists...

Gleizes, Metzinger or Marcoussis, and even André Lhote in spite of his weaknesses and theoretician ambiguities, believe that they are regenerating and contributing with the singularity of their processes to the continuation of a movement which is no longer represented by Braque, Picasso and Gris for various reasons. These three have apparently changed. Their cubism, created by Braque and Picasso, has gone beyond the stage of founding experimentation; with time, the ambiguities of the Salons and the increase in the number of minor painters who have joined the movement, the revolutionary impact of the early stages has turned into a form of academicism, cubism started as a language of conquest, it became a style, then a fashion.

Among the "neo-cubists", Henry Hayden, from Poland like Marcoussis, influenced by Gauguin then by Cézanne, was seduced by the cubo-Cézannism applied by Braque and Picasso in 1908; he turns towards synthetic cubism which inspires him his *Chess Players*, then several experiments in which he mixes different styles without really choosing his own. His inspiration and his references are concentrated in *The Three Musicians* of 1920 (Musée National d'Art Moderne, Paris) painted one year before Picasso's. Hayden will then turn back to reality, and will substitute the angular rhythms of his neo-cubism with the curves of his freely coloured still lifes and landscapes.

Herbin, who lived in Montmartre when he was very young, adhered to cubism in 1909 in the stimulating atmosphere of the Bateau-Lavoir, but it was fauvist paintings that he exhibited in the Salon d'Automne. Preoccupied with the problems of the relationship between colour and form, in 1917 he joins the group of painters who exhibit at "L'Effort Moderne", Léonce Rosenberg's gallery which has become the cubists' shop window. He will explain his choice in the report of *Le Bulletin de la Vie Artistique* in 1924. "Painting has killed cubism, he affirms. Cubism will be revived, greater and purer, by architecture. To continue painting cubist pictures, once one has considered architecture to be vital, is treason..."

Cubism is also a constructive discipline for the Spaniard Maria Blanchard, born crippled; she applies it to her compositions which express melancholic intimism, giving her figures an aspect of spun glass, or shimmering metallic reflections (*Maternity*, 1920, Musée National d'Art Moderne, Paris).

Henry Valensi, one of the organisers of the Section d'Or who will become the theoretician of musicalism, is also associated with cubism. Valmier, cubist in 1911, encouraged by Léonce Rosenberg, later evolves towards decorative abstraction under the influence of Fernand Léger. The Hungarian Alfred Reth, after 1914, turns his more relaxed geometrical forms into constructed figures and landscapes.

Emmanuel Gondouin also started from cubism and showed his work at the Indépendants in 1911; he uses geometrical forms towards a stylisation that causes him to divide up his canvas into volumes and planes

arranged to create original decorative effects. Light is a connecting element. In the 1920 Indépendants he participates in the cubist room with Gris, Metzinger, Hayden, Herbin. But difficulties of existence, in spite of good friends and a few appreciable successes, prevent him from attaining the position that he might have reached through his singularity; he is the "accursed painter" of cubism.

Serge Ferat, of Russian origin – his real name was Jastrebzoff – remains a mysterious character of the cosmopolitan Parisian pre-war circles. He joins cubism under the influence of Picasso and then Braque. Together with the baroness d'Oettinghen, an enigmatic adventuress, they sponsor the second series of the *Soirées de Paris* in 1913-1914. Apollinaire who was on excellent terms with the baroness, asked Ferat to make the scenery and costumes for *Les Mamelles de Tirésias*, over which the poet's friends protested, but Picasso designed the programme for which Matisse did engravings on wood. A discreet and refined painter, more a follower than a creator, he disappeared from the artistic scene a few years after the war and was not heard of again, although he only died in 1968.

Henri Hayden,
The Three Musicians,
1920, oil on canvas,
Musée National d'Art Moderne, Paris.

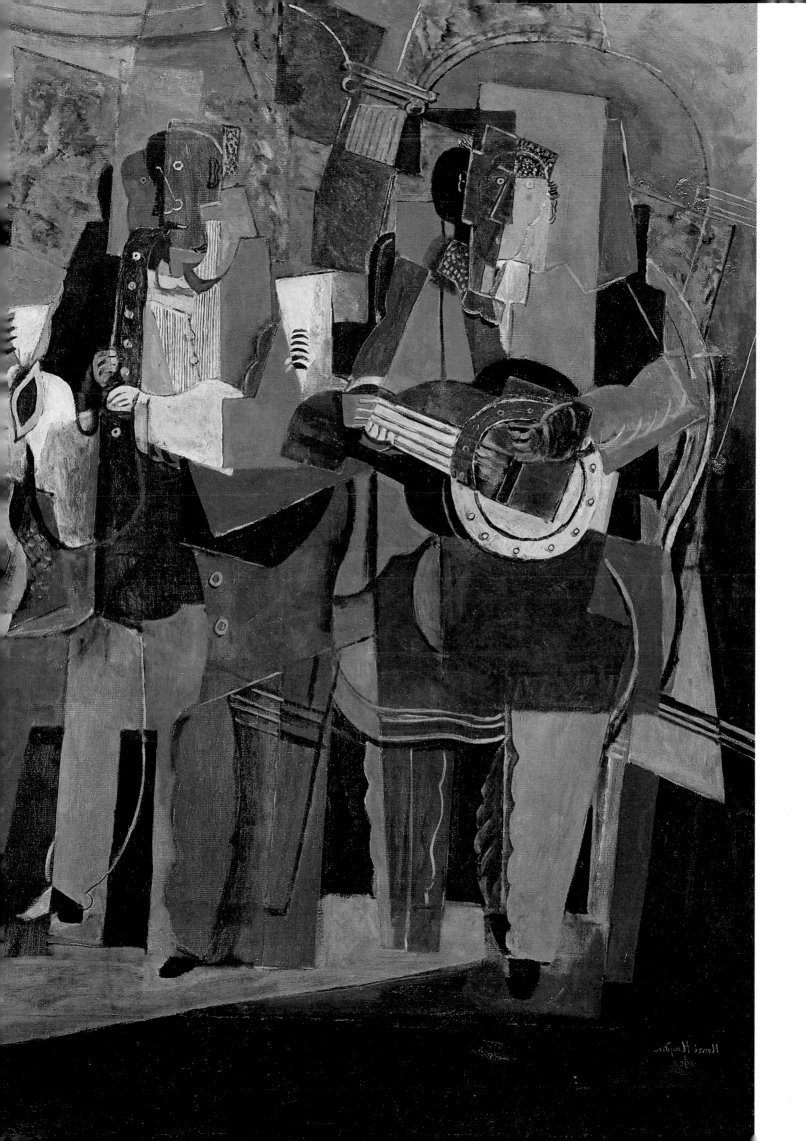

Cold cubism: purism

Two painters, Ozenfant and Jeanneret – the latter will be known as the architect Le Corbusier – publish in 1918 a manifesto, *Après le Cubisme,* which from the very start lays down their intentions: "Art, above all, is in conception." From 1920 to 1925 they use the periodical *L'Esprit Nouveau* to propagate the ideas of the international avant-garde and the new architectural concepts.

Their cubism is that of "L'Effort Moderne", of the followers and users, but their "purism" is meant to be most of all "a general grammar of sensibility". "We shall use the word Purism, write Ozenfant and Jeanneret, to express in one intelligible word the characteristics of the modern Spirit [...]. Purism does not express variations but the invariant. A work must not be accidental, exceptional, impressionist, inorganic, protesting, picturesque, but on the contrary general, static, expressing the invariant [...]. Purism fears what is bizarre and 'original'. It is searching for the pure element to reconstruct it into organised pictures which will seem to have been made by nature itself..."

In their joint book, *La Peinture Moderne,* Ozenfant and Jeanneret specify that "aiming at universality", purism endeavours to "ascertain the fixedness of the coloured sensation"; therefore they begin their research with the study of optical sensations and colour. "Thus starting from formal and coloured elements and considering them as stimulants with a specific determined action, one can create a picture like a machine. The picture is a device intended to give emotion..."

Their concern is for order, purity, logic, for control over form, their research follows "regulating" plans, Ozenfant and Jeanneret's pictorial works are usually still lifes with colour applied in flats composed of mass produced everyday objects and their austere aestheticism has little to do with sensibility which brings the two painters nearer to Léger.

Amédée Ozenfant,
Still Life,
1925, oil on canvas,
Musée National d'Art Moderne, Paris.

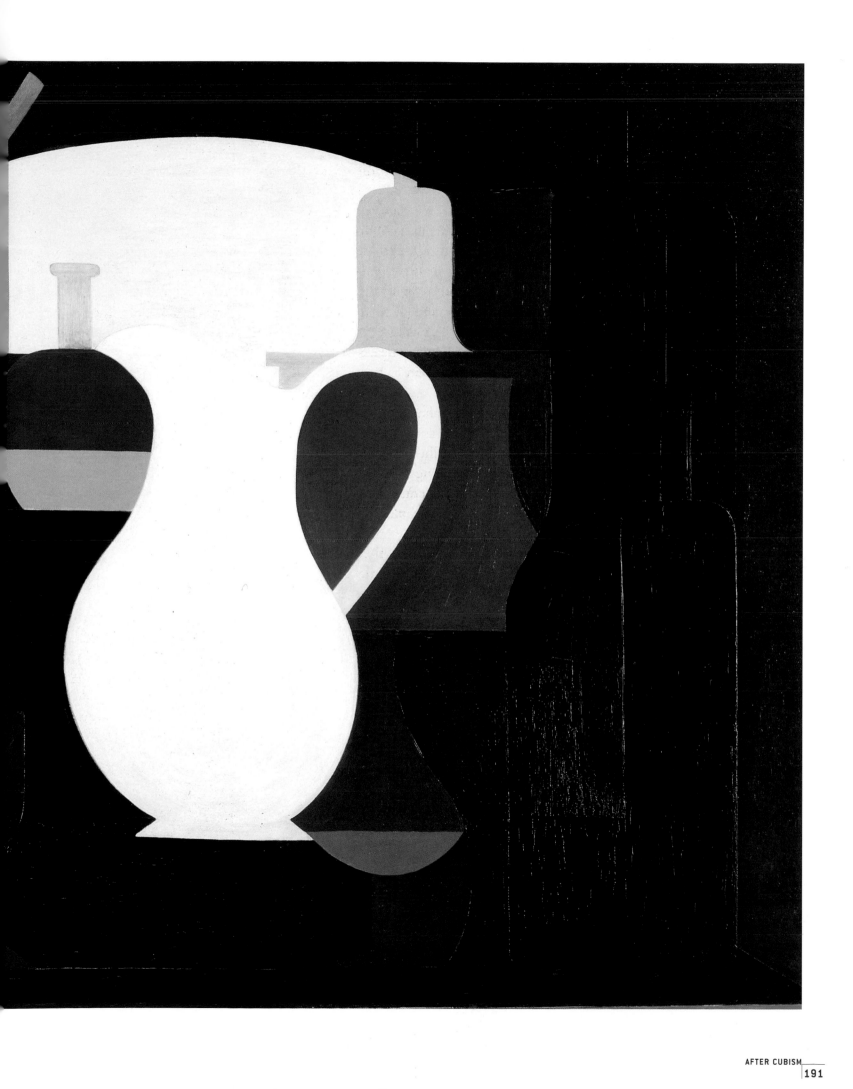

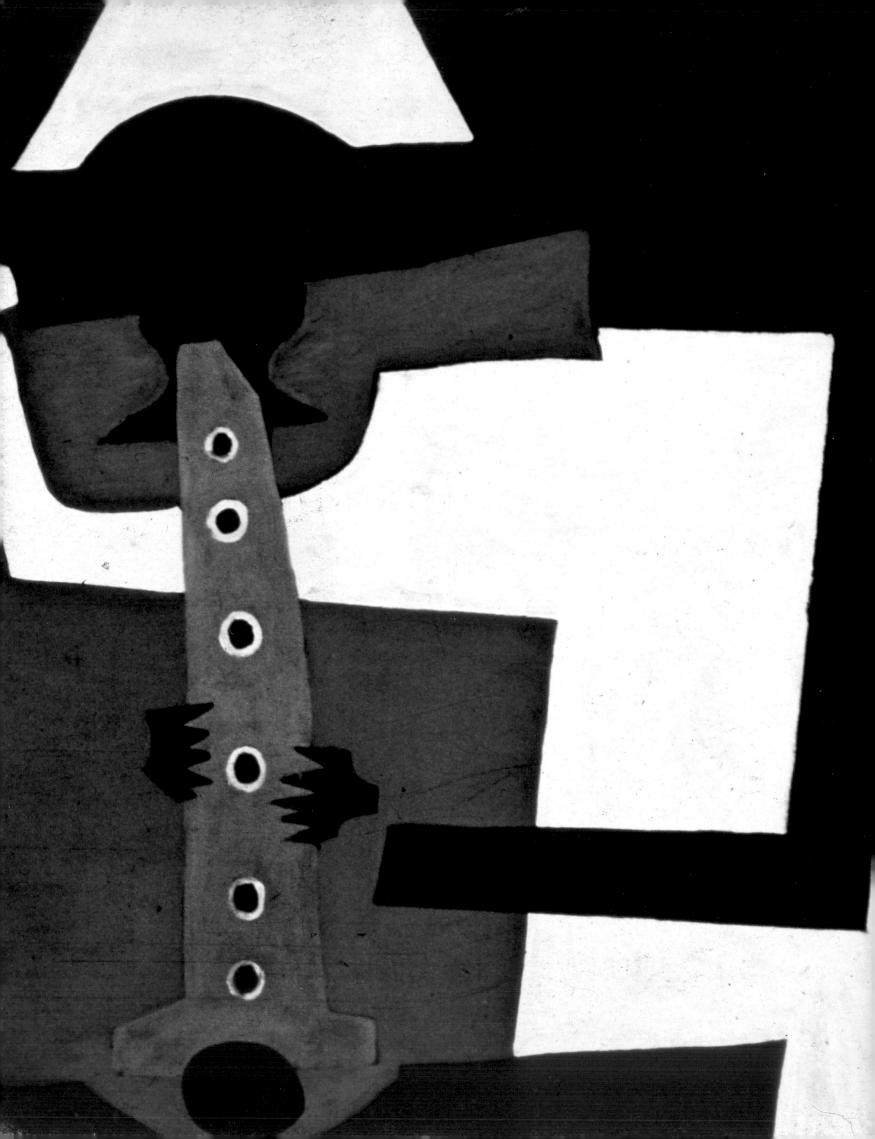

5 The time of memory

New paths open...

The neo-cubists attached to the picture are for most of them turning towards realism, they are now merely the survivors of an adventure, its relay in the avant-garde is taken over by Dada. After the historical foundation of the movement at the cabaret Voltaire in Zurich in 1916, its instigators in France, Picabia and Tzara settle in Paris, respectively in 1920 and 1921, bringing with them the freedom and subversion experimented in various German centres.

Futurism, like cubism, does not survive the war and loses its initial originality in many different and complicated directions, before falling into the hands of Mussolini's fascism. The Dutch Stijl of Mondrian and Van Doesburg, and Russian constructivism will continue the lessons of cubism which also inspire the architects of Prague, Le Corbusier as well as Mallet-Stevens who is very close to Art Deco; they contribute with their syntax of order and rigour to the constructive heritage of movement but they are exposed to the perils of fashion and taste. In stead of offering a new space for experimentation and ideas the Exposition Internationale des Arts Décoratifs held in Paris in 1925 will simply add to the confusion by spreading a hybrid form of art in which cubism only plays a role of decorative ornamentation.

After *Parade*, Cendrars wrote: "The locks of the new language are open. The countless letters of the new alphabet are rushing out. Everything becomes possible...!" "Let's choose the cinema...", exclaims Max Jacob, a regular spectator with Picasso in a small cinema in the rue de Douai where they take Apollinaire also an adept of popular entertainment. "The person who projects a film today is in the role of the minstrel of the past", wrote Guillaume[47]. "The epic poet will express himself through the cinema, and in a beautiful epic where all the arts will be joined together, the musician will also play a part to accompany the lyrical sentences of the narrator...". "Now I only write verse for the cinema...", affirms Salmon whose scenarios written in collaboration with Apollinaire nonetheless fall flat.

In one of the manuscript notes found after his death, the sculptor Duchamp-Villon had written: "A mobile form of art (it will not is be painting) is about to be born, in which colours will vary on the screen, and the pictures thus created may or may not come from nature..." But the first person to achieve a mobile plastic work associating light,

47 G. Apollinaire, "Les Tendances nouvelles", in *Sic*, n° 8-10, 1916.

colour and movement, is the Russian emigrant, Leopold Survage – Sturzwage, by his real name — who arrived in Paris in 1908.

He goes through cubism that he discovers in the Indépendants of 1911 and comes very near to abstraction; from cubism, as shown in his pictures of 1910-1912, he borrows the articulation of planes following rhythms that lead according to him to a "plastic synthesis of space". He has metaphysical preoccupations, and tries to find in the study of science the means to express cosmic dynamism. Survage studies the relationship of colours between themselves, their movement in time according to their nature, their shape, their quality, and creates symphonies that he calls "Coloured Rhythms". Anxious for his research to be recognised by the scientific world, he sends on 23rd June, 1914 a report of three pages to the Academy of Science. He further publishes an article in the *Soirées de Paris* in the July-August issue in which he writes: "Coloured rhythm is not in any way an illustration or an interpretation of a musical work. It is an autonomous art although founded on the same psychological factors as music. It is the mode of succession of the elements in time that establishes the analogy between music — sonorous rhythm — and the coloured rhythm of which I advocate the realisation by means of the cinematograph…" Thus Survage, with the support of Cendrars and Apollinaire, sets out in search of a film company to finance his experience of coloured orchestration.

He is turned him down by the société Gaumont. Yet with his Coloured Rhythms he stands out as a pioneer in a new direction of art.

The professional film-makers do not understand Survage's experiments any more than they do those of Viking Eggeling in 1921 or Hans Richter. At the very best they employ painters as decorators; that is how in 1923 Marcel L'Herbier asks Fernand Léger to make the scenery of the laboratory in his film *L'Inhumaine*. Man Ray films *Le Mystère du Château du Dé* in the cubic rather than cubist architecture of the vicomte de Noailles' villa built by Mallet-Stevens in Hyères.

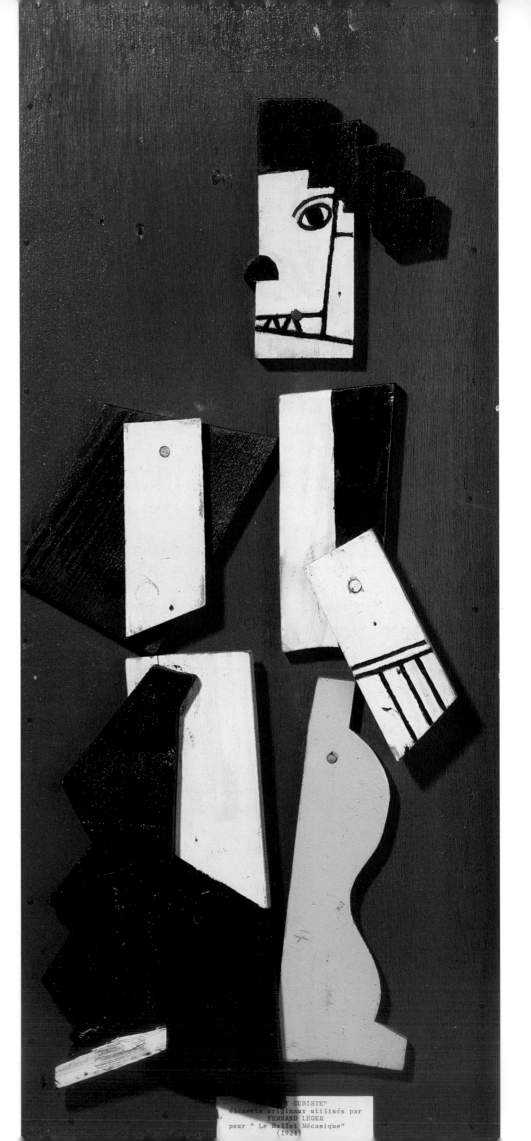

Fernand Léger,

Charlot Cubiste, ━━━━━━●

1924, painted wood,

Musée National d'Art Moderne, Paris.

Léger films *Le Ballet Mécanique*

Fascinated by the cinema to the extent, he says, that he "nearly gave up painting…", Léger receives the full force of the close-ups of Abel Gance's film *La Roue* to which he had collaborated with Blaise Cendrars. "It is the close-ups that seduced me", declares the painter. Around a strange polychrome relief, *Charlot Cubiste* (1923, Beyeler Foundation, Basle), "absolute cubi-cinematic object" (Francis Vanoye), which opens and closes the film *Le Ballet Mécanique* produced in 1924, with the photographers Dudley Murphy and Man Ray, he applies the possibilities of decomposition, acceleration, slow motion and blow up of cinema.

"I transposed onto the screen", declares Léger, "the very objects that I used in my paintings, giving them a calculated rhythm and mobility to make up a harmonious whole. In other words, a contrast of objects in reaction against one another to create a plastic life in images. Close ups, the real invention of the cinema, I used for the construction of the film. The "fragment of object" also has its value. By isolating it, one can personalise it[48]…"

These objects no longer belong to cubist intimism, but to the unexpected element of life, they are the only actors of this film without a scenario for which the American composer George Antheil composed original music reproducing the cacophony of the city with the sound of electric bells, horns, car engines, plane engines.

If the *Ballet Mécanique* is not, as it has been said, a cubist film, at least cubism has inspired its form. By transforming vision, cubism has transformed the relationship between objects and space. Cubism has not remained specifically limited to painting, sculpture and plastic arts, it has opened up the way in all fields of creation and has gone beyond Rimbaud's formula "to change life", "in search of, wrote Apollinaire, a new language with regards to which the grammarian of any language will have nothing to say…"

The serene cubism of the *Balconies*

During the immediate post-war years, when the "return to order" is predominant, the cubism of before 1914 is practically unknown, indeed it belongs to Kahnweiler's sequestration — he only returns to Paris in 1920 — which contains some of the most characteristic works of an exceptionally creative period. Married, soon to be a father, popular in society, looked after by famous dealers, has Picasso changed? What is there in common between the bohemian revolutionary of the heroic years of cubism and the star of the beginning of the "roaring twenties"? Back in France after the end of the war, Wilhelm Uhde goes to see one of the painter's exhibitions at Paul Rosenberg's; disconcerted, he writes[49]: "I found myself looking at large portrait in what is called the "Ingres style". What did these pictures mean? Was it an interlude, a game, a beautiful one but of no consequence, that his hand had enjoyed doing while his mind, tired by the journey behind it, was resting? Or else in times when men were governed by hatred, when Romanesque circum-

48 F. Léger, *op. cit.*
49 W. Uhde, *Picasso et la tradition française*, Paris 1979.

spection, self-conscious, rose up with hostility against nebulous German metaphysics (Picasso), did he feel that untouchable people were pointing at him because of German affinities deep down in his feelings and accusing him of being in connivance with the "enemy"? Was he suffering from moral isolation in a foreign country? Was he trying to associate himself with the specifically "French" side?"

Uhde who had been away from France since 1914, could hardly understand Picasso's evolution, Kahnweiler, on the other hand, was perfectly well informed, but, in addition to his aesthetic disapproval, serious financial difficulties arose between the two men. The auction sales of the sequestrated works of the Kahnweiler Gallery take place between 1921 and 1923 in a detestable atmosphere; despite their ridiculously low price, Kahnweiler does not buy a single of his friend Picasso's pictures.

The fact that Picasso has moved away from cubism will sustain the criticism against his work, the exhibition known as the *Balconies* or the *Windows at Saint-Raphael*, at Paul Rosenberg's in 1919, showing drawings and watercolours produced during his summer stay with Olga, surprises and irritates the public. The critic Waldemar George writes: "Armed with caducei, the critics, the buffoons, toll the bell of cubism, Picasso recognises defeat. The purists, the fanatics of absolute painting refuse to follow the traitor; their device was, live cubist or die..."

Cocteau who never misses the boat says in an "artistic" conference that he gives in Brussels in December 1919 that he is responsible, with *Parade,* for Picasso's detachment from cubism. "The painters in his circle rediscover the powerful work of classicism" he declares. Which does not prevent him from writing: "It has been said that Picasso was giving up cubism. It is an absurd rumour. Objects follow him as long as he wishes, and then they are deformed, and reconstructed without losing anything of their force... Picasso is an object charmer[50]...", which is pure Cocteau.

The clear and airy cubist syntax of the *Balconies,* geometrical tables on which are set still lifes coloured without excess, clearly cut out in a fixed space which opens out onto a perfect blue sea, is a long way from the austere, hieratic and complex vocabulary of the past. The poet is evoked "Tout est ordre et beauté..." It reflects the painter's fulfilment, in a happy period of his life, untroubled by major worries and dark thoughts, economically secure. Cubism has moved from the mental to the visual.

The year 1920 is taken up by the scandalous events and aggressions of Dada; having at first asked the dadaists to participate in the third exhibition of the Section d'Or, the cubists decide to exclude them after a general meeting held in February and Gleizes violently attacks them in the periodical *Action.* Picabia never short of repartee, replies in *Cannibale* to "Monsieur le chef du Cubism", accusing his "sexual apparatus" of "building aquatic cubism...". Picasso must have enjoyed that!

50 Jean Cocteau, *Carte Blanche*, Lausanne 1919.

Pablo Picasso,
Still Life Before a Window, ●
1919, watercolour and pencil
on paper, 32x22 cm,
private collection.

Pablo Picasso,
The Three Musicians,
1921, oil on canvas,
203x223 cm,
Museum of Modern Art, New York.

From the *Three Musicians* to the *Three Women*

The Spaniard from Malaga refuses to join the cubist gathering organised by the Salon des Indépendants of 1920. Braque, for the first time since1908, is present with Léger, Delaunay and Gris, together with Metzinger, Lhote, Hayden, Serge Ferrat, Villon, Marcoussis, the sculptors Lipchitz, Archipenko, Zadkine. It is a kind of common front of modernity with in the epicentre the first revolutionary style of the century henceforth taken over by history.

Nevertheless, Picasso accepts to be represented at the third exhibition of the Section d'Or, organised in 1925 by the new Vavin-Raspail gallery. Is this a historical rereading of the movement, symbol of the breaking up of cubism, of which until then Braque and Picasso had kept clear? Thirteen years after the deviationist event organised by the Puteaux group, it is a time for reconciliation and revision; the "return to order" is once more being accomplished.

At Fontainebleau where he is living peacefully with wife and child, Picasso paints during the summer of 1921 the two successive versions of the *Three Musicians* (Philadelphia Museum and Museum of Modern Art, New York). In a monumental style with very stylised and colourful cut up flats, he has reassessed cubism from the heroic orthodoxy to the classical illusionism; and at the same time through the themes dear to his younger days, he pays homage to his dead or distant friends. The monk holding a sheet of music evokes his close friend Max Jacob retired in the monastery of Saint-Benoît-sur-Loire (when Picasso not long beforehand had heard about his decision, he drew a *Symbolical Portrait of Max Jacob as a Monk* in charcoal), Pierrot playing the flute represents Apollinaire, they are both standing either side of Harlequin with the guitar, Picasso himself, who is wearing the multicoloured costume of the past.

Bright colours and opposition of warm and cold tones, stand out against a dark background. The great Picassian theatre in which, in the Philadelphia version, a few modifications invert the order of the characters or change the musical instruments, is a blown up commemorative monument to the death of youth and the end of the cubist adventure. Yet during the same period, the summer of 1921, Picasso paints another doublet, but classicist in this case, *The Three Women at the Spring*, of the Museum of Modern Art in New York and the other version discovered in the artist's succession, now in the Musée Picasso in Paris.

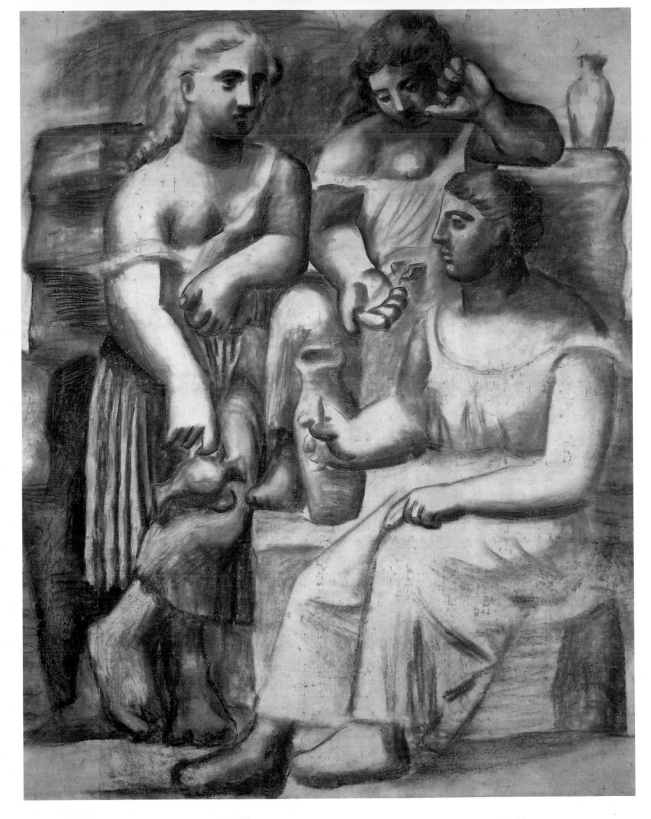

Pablo Picasso,
Three Women at the Spring,
1921, pastel,
Houston Museum of Fine Arts.

These two canvases which contain echoes of Poussin and antique souvenirs dating from when Picasso's stay in Rome for the preparation of *Parade*, each represent three large women in close-up, with disproportionate limbs, strait profiles, talking together, one of them is seated and the other two are taking water from the fountain; they are wearing draped tunics like statues.

Like the *Three Musicians* of which they constitute a kind of antithesis, these *Three Women* are inserted in the fixed time of memory. An epoch is over, another one begins in which for a time cubist stylisation and classical revision will cohabit, until the irruption of surrealism into Picasso's world of metamorphosis.

Conclusion

Cubism in the century

After the artists and the critics, cubism was taken over by history. Born in the secrecy of the studios in Montmartre, during its short period of creation from 1907 to 1914, it remained constantly a source of scandal and stimulation for the mind. Beyond the vision, a new conception of the world was asserted in spite of the opposition it aroused. For several years the hostile critics declared, announced and desired the death of cubism, and they actively contributed to this purpose. Yet this monochrome, hermetic and austere art, produced with traditional means in a new realistic spirit, vanquished the predicted death.

Forty years later the painter Jean Bazaine will write[51]: "The profound truth of cubism is not... that it decomposed and analysed the object, but that it recaptured its creative rhythm, its vital impulse, from the human element, from the human creative act..."

If cubism is the most radical and complete artistic revolution since the Renaissance, it also represents the first great style of humanist conquest of the 20th century.

By its simple and unadorned vocabulary, its intention of figuration through basic geometric volumes, cubism was opposed to nature as an expression of thought and enjoyment of life and therefore to the sensualistic styles that come from its contemplation. It was also opposed to abstraction; each time the conceptual handling of the object endangered its immediate perception, Braque and Picasso found a way of coming back to reality; that was the function of the papiers collés, stencilled letters, imitation wood and the introduction of heterogeneous materials. The assertion of the real, true object was not an illusionist process, a trompe-l'œil, but a method of knowledge. It was a prelude to the three-dimensional assemblages, then to the relief pictures.

In its syntax of intellectual break based upon the arrangement of discontinuous forms, cubism comes close to poetry and music. The company of the rhymers of La Butte Montmartre was always a source of inspiration for the painters – "Au rendez-vous des poètes" was written on the door of Picasso's studio – and, like Braque, Picasso was aware of the importance of the poetic image and humour in his work. The poets, Max Jacob, Salmon, Apollinaire, Reverdy, Cendrars, shared with the painters the same boldness of language, they disrupted their lines like the latter disassembled form; they gave to poetry and painting a similar musicality between the world as it is perceived and the world as it is dreamed.

Cubism spread throughout Europe and to the United States; its relationship with the movements that it influenced or from which it received various contributions, was reciprocally enriching and its confrontation with the futurists, from 1912 onwards, brought new elements to the avant-garde with regards to movement and modern life.

The dispersion brought about by the war, which occurred after the "break up" of cubism, opened up the way to several many-sided trends that were to proliferate and influence architecture, the decorative arts, everyday objects and even the cinema, but by 1914 the essential was

51 J. Bazaine, "Le Cubisme et nous" in *Esprit*, June 1950.

already accomplished. Cubism provided the artist with a new field of knowledge and associated learning with perception; an artistic movement seldom came so near to things. The cubist space is one of touch. Eyesight only allows one to perceive one side of an object, touch on the contrary gives the possibility of apprehending all sides at once. Braque put forward the existence of a "tactile space", cubism was searching for the materialisation of this space.

Cubism appeared at the same time as the considerable development of mechanisation, when, thanks to the first aeroplanes, man was beginning to conquer space, and it cannot be dissociated from the formidable transformations of the beginning of the century and the new curiosity that they brought about. Only on the surface the cubist man appears to be static in his world of mental painting where "the subject shrinks modestly, towards silence", writes Jean Cassou. Inside the space of the picture, this art will take on the demands of the stage from which it will afterwards break free, it will follow the ventures of the mind and the hand.

Cubist art is one of discontinuity; its components, from the geometrical asceticism of the Bateau-Lavoir to the temptation of abstraction of Orphism, from Braque's papiers collés to Léger's "contrasts of forms", follow the sinuous path of the very bold combinations of creation; with works in drawing rather than colour, at least during the heroic years, cubism managed to avoid being petrified in an excess of rigour and to stay in contact with life and the intellect. The evolution of its creators, who freed themselves from convention, did not signify renunciation or denial, but rather a widening and development of its singularity.

There is no conclusion to the history of cubism because it has proved that in art the freedom of those who take risks is boundless, it remains a style both present and alive.

Photographic Credits